ART/A/e15·99
9/1/92
T

FASHION IN PHOTOGRAPHS 1880-1900

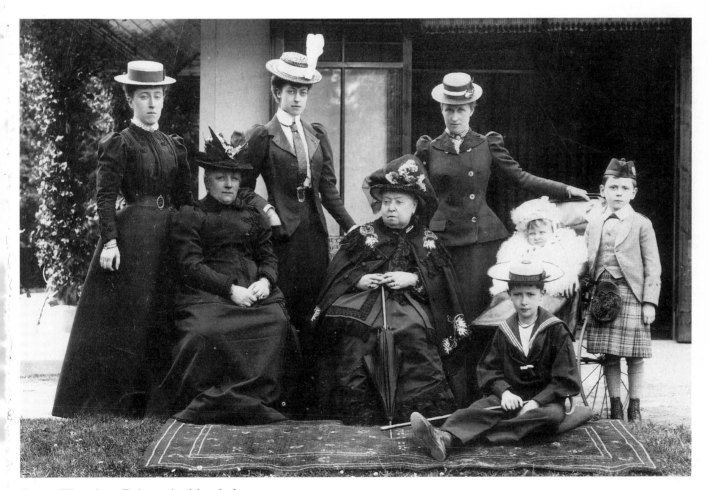

Queen Victoria at Balmoral with relatives
1898
Robert Milne of Aboyne and Ballater, Balmoral (NPG x 8490)

(From left to right:) *Princess Helena Victoria of Schleswig-Holstein; Princess Maria of Leiningen; Victoria, Princess of Wales; Princess Henry of Prussia; Princes Waldemar and Sigismund of Prussia; Prince Maurice of Battenberg.*

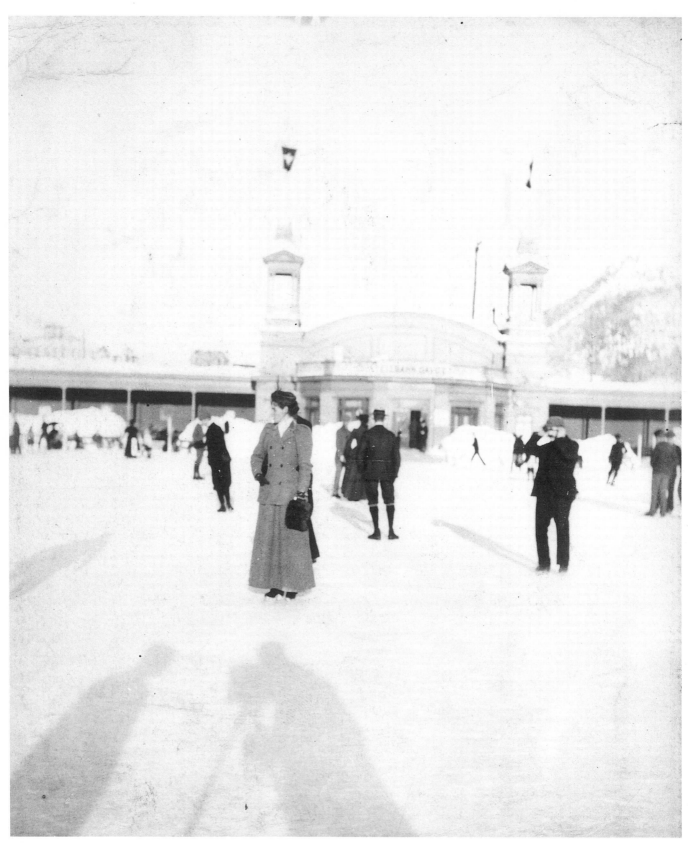

Iris Mitford with the shadow of her photographer
c. 1898
Photographer unknown (NPG x 27951)

FASHION IN PHOTOGRAPHS 1880-1900

Sarah Levitt

IN ASSOCIATION WITH
THE NATIONAL PORTRAIT GALLERY

B.T.Batsford Ltd·London

For Julian and Catherine

First published 1991

Typeset by Servis Filmsetting Ltd, Manchester

and printed in Great Britain by
BPCC Hazell Books, Aylesbury
Published by
B.T. Batsford Ltd
4 Fitzhardinge Street
London W1H 0AH

A catalogue record for this book is available from the British
Library

ISBN 0 7134 6120 9

CONTENTS

Acknowledgements 6

Picture list 7

A note on this series 9

Introduction 10

Part 1: 1880–85 15

 Male 16

 Group 28

 Female 33

Part 2: 1886–90 41

 Male 42

 Group 58

 Female 63

Part 3: 1891–95 78

 Male 79

 Group 94

 Female 104

Part 4: 1896–1900 115

 Male 116

 Group 129

 Female 133

Notes 141

Further reading 143

Index 144

ACKNOWLEDGEMENTS

The research for this book involved many happy hours delving in the National Portrait Gallery Archive. I would like to thank the staff of the Archive, in particular Terence Pepper, Research Assistant in charge of Photographs, and his assistants, Ian Thomas and David Chandler, for their enthusiastic help and encouragement.

All plates reproduced by kind permission of the National Portrait Gallery Archive.

PICTURE LIST

PART 1: 1880–85

1. George Joachim Goschen 16
2. George Joachim Goschen 16
3. George Joachim Goschen 16
4. George Joachim Goschen 16
5. 6th, 7th, 8th and 9th Earls of Albermarle 17
6. James Lowther 18
7. 2nd Earl Granville 19
8. General Charles George Gordon 20
9. Major-General Thesiger, 2nd Baron Chelmsford 20
10. Sir John Everett Millais 21
11. Sir John Everett Millais 22
12. Sir John Gilbert 23
13. Henry Irving 23
14. Lord Charles Beresford 24
15. Edward King (Bishop of Lincoln) and other clerics 25
16. Captain Matthew Webb 25
17. Henry Morton Stanley 26
18. Henry Graves 27
19. G. A. and Emily Storey 28
20. Professor, Fanny, and Charles Prior Ellison 29
21. Edward, Prince of Wales, Princess Alexandra, and their children 30
22. John Nevill and Elizabeth Maskelyne, and their children 31
23. Sir James and Lady Anderson 32
24. Madge Robertson Kendal 33
25. Georgiana Burne-Jones 34
26. Ellen Terry 35
27. Baroness Haldon 36
28. Eugénie, ex-Empress of France 37
29. Queen Victoria and Princess Beatrice 38
30. Margaret Leighton 39
31. Lillie Langtry 39
32. Lady Randolph Churchill 40

PART 2: 1886–90

33. Thomas Holdsworth 42
34. William Ewart Gladstone 43
35. Brooke Boothby 44
36. George H. Lewis 45
37. William Thomas Stead 46
38. Harry Cust 46
39. 5th Marquess of Lansdowne, 1st Earl Roberts, and members of the British Administration in India. 47
40. George Frederick Watts 48
41. Lawrence Alma-Tadema 48
42. Edmund Constantine Phipps 49
43. George Augustus Sala 50
44. Joseph Chamberlain 51
45. 5th Baron Ashburton 52
46. Sir Edward Birkbeck 53
47. Marquis of Hartington 54
48. William Gilbert Grace 55
49. John Burns and a colleague 56
50. George Bernard Shaw 57
51. Fanny and Harry Stone 58
52. Francis, Harriette, Emily, Alice, and Mary Penrose 59
53. Mr Woods and the Misses Cameron 59
54. William Ewart and Catherine Gladstone 60
55. Princess Alexandra, King George I of the Hellenes, and Czarina Marie Feodorovna 61
56. G. A. Storey, Emily Storey, and family and friends 62
57. May Morris 63
58. Gladys Storey and a maid 64
59. Dorothea Beale and staff of Cheltenham Ladies' College 65
60. Emily Penrose 66
61. Adelina Patti 67
62. Amy Roselle 68
63. Marchioness of Stafford 69
64. Lady Daisy Brooke 70
65. Rhoda Broughton 71
66. Marie de Rothschild 71
67. Agnes Huntington 72
68. Lady Dunlo 73
69. Grand Duchess of Mecklenburg-Strelitz 74
70. Lady Randolph Churchill 75
71. Mary Moore 76
72. Frances Hodgson Burnett 76
73. Victoria, Empress of Germany 77

PART 3: 1891–95

74. Sir Edward Robert Pearce Edgcumbe 79
75. John Ruskin and Sir Henry Wentworth Dyke Acland 80
76. The Honourable Alfred Percy Allsop 81
77. Arthur Wing Pinero 82
78. R. Jope Slade 82
79. Sidney Herbert, 14th Earl of Pembroke 83
80. Norman Evelyn Leslie, 19th Earl of Rothes 84
81. Cyril Flower, 1st Baron Battersea 85
82. Lewis Flower 86
83. Robert Louis Stevenson, Lloyd Osbourne, Captain Wurmbrand, and Henry Simele 87
84. Wilfrid Scawen Blunt 88
85. William Thomas Stead 89
86. Oscar Wilde and Lord Alfred Douglas 90
87. William Morris and staff of the Kelmscott Press 91
88. James Kier Hardie 92
89. Sir George Scharf and Frank Donnely 93
90. King Alfonso XIII of Spain and his mother, Queen Maria Christina 94
91. May Morris, Henry Halliday Sparling, Gustave Steffen, and Anna Steffen 95
92. Alice Mary Roe, Charles Edward Roe, Robert William Dolling, and four others 96
93. Edward, Prince of Wales and a shooting party 97
94. Sir Richard Strachey, Lady Strachey, and their family,

including Lytton and Pippa 98
95. Montague and Mary Annie
 Sharpe 99
96. 2nd Duke of Cambridge
 and group 100
97. 5th Earl and Countess of
 Clancarty 101
98. Weedon and May
 Grossmith 102
99. Archibald and Alicia Little 103
100. Lady Clare Annesley and
 her nurse 104
101. Lady Frances Edgcumbe 105
102. Fanny Brough 106
103. Augusta, Empress of
 Germany 107
104. Rachel, Countess of Dudley 107
105. Baroness Rodney 107
106. Edith Ailsa Craig 108
107. Pippa Strachey 109
108. Ethel Smyth 109
109. Lady Susan Beresford and
 Lady Clodagh Anson 110
110. Marchioness of Granby 111
111. Countess and Lady Clare
 Annesley 112
112. Lady Caroline Ridgeway 112
113. Baroness Mowbray,
 Segrave and Stourton 113
114. Mrs R. F. Brain 114
115. Priscilla, Countess Annesley 114
116. Priscilla, Countess Annesley 114

PART 4: 1896–1900

117. David Walker 116
118. Ignatz Paderewski and
 Camille Saint-Saëns 117
119. Charles Hayden Coffin 118
120. Lloyd Tyrell-Kenyon 119
121. Horatio Herbert, 1st Baron
 Kitchener of Khartoum 120
122. Cecil Higgins 121
123. Horace Rumbold 122
124. George Herbert Hyde
 Villiers 122
125. Baron de Heeckeren 123
126. Baron de Heeckeren 123
127. Baron de Heeckeren 123
128. Harry, Charles, Walter,
 John, Ernest, and Arthur
 Masterman 124
129. Arthur Balfour and the
 Harvard and Yale student
 rowing teams 125
130. The Imperial Penny
 Postage Conference 126
131. T. M. F. Minstrell,
 Theodore Bello, J. F. M.
 Bussy, and Alfred James 127
132. James Oram 127
133. Directors and staff of Henry
 Graves & Company
 Limited 128
134. Karl Pearson, Maria
 Pearson, and family 129

135. Algernon Swinburne and
 family 130
136. Edward and Alexandra
 (Prince and Princess of
 Wales), the Duke of
 Connaught and family,
 Nicholas and Alexandra
 (Czar and Czarina of
 Russia), and other royal
 guests 131
137. Mr and Mrs Brownsfield,
 Mr and Mrs J. C. Macdona,
 and Esther MacDona 132
138. Francis, Rosina, Ethel and
 Miss Burnand, Mrs Phil
 May, William Jones, Nancy
 Lucy, and Miss Cavendish 132
139. Mary Anne Keeley 133
140. Lady Randolph Churchill 134
141. Kate Courtney 135
142. Emily, Harriette, Alice, and
 Mary Penrose 135
143. The Honourable Elaine
 Guest 136
144. Theresa Escombe 136
145. Countess and Lady
 Dorothy Orford 137
146. Emily Penrose 138
147. Lady Musgrave 138
148. Lady Elizabeth Wardle 139
149. Baroness Seaton 139
150. Lady Mary Grey-Egerton 140

A NOTE ON THIS SERIES

THE AIM OF THE SERIES

This series sets out to present a photographic, and thus historically accurate, record of the clothes worn by men, women, and children during the period 1860–1940. Using unpublished photographs from the National Portrait Gallery and other archives, the authors have taken a representative selection from society (within the constraints of the collections) to demonstrate how fashion changed so enormously over these 80 years.

A general note

Some of the most notable men and women of recent history are featured here: politicians, writers, actresses and royalty. Children too, are featured; some from prominent families, some virtually unknown.

For many of the photographs the author gives a detailed and expert description of the sitter's costume, hairstyle, footwear, and jewellery, as appropriate. This enables the reader to build up a picture of how fashion evolved during the period concerned. Furthermore, the authors give a glimpse of the world of past fashion through contemporary eyes, by including extracts from fashion magazines of the day, and comments from contemporary observers. They explain how designs originated, how they were made up, where they were bought and how – and by whom – they were worn and cared for.

How to use the books

In each book, approximately 150 photographs are presented in chronological order, divided into five-year periods and then further sub-divided into male, female, and group portraits. This means that even a rapid look through the photographs shows the changes in fashion that occurred over any given time.

Every caption begins with a title giving the following information (where available): name of sitter, date and location of photograph, name of photographer, and the National Portrait Gallery (or other) reference.

Beneath the title is the author's detailed description of the photograph, including biographical information on the sitter.

For those readers looking for a particular photograph, there is a numerical list at the front of the book or, of course, the Index.

The sitters

Many of the people pictured in these books were prominent members of society who were considered important or interesting enough to merit a permanent record of their features. This group includes royalty, politicians, writers, artists, and industrialists. On the whole, working-class heroes, unsung campaigners, and professionals are less well represented. However, the newly prosperous middle-classes could afford studio portraits of themselves, and there are many surviving photographs of such families, some of which have been included here.

Photographs of men outnumber those of women in the National Portrait Gallery Archive. Men were usually more active than women in public life, and masculine hobbies, such as shooting, tended to have a higher profile than female pursuits. However, there are more photographs of women than might be expected: some wives appear, along with children, friends and servants, merely as appendages of great men. In addition, photographs of pretty women have always been sought after, and the collection is therefore comparatively rich in actresses and society beauties. Photographs of women who were considered outstanding for reasons other than their beauty, wealth, or husband are less numerous, but where these are available – such as Florence Nightingale, Frances Hodgson Burnett, and Miss Beale – they are included.

THE NATIONAL PORTRAIT GALLERY ARCHIVE

The National Portrait Gallery was founded in 1856 and for most of the nineteenth century the collections did not encompass photographs, since acquisition policy was directed wholly towards painted or drawn portraits of the royal family and its entourage. Moreover, for inclusion in the NPG the person depicted, unless one of the royal family, had to have been dead for at least ten years. This stipulation effectively ruled out almost all portrait photography for at least a decade. In 1895 Sir George Scharf, the first Director, bequeathed his own photographic collection to the Gallery, together with the rest of his library; and from the turn of the century other photographs were acquired. The first major acquisitions, in 1904, were the daybooks of the 1860s studio photographer Camille Silvy, which contained some 17,000 file-prints for cartes-de-visite.

In 1917 the National Photographic Record was established by the Gallery's Trustees to photograph living personalities for the collection, and this lasted until 1970. Some 7,000 portraits were taken and alongside this the reference library was active in its collection of historical photographs.

The 1960s and 1970s saw the establishment of both an outstanding collection of contemporary photographs, and also a series of much lauded exhibitions and one-man shows. The collection in the 1990s comprises over 100,000 photographs of prominent men and women, and the vast majority of illustrations in this series has come from the National Portrait Gallery archives. Serious students, wishing to make further research, can usually visit the archive by prior appointment.

INTRODUCTION

The National Portrait Gallery's collection of more than 100,000 images includes around 4,000 dating from 1880 to 1900, from which the present selection has been taken. Gaps are filled whenever possible; individual pictures are acquired together with published volumes of photographs, and private albums and collections. In the last-mentioned category can be found the following notable items: Lord Battersea's record of his house guests around the year 1890, MP Benjamin Stone's pictures taken from 1897 onwards of visitors, staff, and members of the House of Commons, and original negatives from the fashionable studio photographer Bassano.

VICTORIAN PHOTOGRAPHIC TECHNIQUES

In 1839 the first commercially viable photographs were produced in France by Louis Daguerre. These silvery images on copper plates were extremely popular, despite their fragility. Frederick Scott Archer's 'collodion wet-plate process' of 1851 created a glass negative which appeared positive when mounted on a black backing paper. This revolutionized photography, bringing the price within reach of many ordinary people. These negatives could also be developed onto light sensitive paper treated with egg albumen, but this method was less popular until the French photographer André Disderi patented a multi-lensed camera that produced several prints from one negative. 'Carte-de-Visite' photographs (so called because, when mounted, they were the same size as visiting cards) were hugely popular in England in the 1860s. The 6½in. by 4½in. 'Cabinet' format was preferred from the 1870s.

FURTHER DEVELOPMENTS IN PHOTOGRAPHIC TECHNIQUES

The quality of many late nineteenth-century photographs compares well with modern ones. Through careful lighting, depth of focus, large glass negatives, and quality printing every fibre and stitch of a garment could be captured forever.

Contemporary photographic limitations influenced the clothing worn in pictures like those in this book. Amateur photography was in its infancy and the snapshot was virtually unknown until the twentieth century. Most of the portraits were taken in the formal setting of professional studios. The subjects posed in smart outfits chosen to convey the right effect for posterity. They rarely appear 'off duty', there is more indoor than outdoor dress worn, and hardly any sportswear to be seen. Female evening gowns are frequently recorded, but the strongly contrasting black and white of male evening wear was hard to capture, and sitters rarely wore it. On the other hand, photographers liked middle tones and interesting textures, so there may be a comparative abundance of tweed, and too many grey rather than black frock coats represented in the collection.

A great step forward came in 1877 when Van der Weyde's electric-lighting studio opened in London. The improved illumination not only reduced exposures to two or three seconds for cartes-de-visite, and eight or ten seconds for larger format pictures, but also enabled studios to open late into the night. Fashionable ladies now had their pictures taken on their way to the theatre ready for collection by the interval.

Another turning point was reached around this time with the adoption of dry-plate negatives. These required far less equipment; plates could be prepared beforehand by the photographer or by a specialist supplier. The American Eastman company went a stage further, patenting celluloid films in 1889: their 'Kodak' camera was designed for this type of film. It was sold ready-loaded, sent back to Eastman for developing, and returned with the prints and a fresh film inside. It weighed only 2¼lb (1kg) and featured push-button and shutter mechanisms. With simple equipment and professional backup, amateur photography could begin in earnest. George Bernard Shaw was among the one in ten people in England who owned a camera by 1900.[1]

In an age of instant news, when television brings men of the moment across the world in seconds, it is hard to imagine a time when the features of people like the Duke of Wellington were known mainly through crude woodcuts, and such worthies as the local MP were hardly recognized at all. From its earliest days, the camera transformed people's perception of Society and the role of famous people within it; for the first time they were not only known by reputation but recognizable wherever they went.

From the 1840s onwards wood-engravings from photographs brought life to journals like the *Illustrated London News*. Half-tone printing processes enabled photographs to be reproduced with great accuracy from the end of the century, but even before then expensive publications included actual photographs, printed by the thousand, using a wide range of processes.

The early cartes-de-visite were not restricted to family mementoes. Ever since 1859, when Napoleon III was photographed in uniform while his army waited outside the studio, pictures of the famous had been sold to an avid public. Characters like General Tom Thumb or Madame Taglioni appeared in the family album side by side with great aunts and baby nephews. Magic lanterns and, from 1889, Friese-Greene's cinematographic pictures also helped to turn distant statesmen into household names and the adornments of London drawing-rooms into nationally known pin-ups.

As a little girl, Lillie Langtry used to admire photographs of Lady Dudley on sale in a stationer's shop, 'and I sometimes wondered what it must be like to be such a great and fashionable beauty.' She soon found out. After taking London by storm:

The photographers, one and all, besought me to sit. Presently, my portraits were in every shop-window, with trying results, for they made the public so familiar with my features that wherever I went – to the theatre, picture-galleries, shops – I was actually mobbed.[2]

Photographs also helped to win elections. Gladstone's granddaughter Dorothy

> grew into a sturdy child with a mass of photogenic golden curls, and the photographers had a splendid time producing pictures of the Grand Old Man and his dear little granddaughter – wisdom and innocence – which the public bought by the thousand.[3]

Photography gave the first accurate representations of the monarch's appearance and helped to bind the nation together in unprecedented affection for the crown. Victoria was a great fan of the camera. Publicity pictures of her with her husband and young family enhanced their popularity. Throughout her long years of seclusion photographers kept the mourning Queen in the minds of the nation and helped to spread the fashion for widows to wear black for protracted periods. By the 1880s and 1890s, with the Golden and Diamond Jubilees reviving interest in the Queen, her photograph was hung in parish rooms the length and breadth of the country. Pictures of royal brides, from Alexandra onwards, and of bevies of grandchildren and great-grandchildren all helped to consolidate a tradition of national interest in the royal family.

It should be said that photography did not at that time place an intolerable strain on most famous faces; even Edward, Prince of Wales, when 'off duty', could walk down the Mall in a way that would be impossible for Prince Charles a century later. The following story shows how pictures of well-known people could be used, and suggests some hesitancy remained in trusting the camera rather than the intellect, at least among the visually aware.

In 1878 Francis Burnand, editor of *Punch*, invited the illustrator Linley Sambourne and his wife to dinner, mentioning that there would be a surprise fellow-guest at the party. *Through the Dark Continent*, by H. M. Stanley, had recently appeared, describing his adventures in Africa. Sambourne half-jokingly asked if Stanley might be the mystery man, so Burnand persuaded another guest to impersonate the great explorer. The Sambournes were completely taken in as everyone else wickedly grilled the supposed traveller about his exploits. Sambourne remained convinced despite having recently drawn a cartoon from Stanley's photograph. When questioned later, he conceded that 'he didn't look like Stanley from photographs he had seen, but did not doubt it was him.'[4]

Sambourne's assumption was not as unreasonable as it might seem. London was a smaller place than it is today and influential people did tend to know each other; for instance W. S. Gilbert was present on that memorable evening. As it happened, Burnand was later invited by Henry Irving to dine at the Beef Steak Club with his friend George Augustus Sala, H. M. Stanley, and Richard Burton.[5]

SOCIETY

After the pictures had been selected for the present book it became apparent that most of the sitters were on nodding terms with each other, if not close acquaintances. Take an example such as George Lewis: Burnand twice 'bent the ear' of Lewis, 'the universally sought and exceptionally astute solicitor, who was able to do me one of those "good turns which deserves another."';[6] he acted for Lord Dunlo in his famous divorce suit against the lovely Belle Bilton;[7] Lord Charles Beresford's wife deposited letters with him, written in spite by Beresford's mistress Daisy Brooke. Lewis refused to release them, even to the Prince of Wales;[8] Lillie Langtry engaged him to sue a bank which had given a stranger £40,000-worth of her jewellery from its vault.[9]

The 1880s and 1890s were remembered as an age of beauty, elegance, and conviviality. A sophisticated few had affairs, divorced, smoked, gambled, wore make-up, and dyed their hair. The Church, riding on a wave of strength and enthusiasm, condemned such activities and the gulf between the 'moral majority' and fast-living High Society widened. The Prince of Wales, whose mistresses included the Countess of Warwick, Mrs Langtry, Mrs Cornwallis-West, and Mrs Keppel, was particularly censured and his suitability for kingship publicly questioned on several occasions.

It was largely due to the Prince of Wales that some doors in the best circles were now opened to anyone sufficiently interesting or rich, regardless of their background. For the first time great artists like Paderewski could be regarded as guests rather than hired entertainers; Henry Irving was one of the first actors to be accepted in society, but theatrical ladies probably graced more drawing-rooms; pretty women were sure to receive plenty of invitations. Americans and Jews were also admitted into many homes for the first time and some stayed, bringing new money into old families. Lady Saint Helier commented disapprovingly on the social scene in the 1890s:

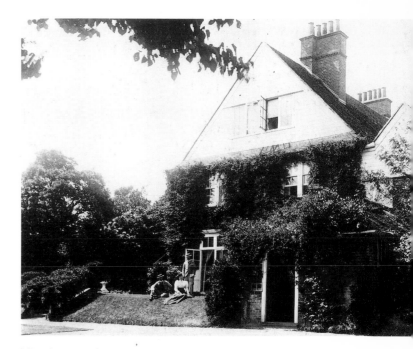

The Somers-Cocks family outside G. F. Watts's house, 'The Briary'
c. **1895**
Photographer unknown, (NPG x 36076)

Society now runs mad after anyone who can get himself talked of, and that not in the sole direction of great ability or distinction. To have a good cook, to be the smartest-dressed woman, to give the most magnificent entertainments where a fortune is spent on flowers and decorations, to be the most favoured guest of Royalty, or to have sailed as near to the wind of social disaster as is compatible with not being shipwrecked, are a few of the features which characterize some of the smartest people in London society. It must be admitted that these qualifications are not high or difficult to attain to, while the training ground is large and well studded with instructors.[10]

London's glittering Season lasted from spring to early summer, the time when country families traditionally flocked to the metropolis for the parliamentary session. Parliament was a relaxed affair, sitting for just four months a year. When Lord Salisbury was Premier he never called a cabinet when there was racing at Newmarket and the House of Commons used to adjourn for Derby Day.[11]

The court calendar coincided with parliamentary sittings. Four drawing-rooms were held at Buckingham Palace during February and March, at which young ladies were presented to the Queen or to the Princess of Wales. This was almost a pre-requisite for admission to society. Women were presented again after marriage, their husband's promotion, or succession to a title. The Prince of Wales held separate levees for gentlemen at Marlborough House.

The London Season was orchestrated by a small circle of great ladies, magnificent of carriage and costume. The Duchesses of Buccleuch and of Devonshire together with the Ladies London-derry, Cadogan, Illchester, and Ellesmere were the 'Grandes Dames' of the 1880s and 1890s,[12] whose sumptuous receptions set the tone of London life. The high standards of dress and dignified behaviour seen at the grandest ball were reflected at every kind of entertainment, such as dinners, musical evenings, teas, luncheons, garden and tennis parties, and fancy bazaars.

The West End streets buzzed with activity for these few months, except when terrible traffic jams brought everything to a standstill. But in August the city emptied as if by magic. Some went to fashionable resorts – Brighton, Trouville or perhaps Monte Carlo – whereas others with their own estates, or an invitation to someone else's, would head for the grouse-moors in time for the Glorious Twelfth. Anyone unlucky enough to be in Town could dress in country clothes, since they were clearly 'just passing through'!

London houses from Mayfair to Belgravia were shrouded in dust sheets as country residences were opened up. Some of these were immense: Welbeck Abbey, seat of the 6th Duke of Portland, was 'vast, splendid and utterly comfortless'. At the turn of the century the Duke employed 35 kitchen and service staff, 23 house and personal servants, 15 mechanics, 32 domestic stable workers, 33 garage workers, 16 racing-stablehands, 96 gardeners, 20 home-farm and vegetable garden workers, 11 golf-course staff, 13 laundresses, three window cleaners, an estate manager, a chaplain, a librarian, and a Japanese gymnasium instructor.[13]

Such establishments could provide lavish entertainment. Many people spent autumn and winter in a round of continual house parties at which hunting and shooting gave way in the evenings to dinners, receptions, and balls.

This was the last era in which estates could meet the running costs of large expensive houses and families. Income tax in 1893 was only seven pence (three new pence) in the pound, rising to one shilling and three pence (six-and-a-half new pence) by 1900, and so a good deal was left over. The Duke of Sutherland pinned £1000 notes to his wife Millicent's pillow while she slept.[14] Life was comfortable for many who were less well off too, housemaids cost just £20 a year, and so ordinary families with annual incomes of around £500 could afford several servants. The average worker in 1900 earned about £1 a week, so £20 per annum plus keep was a reasonable salary. A million people were employed as domestic servants in 1900.

Not all the people illustrated here lived lives of luxury, although *Who was Who* lists London addresses and second homes for most of them. For instance, the journalist W. T. Stead lived at Wimbledon Park and Hayling Island. Some, particularly academics, artists, craftsmen, and actors had comfortable but smallish homes. The playwright Pinero lived at 115a Harley Street. The artist G. A. Storey and Professor Karl Pearson both lived in Hampstead, at that time a picturesque village sur-rounded by modern residences. Bedford Park, a housing development in the aesthetic taste, and Chelsea were also favoured by the artistic. Improved railway links made life in even more distant suburbs a possibility.

These people's lives would have been quite different from that of the average duchess. To them, London was an exciting cultural centre revolving round the university and the British Museum in Bloomsbury, and the museums, artistic and scientific institutions in South Kensington. London University awarded degrees to women from 1878, while an embryonic grant system and the University Extension College encouraged students, like H. G. Wells, from working-class backgrounds. For this new intelligentsia, the social calendar meant a round of public meetings and debates: London buzzed with ideas, many of them left-wing. To them, a society was something you joined, such as the Fabian Society which was founded in 1883 for the promotion of evolutionary rather than revolutionary socialism.

INTELLECTUAL CURRENTS

An egalitarian vision lay behind the Arts and Crafts Movement. Its exponents, the followers of William Morris, felt that ugly mass-produced objects were symptomatic of capitalism. By returning to both traditional handwork and the maker's responsibility for design, beauty and utility could be restored. This viewpoint was greeted with enthusiasm by many in the new schools of art and design, helping to promote a widespread revival of traditional styles and techniques. The Arts and Crafts movement profoundly affected mainstream decorative art, influencing the 'aesthetic' style of the 1870s and 1880s, and Art Nouveau, which followed on from it.

An interest in history was a major element in all forms of creative expression throughout the century. In the visual arts the influence of the Pre-Raphaelites was still strongly felt in the 1880s and 1890s by painters like G. A. Storey, Henry Holiday, and Alfred Gotch. Classical revivalists, led by Frederick Leighton and Lawrence Alma-Tadema, preferred to recreate the everyday life of ancient Greece and Rome. Many subjects depicted by artists were taken from modern historical novels – Walter Scott was a favourite – and scenes from Shakespeare were inspired by Irving's 'accurate' productions at the Lyceum.

Japanese art was another important influence following the opening of Japan to Western trade in 1868. Blue-and-white china, fans, lacquer, and other *objets d'art*, supplied for instance by Liberty & Co. from 1875, were blended with Morris wallpapers in 'aesthetic' interiors. By the 1880s, Japanese motifs were frequently used by mainstream commercial artists. Painters like James McNeill Whistler and the French Impressionists were excited by Japanese woodcuts; they found their approach to the depiction of reality complemented the fresh perceptions brought about by photography.

Photography helped artists to create a high degree of realism, especially in their treatment of modern subjects. Detailed scenes from daily life on all social levels continued to interest painters as diverse as James Tissot and Hubert Herkomer, making an interesting counterpoint to historical themes.

Social realism was of major importance in literature as well as in painting. Many writers who specialized in contemporary themes have subsequently become well known: Arthur Conan Doyle, Thomas Hardy, H. G. Wells, E. F. Benson, Frances Hodgson Burnett, Henry James, and Arnold Bennett were all active at this time. Other novelists, more or less forgotten today (for instance Ouida, Marie Corelli, Mrs Braddon, and Mrs Ward) were household names. Most of these writers produced work in serial form for magazines like *Blackwood's*, *Cassell's*, and *Longman's*, which were avidly read by the newly literate masses.

Most publications provided wholesome family entertainment, but there was a definite feeling, reflected in some art and literature, of *fin de siècle* decadence. Society's increasing opulence and immorality were seen by many as a last fling in the face of inevitable change in the next century. The *Yellow Book*, an exclusive magazine elegantly illustrated by Aubrey Beardsley, became notorious as a symbol of this attitude. Oscar Wilde, whose banned *Salome* was also illustrated by Beardsley, became a public incarnation of decadence when he was gaoled for homosexuality in 1895.

Wilde's court case abruptly ended the successful run of his play *The Importance of Being Earnest*. The cultural richness of the 1880s and 1890s is nowhere more apparent than in the revival of the theatre, encouraged by gifted critics such as George Bernard Shaw. Historical plays were magnificently produced by Irving and Beerbohm Tree. Sophisticated contemporary subjects were dealt with in society dramas, including those by Wilde and Arthur Wing Pinero. Pinero's plays, such as *The Second Mrs Tanqueray* and *The Notorious Mrs Ebbsmith* were highly thought of by his contemporaries.

These were good times too for the popular theatre; tall, handsome, exquisitely attired dancers at the Gaiety Theatre tantalized audiences with glimpses of legs amidst frothy petticoats. Lottie Collins launched 'Ta-ra-ra Boom de Ay' in 1892. In this era many other music-hall favourites were first sung by Little Tich, Dan Leno, Albert Chevalier, Harry Champion, Marie Lloyd, and George Robey.

The theatre was a venue for all kinds of public spectacles; conjuring, mesmerism, and quack remedies were demonstrated side by side with significant inventions. In 1896 the Alhambra theatre was the first to show a film of the Prince of Wales's horse Persimmon winning the Derby. By then, popular songs could be heard on the phonograph. Other inventions included domestic electricity, telephones, safety bicycles, motor cars, and airships. The late Victorians were intensely proud of their age of

progress and prosperity, in which one invention succeeded another. British industry was still strong, bolstered by vast markets across the Empire. Britannia ruled 20 per cent of the world's land surface and 25 per cent of its population. The Empire created employment for thousands of missionaries and government officials, as well as the soldiers and sailors who were sent to quell any local disturbances. The Boer War was the most serious conflict of the age, but, like the rest of the nation's military exploits, the tragedy provided heroes and boosted public pride in the British Empire. It was as Empress of a great domain that Victoria was celebrated in 1897, her Diamond Jubilee year. Paderewski was among the millions who remembered the celebrations:

> I was at Queen Victoria's jubilee and it was a wonderful sight – of a splendour hardly to be imagined. I saw the great pageant, that procession of all the vassals of the empire, the Maharajahs, the Governors of Dominions, and the Prime Ministers, all following the carriage of the Queen. One of the greatest impressions I ever experienced was when I saw that magnificent display of riches, especially on the part of the Indian Maharajahs. It was marvellous. They wore all their jewels – they seemed clothed in jewels. Such gorgeous emeralds of a fire and brilliance that was simply dazzling even in that procession of blazing gems.[15]

CLOTHING

Many people visiting London for the Jubilee from every corner of the Empire must have been as amazed by the English, as the English and Paderewski were by the maharajahs.

The rigid class system was nowhere more apparent than in clothing, through which power, wealth, and status were expressed. The upper classes dressed opulently, in glittering splendour or sophisticated restraint, as the occasion demanded. Vulgarity, inferior workmanship and shoddy materials distinguished the less well-bred, while a poor person's situation was instantly apparent.

Maintaining a respectable appearance was a heavy burden for the less wealthy, particularly those with a special position to keep. Not only were clothes comparatively more expensive than they are today, but different social activities called for specific costumes. In the Season, both ladies and gentlemen might change up to six times a day; even sports called for expensive specialist outfits. The most informal clothing of the time was much more elaborate than modern garments, more easily damaged and harder to clean. Those without servants wasted hours on tasks like brushing mud off skirt hems and polishing silk hats, and pounds on laundry bills.

Buying clothes was also a time-consuming, if popular, pastime during the Season. Most fashionable establishments were centred on the area between Regent Street and Park Lane. While London was well known as the world centre for tailoring, wealthy ladies flocked to Parisian couturiers such as Worth, Doucet, and Rouff[16] in addition to patronizing London firms. Most things were made to measure by exclusive tailors, shirtmakers, bootmakers, milliners, and dressmakers. It was only acceptable to buy accessories and certain garments like mackintoshes and furs ready-made.

Clothing factories had existed in this country since as early as the 1850s, when sewing-machines were first introduced. By 1900

the clothing industry employed a million workers, clothed a substantial proportion of the working population, and exported goods across the world. The rich, who could afford exclusive custom-made items, were deeply prejudiced against mass-produced garments and their lead was followed lower down the social scale. 'Fashion' involves one group admiring and imitating another and in the nineteenth century fashions were handed down from the top. Upper-class appearances and attitudes, such as resistance to ready-made clothing, therefore greatly influenced the population as a whole.

The clothing of prominent figures was frequently referred to in the press. 'An elegant costume seen at such and such a soirée' might be described, or a more lengthy account given of, say, the trousseau of Princess Louise of Wales, who married in 1889.[18] Contemporary plays also provided an abundance of elegant toilettes for the press to report in eager detail. Then as now, magazines were treasured and passed around. Improved standards of education meant that even scullery maids and villages housewives could read about the latest fashions. The *Girls' Own Paper* and other good, cheap publications appeared in response to the new readership. From around 1892 even Worth himself allowed his creations to be illustrated.[19]

Photography enabled fashion to travel further and faster. Photographs of 'the good and great' were often incorporated into fashion engravings: in 1897 the *Tailor and Cutter* depicted the Duke of Connaught, the Prince of Wales, the Czar of Russia, and Gladstone as mannequins. Tailors could recommend to clients 'a very aristocratic looking overcoat of Homespun or Harris tweed . . . the type of garment to be found in the outfit of every gentleman',[20] as shown on the back of the Prince of Wales himself.

Many of the people depicted in this book participated in the Season and the ensuing rounds of house parties and holidays. Others, like Dorothea Beale, head of Cheltenham Ladies' College, had neither the time nor the inclination to change six times a day. Busy people often found the social requirements of dress a burden. Nevertheless, the fashions set by society influenced all costume to some extent. Even old-fashioned clothing bears some relation to clothes that used to be fashionable.

Another group included here were not so much old-fashioned as anti-fashion. A substantial minority objected to the tyranny of mainstream fashion which they believed to be ugly, subject to unnecessary change in the case of women, and drearily boring for men. Women's clothes in particular were considered too restrictive, whilst having to maintain a 'respectable' dress that was impractical for work placed unnecessary strain on poorer people. Most important of all were the vociferous objections to fashionable dress on health grounds; tight-lacing was particularly criticized. Although the practice had gone on for generations, technical developments in corsetry meant it could now cause more serious damage.

Dress reformers fell into many categories. Health campaigners included Dr Jaeger, who advocated wearing wool next to the skin and sold specially designed underclothing. Others, like George Bernard Shaw, advocated reform not only on health grounds, but also because he equated the tyranny of fashion with the tyranny of the class system. Many women's suffragists were active in the dress-reform movement. They believed that women needed to wear garments that were more practical and healthy if they were to take their rightful place in society.

Most 'rational' dress was doomed to failure because it looked so peculiar. Reformers who approached the problem from the point of view of aesthetics as well as health had better luck. William Morris's dictum 'have nothing in your house that you do not know to be useful or believe to be beautiful' had been applied to clothing by his wife Jane and other women in Pre-Raphaelite circles in the 1860s. Their loose, quasi-medieval gowns were copied by the artistic avante-garde. By the mid-1870s an identifiable 'look' had evolved, consisting of a flowing green or brown dress, with big sleeves, worn obviously without stays, but with white ruffles at the neck and cuffs. Frizzed red hair 'à la Rossetti' and possibly a wide-brimmed feathered hat completed the picture, which was a cross between Botticelli's 'Primavera' and a Bronzino portrait. The aesthetic male adopted the long hair, soft collar and floppy bow tie which came to be popularly associated with creative genius and clad his legs in knee breeches, which were considered more picturesque than trousers.

Punch had great fun lampooning 'aesthetic' folk in George du Maurier's cartoons, which recounted the adventures of the 'Cimabue Brown' family through the late 1870s. Oscar Wilde's 'aesthetic' costume, which caused so much ribaldry when he wore it in London, inspired Gilbert and Sullivan's opera *Patience* of 1881. This work immortalized the 'aesthetic type', 'with a poppy or a lily' in his 'medieval hand' along with the whole 'greenery-yallery' aesthetic movement.

Artistic dress was, however, not just a passing craze. Pictures in this collection show that it continued to be worn by many people in academic life, the Arts and Crafts Movement, and thinking people generally.

PART ONE: 1880-85

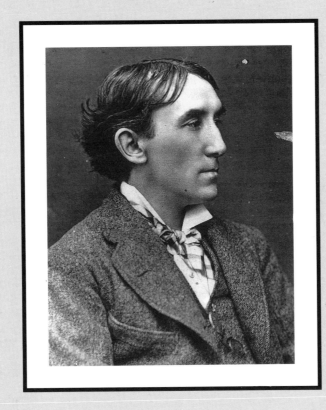

MALE

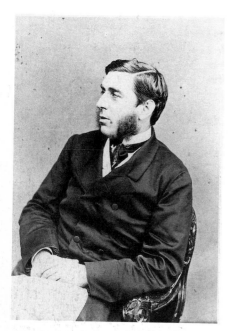

1. George Joachim Goschen
1877
Mayall, London and Brighton (NPG x 27763)

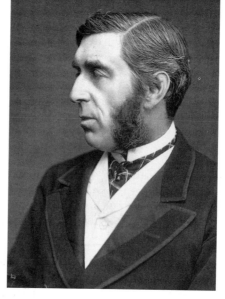

2. G. J. Goschen
c. 1880
Lock & Whitfield, London (NPG x 12502)

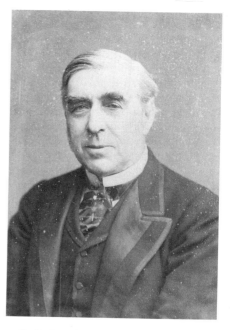

3. G. J. Goschen
c. 1895
London Stereoscopic Company (NPG x 12546)

1, 2, 3, 4

Goschen (1831–1907), who came from a banking family, was appointed Director of the Bank of England in 1858. Between his election as a Liberal MP in 1863, and 1900 when he became a viscount, he was Vice President of the Board of Trade, First Lord of the Admiralty, and Chancellor of the Exchequer.

This period was marked by a tremendous diversity of styles, but whilst some men represented in the collection are shown in many different outfits, others were extremely conservative, remaining faithful to the fashions of their youth. Gentlemen were expected to be reasonably fashionable without appearing in any way remarkable.

Although hairstyle, collar, and neckwear were the cheapest, and therefore the easiest areas to keep up to date, they were also the most sensitive, being closest to the face and subject to the greatest personal choice. Thus, they both conveyed and became part of an individual's character. Many people, therefore, chose safe styles and paradoxically, although fashions in hairdressing and neckwear changed more rapidly than did most aspects of dress, they cannot always be used to date a costume. These pictures of Goschen show an individual retaining the same basic hairstyle, collar, and tie over a quarter of a century.

However, a picture can be dated in other ways. The sitter ages, the type of photograph changes, and so does the frock coat. Plate 1, the earliest picture, shows the glossy, napped surface popular since the mid-century, which went out of fashion in the 1880s. The second picture shows the bound edges so popular in the 80s, and which continued into the 90s, although plain edges, as in the last picture, became more general.

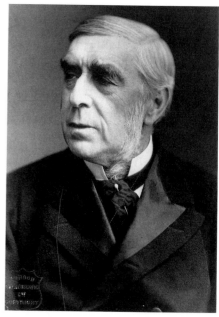

4. G. J. Goschen
c. 1900
London Stereoscopic Co. (NPG ref. neg. no. 8442)

—————— **5** ——————

All four members of the Keppel family were soldiers and politicians of some distinction.

Baby Walter's (1882–1979) shortening dress shows he was about six months old in this photograph. Infants wore very long gowns only until they became mobile, when long clothing would encumber them.

George Keppel (1799–1891), the 84-year-old great-grandfather, and his son William (1832–1884) wear frock coats; the uniform of respectability among the middle-aged and elderly. Arnold (1858–1942), the baby's father, wears the cutaway coat which younger men were increasingly adopting for everyday wear. His outfit of matching jacket and trousers was popularly called a 'suit of dittos' or just 'dittos'. Matching, rather than contrasting, jackets and trousers were a comparatively new fashion and the word suit did not yet imply use of the same materials for both garments, but was used for any set of clothes worn together.

Each man wears the fashionable hair-style of his youth: George's whiskers are reminiscent of the early Victorian period; full beards like William's were popular from the 1860s, while Arnold's clean-shaven face and clipped moustache were up to date for the early 1880s.

The young man's rather rigid pose reflects the stiffening of the fashionable outline, for both sexes, that became apparent in the 1880s. Jackets were cut higher on the chest and the vertical line was emphasized by the increasingly popular single-breasted cut. Dashing young men in the 80s were also beginning to wear higher shirt-collars. By the next decade the trend was widespread.

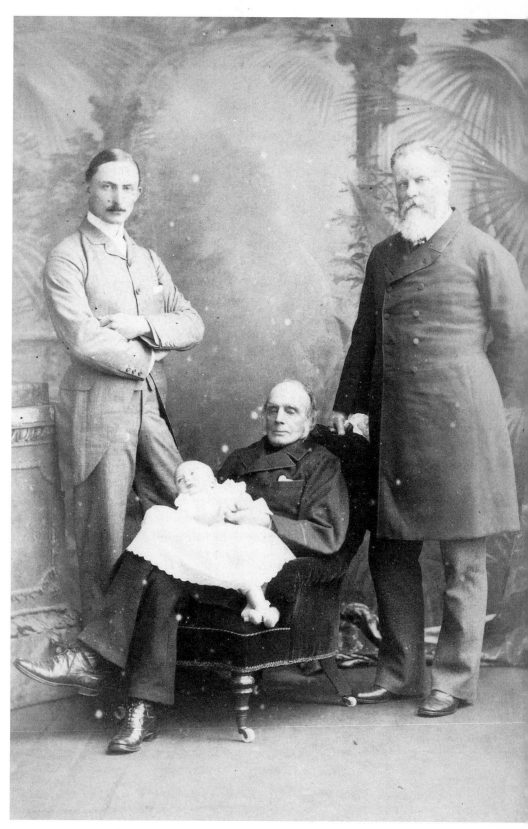

5. George, William, Arnold, and Walter Keppel; 6th, 7th, 8th, and 9th Earls of Albemarle.
c. **1882**
John Edwards, London (NPG x 6072)

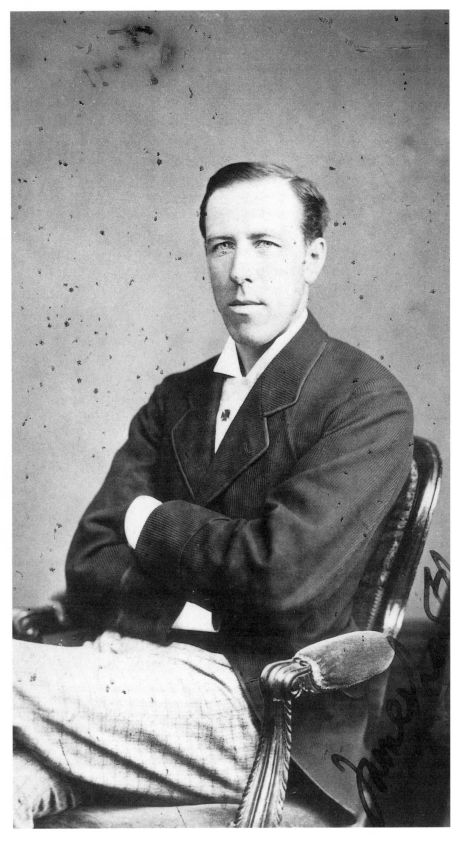

6. James Lowther
c. 1880
Maull & Fox, London (NPG x 4098)

6

A Conservative MP, Lowther (1840–1904) was Parliamentary Secretary for the Poor Law, Under Secretary for the Colonies, and Chief Secretary to the Lord Lieutenant of Ireland. He also bred racehorses and was a prominent member of the Jockey Club.

In contrast to Arnold Keppel's dittos (Plate 5), Lowther wears the traditional, contrasting dark morning coat and pale trousers. The more relaxed fit belongs to the 1870s, with its lower-cut, wider lapels giving a feeling of comfort. Although matching suits became more common, the typical combination of dark jacket and plaid trousers remained a standard throughout the early 1880s.

Tweed, seen in the trousers here, was a comparatively cheap, hard-wearing cloth traditionally used in Scotland. It was introduced as a fashion fabric in the mid-nineteenth century. Unlike most fabrics for menswear, it needed no milling (the process which raised the surface nap). It was also more loosely woven than traditional woollen cloth and therefore especially suitable for the growing mass-market. Some Yorkshire tweeds were made from mungo or shoddy, that is, cloth made from recycled wool.

While this statesman's cuffs illustrate the customary rigidity achieved through starching and ironing to a smooth polish, his collar is in a comparatively comfortable-looking style, again, typical of the 1870s. A man's choice of neckwear was very much a matter of personal taste; the selection available was huge – many wholesalers offered 50 or 60 varieties of collar and tie.

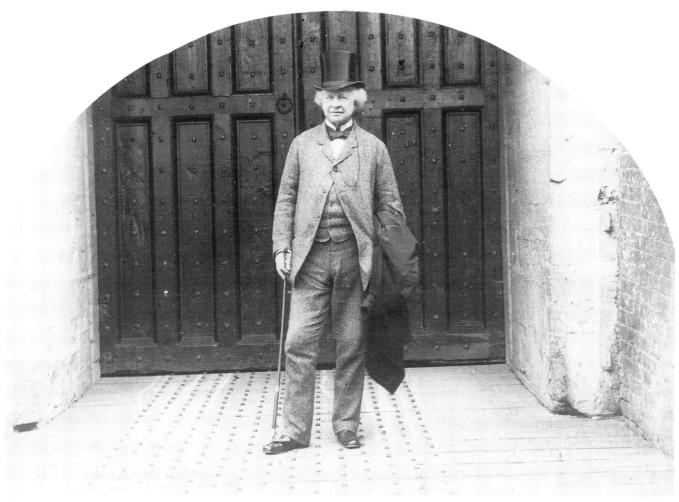

7. George Leveson-Gower, 2nd Earl Granville
c. 1880

J. Berryman, Deal (NPG x 16813)

————————— 7 —————————

Granville (1815–1891), joint leader of the Liberal party with Lord Hartington from 1875 to 1877, served as Secretary of State for Foreign Affairs from 1880 to 1885 and Secretary of State for the Colonies from 1886.

A succession of photographs from the 1860s onwards shows that Granville dressed conservatively, always wearing similar collars and bow ties. When younger, his curly hair lent itself to the prevalent look of the mid century: flat on top, with curly sides which he finished off with long, pointed, side-whiskers. Pictured here in his late 60s, he still wears the hairstyle of his youth. This photograph perhaps helps to explain this common hairstyle – the heavy top hat flattened the crown and retained hair oil and moisture,

while the longer sides were unrestricted and drier.

In *The Science of Dress* (1885) Ada Ballin noted that baldness was most common among the upper-middle classes. She ascribed this not only to the intellectual nature of their work, but also to the extent to which they wore heavy hats:

> The tall, stiff hat, whether silk or felt, is an insanitary article of dress. It presses on the arteries entering the scalp, and so lessens its blood supply, interfering with the nutrition of the hair. It is practically impervious to the air, of which it contains a certain quantity that soon becomes poisoned by the excretions of the skin of the head. . . . It also becomes charged with moisture from the skin, and the hat is so constructed, with a leather round the edge, that this cannot

be absorbed, and frequently runs down on to the forehead in the most unbecoming way.[1]

The discomfort of top hats was generally accepted as part of the male lot, although manufacturers invented elaborate ventilators to aerate the interiors. The cord leading from Granville's top button to the back of the hat was another ingenious device; hat securers held hat and wearer together on a windy day. Sherlock Holmes, in 'The Blue Carbuncle', deduced from the presence of a disc and loop on a hat that its owner had at one time been a careful person, because these were never sold on hats, but had to be ordered specially. Since it secured only a broken bit of elastic however, Holmes diagnosed a weakening mental state in the owner!

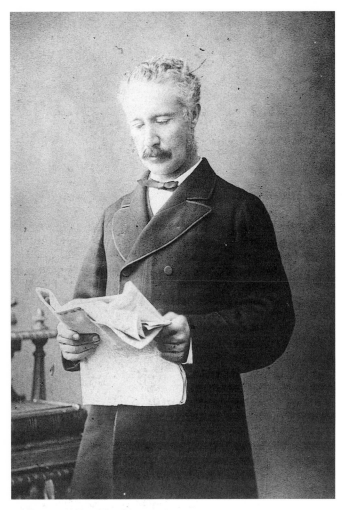

8. General Charles George Gordon
1880
Adams & Stilliard, Southampton (NPG x 12605)

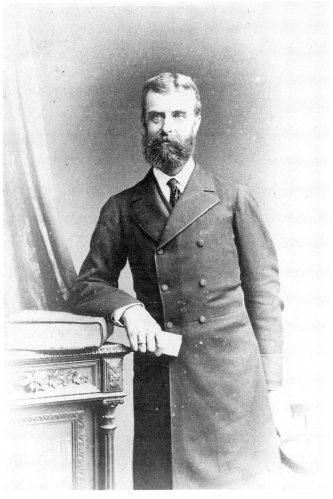

9. Major-General Frederick Augustus Thesiger,
2nd Baron Chelmsford
1882
Elliott & Fry, London (NPG x 6012)

——————— 8, 9 ———————

Lord Chelmsford (1827–1905) commanded troops in the 1878 Kaffir war and the 1879 Zulu war. General Gordon (1833–1885), the more widely remembered of the two, had moved from being Governor-General of Sudan to the position of Commander of the Colonial Forces in South Africa shortly before the Sudan, now under Egyptian control, experienced a Moslem revolt. Egged on by a newspaper campaign led by the *Pall Mall Gazette*, the government sent Gordon to evacuate the Egyptian garrisons. Instead, he fought back but by July 1884 he was surrounded in Khartoum; a relief mission arrived two days after Gordon – and most of the inhabitants – had already been killed.

Both men wear low, turn-down collars, a fashion introduced in the 1860s. While the butterfly collar survived into the twentieth century, the turn-down eventually replaced all other styles. Lord Chelmsford's tie, known as a 'four-in-hand', had also been introduced in the 60s, and would similarly triumph over its rivals. General Gordon's narrow bow, almost the bootlace tie adopted in the 'Wild West' at this time, became less fashionable as neckwear grew wider in the 80s.

Interestingly, both men chose to be photographed in frock coats rather than in uniform. These seem identical except for the lapels: Gordon's are slightly more curved. This could have been a personal fancy, or a device carefully chosen by his tailor to enhance his figure. A great deal of the tailor's skill lay in balancing the seemingly standard elements of male dress to suit individual clients.

10

Millais (1829–1896) formed the Pre-Raphaelite Brotherhood with Dante Gabriel Rossetti and William Holman Hunt in 1848. Their attention to detail, colouring, and quasi-medieval subjects were intended to revive early-Renaissance aesthetic values. Millais later became a famous landscape, genre, and portrait painter, and President of the Royal Academy.

The *Tailor and Cutter* described his appearance:

> [Millais] had a great liking for the Lounge jacket; but he selected materials that had a marked contrast in them, and so arranged the etceteras of his dress that these harmonised in an excellent manner, so that the general effect of his dress was good. Thus he would wear a Lounge made from a neat (almost Shepherd's Plaid) check of a light shade; this he would wear buttoned, and above the opening a dark spotted silk scarf drawn through a ring might be seen, thus offering an excellent contrast to the jacket. His general appearance was thus made up of sharp contrasts, his long dark hair behind, grey side whiskers, and bald head being quite in keeping with the rest of his appearance.[2]

Lillie Langry also liked his style:

> He was tall and broad-shouldered; his handsome, ruddy, mobile countenance was strong rather than sensitive in character, and his swinging walk suggested the moors and the sportsman. Manly is the only word which will accurately describe the impression he made. Later, when I came to know him better, I discovered that he affected none of the eccentricities, either of dress or manner, usually ascribed to artists, that he was quite sane, and that in his working hours he did not wear a velvet jacket, but a well-worn, home-spun belted coat, which, I am sure, had done yeoman service on his beloved Scotch moors.[3]

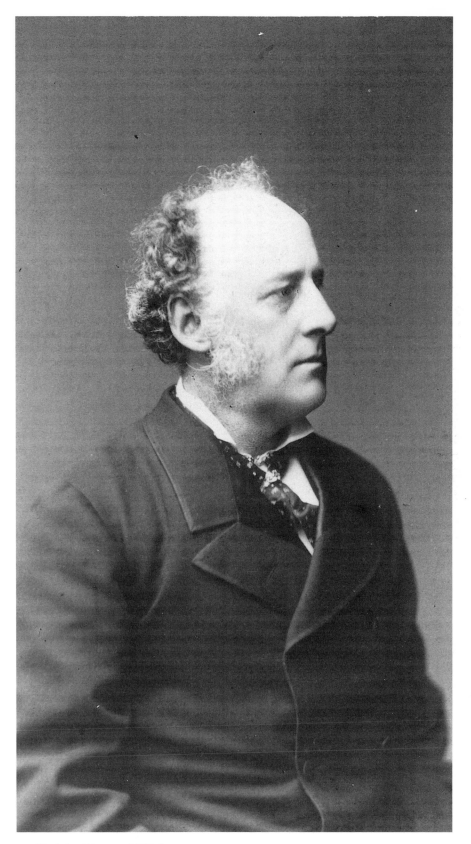

10. **Sir John Everett Millais**
1881
Window & Grove, London, (NPG x 6284)

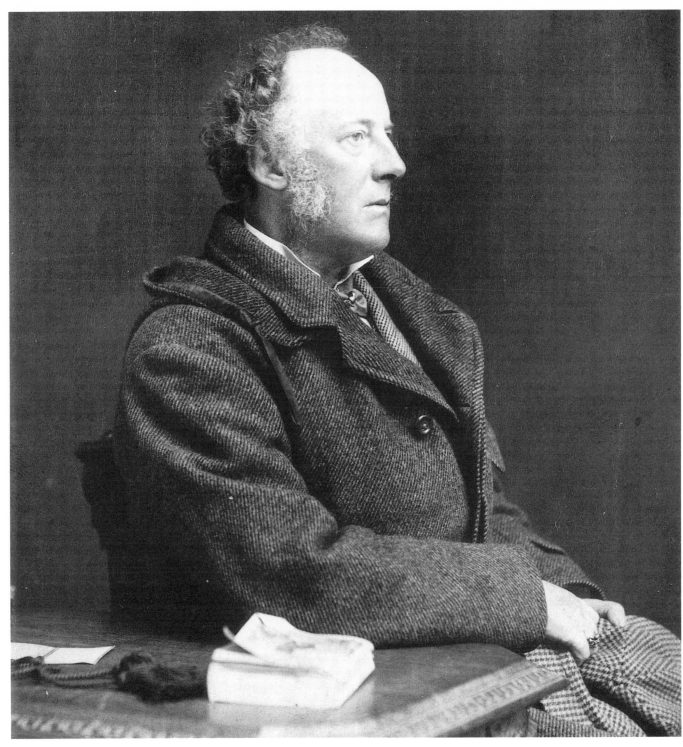

11. Sir John Everett Millais
c. 1885
A. F. Mackenzie (NPG x 1451)

———— 11 ————

In this picture Millais wears a heavy tweed overcoat with a hood, known as an 'Ulster'. It was usually worn belted and could reach as far down as the ankles. The buttons might be of bone, horn, or a hard composition made from a type of rubber. The hood on this example has a silk-ribbon drawstring.

The cap seems to match his suit and is of the type immortalized as the preferred headgear of Sherlock Holmes. It is now known as a deerstalker, but the word was not used in any Sherlock Holmes stories written before 1900. In 'Silver Blaze', the famous sleuth travelled down to the country in an 'ear-flapped travelling-cap'; this was the usual term.

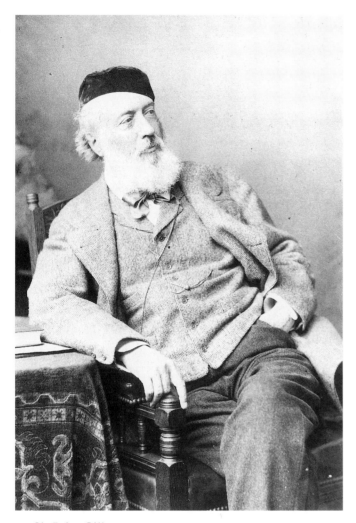

12. Sir John Gilbert
1883
Bassano, London (NPG x 13181)

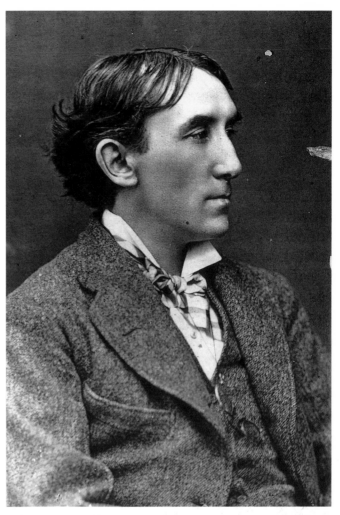

13. Henry Irving
1875–80
Lock & Whitfield (NPG x 17935)

——————— **12, 13** ———————

As a painter, Gilbert (1817–1897) specialized in historical and literary subjects, often taken from Shakespeare and Scott. However, he was more notable as a prolific illustrator. Irving (1838–1905), the famous actor-manager, revived popular interest in Shakespeare through his productions at the Lyceum. He raised the status of his profession to the point where he, as an actor, could be received in polite society, and in 1895 he became the first actor to be knighted.

Soft, loose, large, bow ties became a hallmark of the artistic temperament in the 1870s. Tie silk, often of a soft twill called foulard, was a speciality of the English silk industry – particularly of Macclesfield.

Gilbert's velvet skull-cap was another fancy. G. F. Watts used to wear one in his studio and liked to be told he looked like Titian.[4] Skull-caps were often worn for sports, and indoors they helped you to keep warm in cold houses. Gentlemen also wore caps while they were smoking, to protect their hair from tobacco smell. The widespread use of macassar oil and other hair preparations, as illustrated in Irving's photograph, meant that hair itself could be a nuisance. Antimacassars, invented in the last century, were embroidered cloths used to protect chair backs from hair oil.

Both men wear cords round their necks. Irving was myopic and his pince-nez feature in many photographs. Gilbert probably had a monocle on the dark cord and a watch on the metal one.

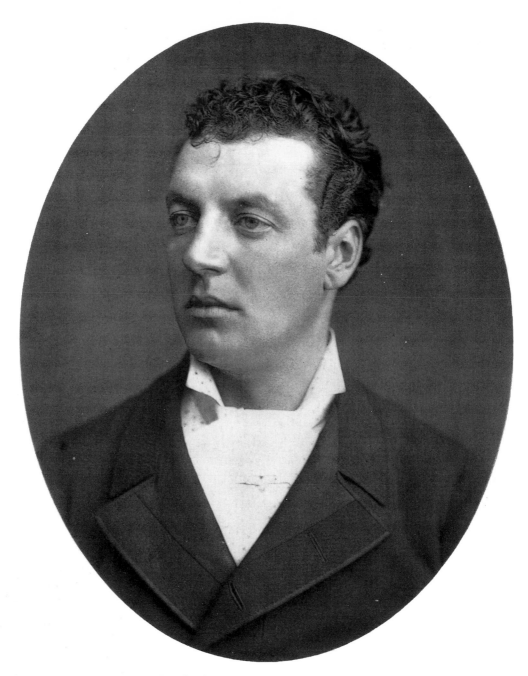

14. Lord Charles William de la Poer Beresford, 1st Baron Beresford 1883 (published, in Men of Mark)
Lock & Whitfield, London (NPG x 755)

———— 14 ————

Beresford (1846–1919) had a distinguished career in the admiralty, culminating in his appointment as Commander-in-Chief of the Channel Fleet in 1907. He was also an MP. Despite these activities he found time to become a close friend of Edward, Prince of Wales, who relieved him of his mistress, Daisy Brooke, later Countess of Warwick. Beresford was fond of practical jokes and once, at Cowes, he turned off the air supply to the lower cabins on his yacht and thus nearly suffocated Lillie Langtry.[5]

Etiquette books constantly warned the parvenu against fancy shirts. One of them stated 'Figures and stripes do not conceal impurity, nor should this be a desideratum in any decent man'.[6] Wealthy gentlemen like Beresford had no reason to fear the suspicion of others that they might be wearing dirty shirts, and dashing young men wore all sorts of designs. This shirt is remarkable for its matching cravat. It shows well the stiff, 'octagon' shape so popular in the 70s and 80s. The style lent itself particularly well to ready-made neckwear with cardboard stiffening. However, while Beresford was happy to wear a spotted shirt, he would certainly have drawn the line at a made-up necktie, a device which would have been quite beyond the pale for a gentleman. The combination of such a shirt and a frock coat seems very curious – it was probably summer wear.

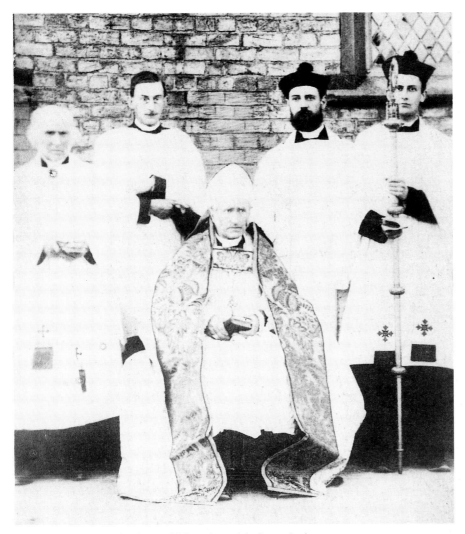

15. Edward King, Bishop of Lincoln, with four clerics
1885
Photographer unknown (NPG x 19142)

───────── 16 ─────────

Webb (1848–1883), a merchant sea-man, became famous when he swam from Dover to Calais in 22 hours in August 1875. Afterwards, he made frequent appearances in music-halls, capitalizing on his achievement, but drowned in 1883 in an attempt to swim the Niagara rapids.

His swimmer's vest was machine-knitted. The knitting frame goes back to the sixteenth century and fine, machine-knitted, woollen garments, such as waist-coats and breeches, were widely advertised in the Georgian period. By the Victorian era ready-made knitwear was big business. The prosperity of cities like Leicester, Nottingham, and Coventry largely depended on it. Hosiery manufacturers took advantage of the growing interest in sports, and by the 1880s specialist garments, such as football jerseys, formed a large part of their output. Webb's vest may have been designed as swimwear, but it closely resembles an ordinary vest.

The time-honoured way of keeping warm was simply to wear two or more shirts at a time, but by the 1840s knitted vests and drawers for men were being manufactured in large quantities by Leicester hosiery firms such as John Biggs & Sons, half a century before Doctor Jaeger began to extol the virtues of wearing wool next to the skin.

───────── 15 ─────────

This picture was taken in the year King (1829–1910) became Bishop of Lincoln. As Professor of Pastoral Theology at Oxford, and before that as Principal of Cuddesdon Theological College, he had been much influenced by the Oxford High-Church Movement. In 1889 he was unsuccessfully prosecuted for illegal ritualistic practices by the Church Association.

The High-Church Movement, which sought to re-establish such activities as confession within the Church of England, became an important force in the 1830s. At the same time 'gothic revivalists', led by the architect Augustus Welby Pugin, began designing churches, ecclesiastical furnishings, and vestments in medieval rather than neo-classical styles.

Although many followers of the Oxford Movement eventually 'went over to Rome', the nation as a whole was not converted to Catholicism. However, the effects of this new interest in ritual were felt throughout the land. By the 1880s the smallest parish church had replaced its band of village musicians with an organ or harmonium,[7] and cathedral vestries were being filled with copes and mitres, embroidered chasubles, and lace-trimmed surplices. Most of the vestments in British churches today date from the end of the last century onwards. Splendid church textiles would have been considered an anathema to most of Edward King's predecessors.

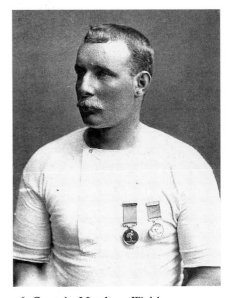

16. Captain Matthew Webb
1875–85
Horatio N. King, London (NPG x 19929)

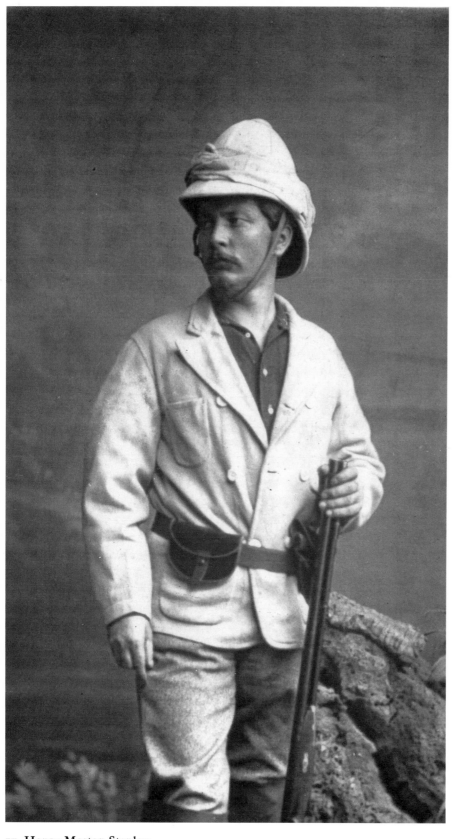

17

Stanley (1841–1904), who was brought up in a Welsh workhouse, ran away to sea. A New Orleans cotton broker adopted him and he became a journalist and a naturalized American. It was as a newspaper employee that he journeyed into the heart of Africa in 1871 to find the missing explorer Doctor Livingstone.

This photograph was published as an advertisement by the well-known outfitters Elias Moses & Son. The firm had operated on a vast scale since the early Victorian period, selling every kind of garment for men, women, and children. Although they ran a tailoring department, most of their goods were ready-made. Moses began as a 'slop-seller', supplying sailors and other travellers with complete outfits on the spot. These were cheap, poor quality, and often made by sweated labour. The firm expanded rapidly from the 1840s to meet the increasing demand from the general population for low-cost clothing while still catering for travellers. Soon, emigrants to America, Canada, and Australia were joined by young men bound for the furthest outposts of the growing British Empire, who often required specialist clothing of the type worn by Stanley, together with all kinds of paraphernalia. Moses & Son were expert self-publicists who had for many years produced a stream of self-congratulatory handbills and catalogues. There is no evidence that Stanley actually bought his kit from them, although this might well be inferred from the photograph.

17. Henry Morton Stanley
c. 1875–80
London Stereoscopic Company (NPG x 27584)

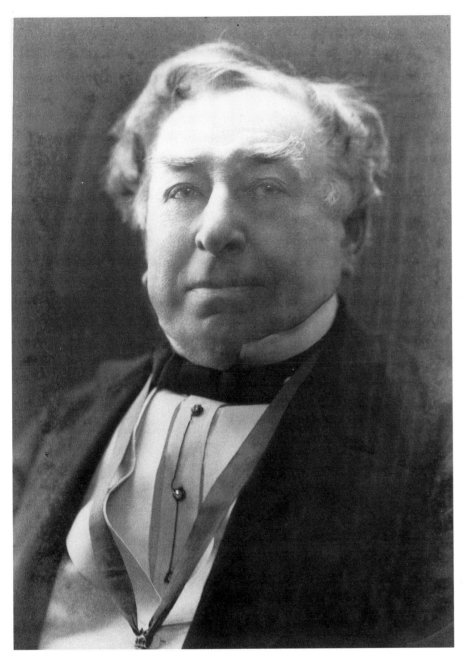

18. Henry Graves
1880–5
H. S. Mendelssohn, London, Newcastle and Sunderland (NPG x 5572)

Few nineteenth-century photographs show men in evening dress because photographers generally preferred medium tones to strong contrasts. A reporter at the Master Tailors' banquet in 1897 described a 'flash-light photograph taken during the evening' in which hardly any details could be seen.

> Indeed at the first glance the picture suggested a crowd of Michael Angelo's [*sic*] cherubims' heads with shirt fronts attached instead of wings, preparing for flight. On a closer inspection one could see that there were bodies to be tailored as well as heads (and shirt fronts) to be photographed. But of all garments I think Evening Dress is the one that the camera is least able to do justice to.[8]

Graves probably defied convention because he wished to be shown wearing his medal: decorations were only correctly worn with evening dress.

Evening dress did not conform to modern rules and the white waistcoat with white necktie stricture was not rigidly applied. All linen was heavily starched and this necessitated the use of studs rather than buttons; such studs could be a useful vehicle for the display of precious stones. By the 1880s it was more fashionable to have a single stud, rather than three, as worn here.

As an elderly man it might be expected that Graves's hairstyle and clothes would appear old-fashioned. His hair, with its side fullness, resembles Earl Granville's (Plate 7) while his tie and high collar, rising above his chin, are reminiscent of the 1850s.

GROUP

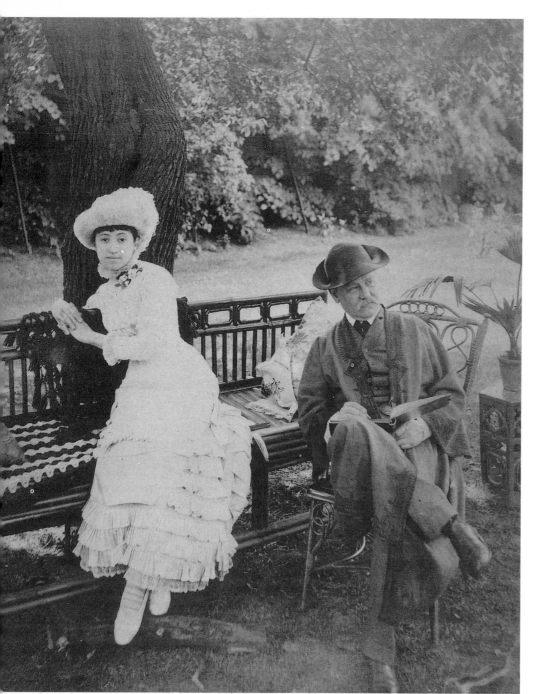

19. G. A. Storey and his wife Emily
c. 1878–81
Photographer unknown (NPG x 26567)

19

Like many artists of his generation, Storey (1834–1919) was deeply influenced by the Pre-Raphaelite Brotherhood and specialized in 'historical' subjects. Some were based on real events but most showed romantic, imaginary episodes.

Storey's soft hat and oriental-looking wrap betray some artistic eccentricity, despite his later comment to the *Tailor and Cutter* that 'so-called artistic costumes generally appear more or less singular and ridiculous'.[9] Mrs Storey evidently shared his view, since she is dressed in the height of conventional fashion, her striped stockings and unusually wide shoes being the only hints of the individuality which might be expected in an artist's wife.

The long line fashionable in the late 1870s which, for the first time in centuries, revealed the outline of the stomach and hips, remained popular in the opening years of the next decade. Because of a supposed resemblance to a Roman breastplate, these were called 'cuirasse bodices'. They required a longer corset and these, worn together with tight skirts that sometimes rendered the wearer hobbled with tapes or elastic, meant that bending was difficult. *Punch* had fun ridiculing ladies unable to sit down or pick up their handkerchiefs.[10]

However, this fashion did help to reduce the weight of female underwear since fewer petticoats were worn. Instead, combinations were worn to give a smooth line. *Punch* also inferred that chamois-leather combinations were favoured in the best circles to create the right slimline effect.[11]

Stiff muslin frills at the neck and cuffs were detachable for cleaning, and protected unwashable dresses from dirt. Another frill, called a *balayeuse*, (sweeper) was tacked round the hem for the same reason.

20. Professor Ellison, his wife Fanny, and their adopted son Charles Prior Ellison 1884
Photographer unknown (NPG x 16489)

——————— 20 ———————

The group pose with '"Vacuum" Tubes and Syphons used in the Process of Effecting "Instantaneous Cures"' by the Professor, discoverer of the 'True Art of Healing' in 1879. This was a gullible age. Quacks and showmen made good livings, and séances seemed to be held in nearly every society drawing-room.

This trio are prosperously if not fashionably dressed, with an impressive display of jewellery. There is an unusual sighting of a watch as well as its chain, and Charles wears a horseshoe tie-pin. Horsey motifs began their long reign of popularity at this time. Bits, stirrups, whips, and horseshoes featured on all kinds of accessories such as belts, brooches, and pins. Horseshoes were often used upside-down; there was evidently not the present superstition that the luck would run out. Mrs Ellison wears a ring, bracelet, watch-chain, brooch, and the rather heavy earrings popular in the 1870s but which would have been considered slightly dowdy by the time of this photograph.

Dark furs and heavy fabrics like velvet and plush all enjoyed a considerable vogue, possibly because the decade saw a succession of bad winters. The average temperature was three degrees lower than in the mid-twentieth century and ice-skating was a popular sport.[12] Then, as now, furs were expensive status symbols. Russian seal skin mantles started at 10 guineas and Russian otter from £20 at Cook & Company, furriers, of 71 Oxford Street.[13]

————— 21 —————

Once the royal family had set the fashion for walking and shooting in the Scottish Highlands, many aristocrats began to enjoy autumn visits to their hitherto neglected Scottish estates. Their need for weatherproof clothing did much to promote the sort of strong, tweedy garments now considered so typically British.

The girls' kilts are short not only for easy walking but also because they were too young for adult-length skirts. Stout buttoned or laced boots were now the usual outdoor footwear for women, replacing the once customary fabric or soft, light-leather, elastic-sided boots.

The women wear versions of the machine-knitted jersey. This had been high fashion in the late 70s, but since then was worn more as a comfortable and flexible garment for outdoor activities. The stretchy fabric gave even ready-made versions a good fit and their popularity represented a major step forward in the public's acceptance of ready-made clothing. Alexandra (1844–1925) and her daughters were even photographed on the Royal Yacht in 1878 wearing 'St Margaret'-brand jerseys made by Corahs of Leicester and supplied by Messrs J. Morgan & Sons of Cowes.[14]

Alexandra completes her outfit with a tweed cap, which was perhaps not unlike the 'little deer-stalking cap' she generally wore each year to the Highland Games[15] while the Prince of Wales (1841–1910) used to appear resplendent in his Stuart tartan kilt.

21. Edward, Prince of Wales, Princess Alexandra, and their children: Albert, Duke of Clarence; George, Duke of York; and the Princesses Victoria, Louise, and Maud
c. **1884**
Russell & Sons, London (NPG x 32163)

——— 22 ———

Maskelyne (1839–1917), one of the fathers of modern conjuring, had been apprenticed to a watchmaker. He first appeared on stage in 1873 and performed at the Egyptian Hall, Piccadilly, until 1904. He wrote an exposé of spiritualism, based on his professional understanding of sleight of hand.

The Maskelynes were married in 1861 and the picture shows two grown-up children and a younger son. It is difficult to assess the young man's age, although he could only have been in his mid-20s. This highlights the nature of men's fashion, which was based on a mature ideal. In contrast, the distinction between juvenile and adult clothing was clear. This reflected the separation between childhood and adulthood usually maintained in well-to-do households. Children led their own lives, supervised by nannies or governesses, and childhood was seen as a golden, yet inferior, age. Promotion from childhood to adulthood was signified by new clothes enabling the fledgling to take his or her place with the grown-ups.

This little boy wears a version of Highland dress, a fashion popularized by royal infants. His Eton collar was another mark of the juvenile, worn by most boys until their early teens.

Middle-class mothers frequently kept their sons' hair long and in ringlets until the age of about seven, when the 'little man' would have a haircut. Working-class boys usually had short, almost crew-cut hair. In one terrible moment in D. H. Lawrence's novel, *Sons and Lovers*, Mrs Morel's aspirations were dashed when her miner-husband cropped their one-year-old's curls 'like a sheep'.[16]

22. John Nevill Maskelyne, (seated) his wife Elizabeth, and their children c. 1885
London Stereoscopic Company (NPG x 21159)

23. Sir James Anderson and Lady Anderson
c. **1885**
Debenham, Torquay (NPG x 56)

23

Anderson (1824–1893) was an engineer who had been involved in laying the first successful transatlantic telegraph cable in 1865.

Until the beginning of Victoria's reign all married women wore caps indoors. Single women also did so in the mornings to perform certain domestic tasks. Lady Anderson, who was probably married about the same time as the Queen, abides by this custom. Mrs Maseklyne (Plate 22), a young bride in the 1860s, no longer considered it necessary to wear a cap, and indeed, they gradually became the mark not of married women so much as venerable old ladies. Cap-wearing did confer some status and it could also conceal grey and thinning hair. In *The Science of Dress*, Ada Ballin recommended lace headwear for wizened features:

> A worn and elderly-looking woman will find herself wonderfully improved by covering her hair, even if it is still plentiful, with a lace mantilla, which will veil the ravage of time about her face, and will form a graceful frame for it. An old woman looks frightful with a bare head; and the light shadows thrown by lace will do much to dissimulate the effects of age.[17]

She also advised the elderly

> to take more pains than ever with your person. If you neglect any of the little habits of neatness, decrepitude will come on all the faster; and an old person who is careless and untidy presents a far more repulsive appearance than a young one, though such negligence is to be reprehended at all ages.[18]

FEMALE

24. Madge Robertson Kendal
1878–81
Photographer unknown (NPG x 19106)

Mrs Kendal (1848–1935) was 'not only the most accomplished actress of the day, but a model of all the virtues, and the only actress at that time received in the "inner circle" of Society.'[19]

This picture could have been taken at the very end of the 1870s. The outdoor coat, probably made in a long-waisted style, shows how deeply sleeves were set into the shoulders at this time. It also shows, as does Mrs Anderson's costume in the previous picture, the extreme tightness of the fashionable fit.

Smoothly-parted hairstyles set off the tilted-back angle of bonnets and hats. Wide ribbons were usually worn with bonnets, but in this case the bow may be a scarf rather than bonnet 'strings'. Elaborate narrow-width fabrics were often imported from France, but they were also made in England, notably by Coventry silk manufacturers. Fresh ribbons would often be bought to perk up an old hat. Many ladies also economized by re-trimming their own headwear with flowers, beads, and feathers. In 1882 Laura Troubridge spent Good Friday overhauling her hats

past and present, an unpleasing occupation. Endeavoured to build fresh edifices from the ruins of several old friends, but didn't accomplish much. Demolished several and only finished one new one. The subject is getting serious – painted a little and felt much soothed.[20]

——————— **25** ———————

As the inspiration for many of the ethereal-looking women in paintings by her husband Edward Burne-Jones, Georgiana's (1846–1920) features considerably influenced the contemporary feminine ideal. Like Lizzie Siddal, Jane Morris, and others painted by the Pre-Raphaelites, Geogiana was not conventionally pretty. However, this school of painting helped to spread an appreciation for different kinds of attractiveness. As Mrs Haweis wrote in *The Art of Beauty* (1878),

> Those dear pre-Raphaelite painters are the plain girl's best friend. They have taken all the Ugly Ones by the hand . . . Morris and Burne-Jones have made certain types of hair and figure, once hated, actually the fashion. Red hair – to say once that a woman had red hair was social assassination – is the rage. A pallid face with a protruding upper lip is esteemed. Green eyes, a squint, square eyebrows, whitey brown complexions are not left out in the cold. In fact the pink cheeked dolls are nowhere. . . . Only dress in the pre-Raphaelite style and you will find that far from being an ugly duck, you are a fully fledged swan![21]

Pre-Raphaelite dress was inspired not only by paintings, but also by real garments devised by Jane Morris and her friends as healthy and artistic alternatives to mainstream fashion. Their flowing, vaguely historical gowns in subtle colours were imitated in aesthetic circles from the 1870s onwards. The fashion continued to spread, becoming widely known through *Punch* cartoons and Gilbert and Sullivan's *Patience*. To Georgiana Burne-Jones at this date the aesthetic style was nothing new. Her costume in this picture appears to be a slightly modified version of conventional dress.

25. Georgiana Burne-Jones
c. **1882**
Frederick Hollyer (NPG x 4906)

———— **26** ————

Ellen Terry (1847–1928), Irving's leading lady and one of the greatest actresses of the period, was a public figure whose face was known to millions. She was much admired for her good looks and sometimes put her name to beauty product advertisements. Thus, a testimonial from 'the ever youthful' Miss Ellen Terry for Barton's Brighton Glycerine Cream stated 'I have used it for upwards of twenty years and still continue to do so.'[22]

Many portraits at this time show her in loose-waisted dresses influenced by artistic styles. In this picture her costume goes well with the aesthetic design of the wallpaper and dado rail behind her. New ideas in clothing went hand in hand with a desire for beauty in all aspects of life. Following the example of William Morris who, after building and furnishing the Red House, sold interior furnishings through his firm Morris & Co., other designers began to concern themselves with the complete environment. Foremost among these was the architect E. W. Godwin, Terry's ex-lover and the father of her children, Edith and Edward Gordon Craig. Godwin's interest in design extended to clothing, which he believed should be healthy and comfortable as well as beautiful. He not only created costumes for Ellen Terry, but actively campaigned for general dress reform; for example he lectured at the International Health Exhibition of 1884.[23]

26. Ellen Terry
c. **1882**
Elliott & Fry, London (NPG x 26375)

27

The details of artistic dress were an eclectic mixture taken from certain historical periods, particularly the Middle Ages and the sixteenth century. Such historical borrowings were not a new idea. Ever since the neo-classical period dress designers had plundered the past in search of novelties. The Victorians were deeply interested in history, filling buildings, themselves in the Gothic or Classical styles, with pictures depicting great historical events or scenes from popular novels set in the past. By this period antiquarians had been researching the minutiae of everyday life in ancient times for over 100 years. A large body of published material was available, including thorough explorations of costume history. A surprising degree of scholarship was evident not only in stage costume and fancy dress but also in everyday wear.

This fashionable afternoon dress worn by Baroness Haldon (1847–1926) has been given a fourteenth-century feel by the application of a row of buttons from elbow to wrist on its tight sleeves. Its sheath-like bodice also recalls that period, the last in which women's clothing fitted so tightly over the hips. The rich velvet, ruffs, and fan complete the historical effect. Fans were important accessories and beautiful, old ones were highly prized by users and collectors alike.

The sleek bodyline was often complemented by long, elaborate trains. This outfit shows how the overskirt and back-draperies were gradually gaining importance; by the following year dresses were being made with definite bustles. The changing line was reflected in hairstyles: curled fringes began to be worn, moving the emphasis away from the low bun. As the bustle enlarged the hair was dressed higher on the head.

27. The Honourable Constance Mary Palk, Baroness Haldon
1882

O. Schoeftt, Cairo (NPG x 21711)

28. Eugénie, ex-Empress of France
1879–80
W. & D. Downey, London (NPG x 3813)

— **28** —

Eugénie (1826–1920) is seen here in deep mourning for her only child the Prince Imperial, killed fighting for the British in the Zulu war in June 1879. After the fall of the Third Empire in France the Imperial family had settled in this country. Eugénie eventually made her home in Farnborough.

As Empress of France, Eugénie had been renowned for her beauty and for the splendour of her wardrobe which, from 1860, was largely created by the *couturier* Worth. Even when living in comparative poverty, in exile, she never lost her reputation for elegance and charm. The composer Ethel Smyth, a close friend from 1883, wrote,

> I remember saying to the Duchess de Mouchy that it was hard to believe that she could ever have been more beautiful than now, and the reply was: 'I think in some ways she is more beautiful now than she was young, because years and sorrow have done away with the accidents of beauty – youth itself for instance, and colouring – and revealed the exquisiteness of design.'[24]

The usual period of mourning for a child was 12 months, with black crape worn for the first six. Crape, which Eugénie wears on her cuffs, was a hard, fine silk, crimped by a special heat process. The best was made by Courtaulds at their factory in Essex. It was difficult to maintain, being spoilt by the slightest spot of rain, but it was actually quite a flattering material. Eugénie demonstrates that it was possible to look very handsome in deep mourning. Although jewellery was not generally worn, she has not abandoned her customary make-up.

29. Queen Victoria and Princess Beatrice
1882
Bassano, London (NPG x 32717)

Victoria (1819–1901) first met Eugé-
nie (Plate 28) in 1855 and their
unlikely friendship was one reason why
the Imperial family was offered a home in
England in its exile. Victoria, who wears
Albert's miniature as a brooch, had been
a widow for about 20 years, but was to
wear black on most occasions for the rest
of her life, together with her well-known
widow's cap of white tulle frills on a wire
frame, with long streamers. Although
handmade lace like the Queen's was
highly prized, machine lace could be
made in large pieces and so it was
extensively used for scarves, shawls, and
dresses. Victoria's black lace and jet were
of types typically worn by older women.

Princess Beatrice (1857–1944), Victor-
ia's youngest daughter, married Prince
Henry of Battenberg in 1886. Her moiré
silk dress with its deep pleating and use of
contrasting materials is fashionable, but
it looks fussy rather than smart. With the
notable exception of Princess Alexandra,
none of the ladies in the English royal
family were renowned for their dress
sense and they were often accused of
looking dowdy. An onlooker at the 1887
Jubilee celebrations described Victoria's
oldest daughter Vicky, Crown Princess
of Germany, as 'looking like a funny little
Dutchwoman with a blk. & white striped
silk, and oldfashioned white bonnet, &
most absurd blk. satin basqued bodice'.
The Queen, before a crowd of 11,000
people, looked no better: 'She was very
dowdy, in a short black dress with her old
blk. bonnet on agn., & some kind of
round cape of an antediluvian cut'.[25]

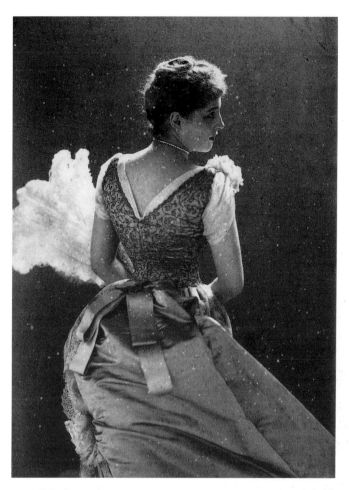

**30. Margaret Leighton
1881**

Lock & Whitfield, London, for the Theatre *(NPG x 19998)*

**31. Lillie Langtry
1885**

Van der Weyde, London (NPG x 19877)

30, 31

Both actresses were dressed for the stage; Langtry (1853–1929) wears Lady Ormonde's costume from *Peril*. Leading ladies were often clothed by top couturiers, in dresses of the same quality as their usual output. Worth provided all Langtry's dresses when she appeared as Lady Teazle in Sheridan's *School for Scandal* in 1885. Her wardrobe for the production was described in the *Queen*.[26] Costumes for contemporary drama and their descriptions in magazines often inspired fashionable dress, just as clothes for American television 'soap operas' a century later were reproduced by clothing manufacturers.

Lillie Langtry's outfits had been copied long before she appeared on stage. Although in mourning for her brother when she made her début in London Society, and possessing no evening clothes apart from one, plain, black dress, she was an instant hit:

> Her astonishing beauty, the perfect figure and flawless skin, the blue eyes tinged with green, the gold hair shading into Titian . . . caused a stunned silence of admiration when she walked into a reception or ballroom.[27]

Once, as she recounted in her memoirs, she

> twisted a piece of black velvet into a toque, stuck a quill through it, and went to Sandown Park. A few days later this turban appeared in every milliner's window labelled 'The Langtry Hat'. 'Langtry shoes', which are still worn, were launched, and so on and so on.[28]

—— 32 ——

Jennie Jerome (1854–1921), who grew up in Paris, was one of the first Americans to marry an English aristocrat. She was renowned for her beauty, intelligence, and native charm. A shrewd observer, she recalled her early impressions of English dress:

In those days Parisian fashions made their appearance in London about two years after they were the mode in Paris. In the matter of dress English women have so improved of late years that it is difficult to realize how badly and inappropriately they used to attire themselves. Having formed my opinion by what I had heard abroad, I fancied that they generally wore a muslin and a seal skin – and perhaps I was not far wrong; but the genial climate of England, with its variation of from fifteen to twenty degrees in a day, might be offered as an excuse.

What would now be thought proper only for a dinner could then be worn at Ascot. . . . On the other hand, black was alone thought possible for a lady to wear at the Play, and once when I appeared in pale blue, Randolph implored me before starting to change it, as it was 'so conspicuous.'

The late Lord Dudley, like Napoleon I, disliked black and dark colours, and never allowed any member of his family to wear them. Not knowing this, I went to a ball at Dudley House in what I thought a particularly attractive costume – dark blue and crimson roses. To my discomfiture my host came up to me and nearly reduced me to tears by asking why I came to his ball in such a 'monstrous dress?' [29]

32. Jennie, Lady Randolph Churchill
c. **1885**
Nadar, Paris (NPG x 20592)

PART TWO: 1886-90

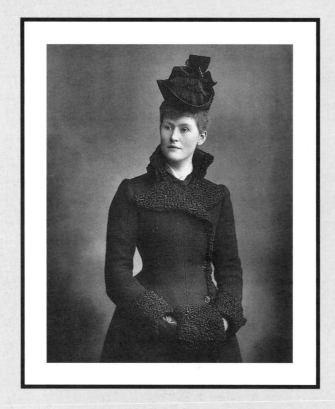

MALE

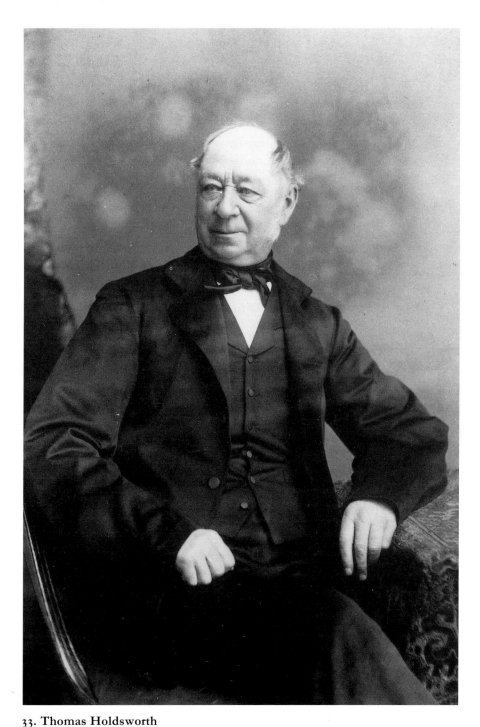

33. Thomas Holdsworth
1886
W. W. Winter, Derby (NPG x 4990)

———— 33 ————

Holdsworth (1811–1893) made his fortune as a colliery owner at Clay Cross, Derbyshire. He was not only a well-known local benefactor; in his closing years he financed the restoration of Selby Abbey.

This elderly gentleman is more than half a century out of date. His hair and side-whiskers are carefully combed forward in a style reminiscent of Regency dandies, whilst his neckwear could have been worn without comment in the 1820s. The black silk stock appeared as a military style before 1800, and was later popularized by George IV. It was stiffened with buckram and whalebone and fastened behind with a buckle. It sometimes featured a bow and from this evolved all subsequent styles of necktie.

Holdsworth's suit looks new, although it was made from a shiny-napped old-fashioned cloth. The flat, mid-century-style, fabric-covered buttons would be made by the tailor, who wrapped thread round the cloth to form a shank. The original photograph shows clearly how the trousers were fastened with a full-fall front, that is, a drop-flap which buttoned on both sides. They had generally been superseded many years previously by fly fronts, as worn by Gladstone in the next picture. However, old men could still order full-falls from Montague Burton Limited as late as the 1930s.

Gladstone and Holdsworth together show the extreme variations in colour permissible even in old men's clothing at a time when men's dress is generally regarded as having been dull. While light colours were only correct in summer – and could extend even to the wearing of a white top hat – black clothes were worn all year round and it would have been possible for one gentleman dressed like Holdsworth to be seen alongside another dressed as Gladstone in his light outfit.

34. William Ewart Gladstone
1887
Byrne & Co., Richmond (NPG x 22230)

Gladstone's (1809–1898) photograph marked Queen Victoria's Golden Jubilee. At 78 years of age he was still Prime Minister and would serve for a third term from 1890–4. Known fondly as the 'Grand Old Man', his fame spread far and wide. In 1887, a friend travelling in Burma was invited to inspect one of Buddha's bones. He commented that as the relic was slowly unwrapped, 'behold we came suddenly on a whole layer of red cotton Manchester handkerchiefs, each adorned with a well-known portrait of the G. O. M!'[1]

Gladstone wears a fine-knitted cotton glove. Stick, gloves, and hat were correctly carried or worn when outdoors. Although the dark colour reflects the current female fashion for contrasting accessories, it may just be an example of the Gladstones' notorious lack of interest in their appearance. Beatrix Potter once described Gladstone looking 'as if he had been put in a clothes-bag and sat upon. I never saw a person so creased'.[2] Queen Victoria, who admittedly thought him a 'dreadful old man' was struck, when he accepted office from her in 1892, by his 'wild weird appearance & strange manners'.[3] Gladstone was a great fan of the theatre. Once, when Langtry was playing in *Anthony and Cleopatra*, the doorkeeper told her that an old man purporting to be Gladstone had called, but since he was not in evening dress he 'felt sure there was some mistake'.[4]

It seems strange in the light of all this that the *Tailor and Cutter* should have used Gladstone's image as the basis for a fashion plate![5]

—— 35 ——

Brooke Boothby (1856–1913), who later inherited the family baronetcy, entered the diplomatic service in 1881. In 1889 he was Second Secretary at the British Embassy in Vienna, where it was the practice to preserve photographs of staff members.

English gentlemen were traditionally supposed to avoid excessive jewellery. In the 1830s the American writer James Fennimore Cooper noticed the lack of adornment of English men, in contrast to the much bejewelled Parisians. Noticing the rings worn by a French nobleman he commented 'a piece of soap would have done more to embellish the hand than all this finery'.[6] However, photographs in this book show plenty of jewellery being worn in the 80s and 90s. Boothby and Gladstone wear signet rings and watch chains, George Lewis sports cufflinks and shirt studs, whilst tie-pins and fancy scarf-rings abound.

Heavy and impressive chains were important fashion accessories. Arnold Bennett described Cyril Povey's:

> In the year 1893 there was a new and strange man living at 4 St Luke's square. One of the striking things about him was the complex way in which he secured himself by means of glittering chains. A chain stretched across his waistcoat, passing through a special button hole, without a button in the middle. To this cable were firmly linked a watch at one end and a pencil case at the other. The chain also served as a protection against a thief who might attempt the snatch the fancy waistcoat entire. Then there were longer chains beneath the waistcoat, partly designed, no doubt, to deflect bullets, but serving mainly to enable the wearer to haul up penknives, cigarette cases, match boxes, and keys from the profundities of his pockets.[7]

35. Brooke Boothby
1889
W. & D. Downey, London (NPG x 1170)

——————— 36 ———————

The senior partner in the firm Lewis & Lewis, George Lewis (1833–1911) was knighted in 1893. He was an intimate friend of the Prince of Wales and an excellent host, who knew and was known by most of Society. Many people went to him, because he was one of the best and most fashionable lawyers in town. A friend of Francis Burnand, after nodding smilingly to Lewis in the theatre, said 'There goes a man who could hang one half of the house and transport the other'.[8] Lewis had dealings with Burnand and others in this book, including Lord Dunlo, Lillie Langtry, and Lord Charles Beresford.

Lewis's clothes reveal a man of some character and fashion, with his suit of highly unusual fabric, monocle, spats, and shoes decorated with broguing. Spats, originally part of eighteenth-century military uniform, appeared in fashionable dress in the 1870s, in white canvas for summer and fawn wool for winter. By the 1890s they were correct with frock coats, and in the Edwardian period they were customary wear for formal dress. Spats may look sensible, warm garments, but they require considerable maintenance to keep the fabric looking clean and fresh. So too did a gentleman's shoes, which had to be glossily polished at all times. Brogue shoes, with punched holes and pinked edges to the leather, were named after rough, traditional, Irish footwear. Broguing, which was easily produced by mechanized techniques in the shoe industry, became very popular in the 80s and 90s.

36. George H. Lewis
1888 (published)
(for Our Celebrities: A Portrait Gallery, *pubd annually 1888–96) (NPG Ax 9144)*

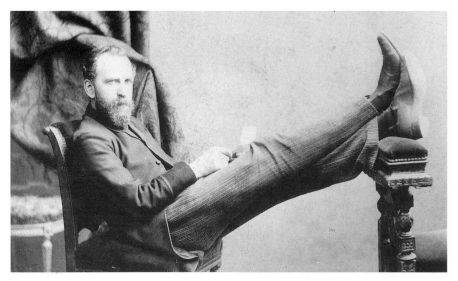

37. William Thomas Stead
1890
London Stereoscopic Company (NPG x 24952)

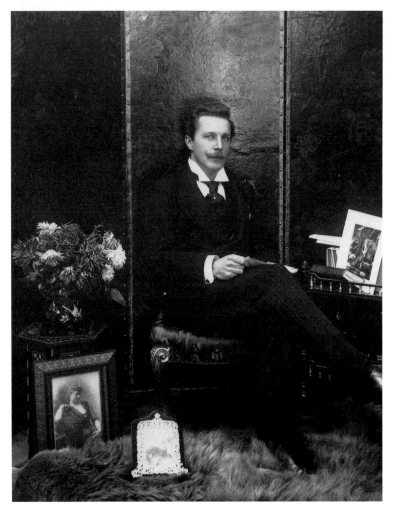

38. Harry Cust
c. 1890
Lord Battersea, Aston Clinton (NPG x 15609)

Stead (1849–1912), Editor of the *Pall Mall Gazette* from 1883 to 1890, was one of the first campaigning journalists. Through his efforts General Gordon was despatched to Khartoum in 1884. He was imprisoned for his investigations into child prostitution, which resulted in the Criminal Law Amendment Act of 1890. On leaving the *Gazette* he went into publishing. He perished on the *Titanic* in 1912.

Harry Cust (1861–1917) brought literary excellence to the *Pall Mall Gazette* under his Editorship from 1892 to 1896. While Stead was of Nonconformist merchant stock, Cust was a flamboyant aristocrat whose political and literary ambitions were overshadowed by his womanizing, and expectations of vast inheritance. He was considered extraordinarily good looking, with a profile reminiscent of those on Greek coins. Lady Diana Cooper, one of his unofficial offspring, remembered his blue eyes, immaculate dandified clothes, and negligent yet unruffled appearance:

> Very beautiful, I thought him, with noble hands and impeccable filbert shaped nails. He wore a coat such as I never saw another wear – dark blue cloth, flaring full, with a flat sable Eton collar. It was like Holbein's *Ambassadors*.[9]

Although Stead's pose is unconventional, his appearance is conservative. Beards and elastic-sided boots were becoming old-fashioned by 1890. The latter, which had reigned supreme for half a century, were ousted in the 90s by lace-ups for both sexes, and did not reappear until the 1960s. High boots continued as everyday wear well into the next century, but low-quartered shoes like Cust's were considered more gentlemanly.

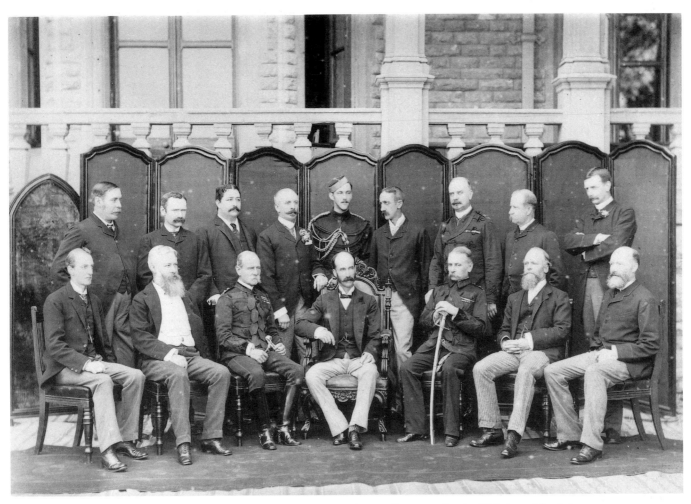

39. Lord Lansdowne, Viceroy of India, with Sir Frederick Roberts, Commander-in-Chief, on his right, photographed with other members of the British administration in India
1890
Bourne & Shepherd, India (NPG x 32167)

——— 39 ———

(Back row – left to right): Sir Edward Buck; Sir Anthony Patrick Macdonnell; Mr Harvey James; William Leslie de la Poer, Lord Beresford; Colonel George Washington Brazier-Creagh; Major-General Sir John Charles Ardagh; Lieutenant-General Sir Edwin Henry Hayter Collen; Major-General Sir Wykeham Leigh Pemberton; Mr Jenkinson.
(Front row – left to right): Sir Philip Perceval Hutchins; The Right Honourable Sir Andrew Scoble; Frederick Sleigh Roberts, 1st Earl Roberts; Henry Charles Keith Petty Fitzmaurice, 5th Marquis of Lansdowne; General Sir George Tomkyns Chesney; Sir Charles Alfred Elliott; Sir Donald Miller Barbour.

Most of the sitters in this photograph wear cutaway rather than frock coats. These may have been preferred for their coolness in India, but the thick, woollen cloth of all the coats and uniforms cannot have been pleasant in a hot climate. Traditional contrasting rather than matching trousers predominate. The creases around the hems of several pairs suggest they had recently been turned up. This was often done temporarily to keep them out of the mud. They were not yet made with turn-ups, but were shaped at the hem to follow the contour of the foot.

All the civilians wear lace-up rather than elastic-sided footwear, which was by now out of fashion. Highly polished shoes were a social necessity and one's valet might have cherished a secret recipe for a perfect sheen. Beau Brummel's man was said to use champagne froth. Lesser beings could buy commercial shoe-blacking, which in the last century came as a liquid in stoneware bottles.

Lord Lansdowne's (*centre front*, 1845–1927) low shoes provide a very unusual view of a Victorian male's socks and show that a respectable gentleman could wear surprisingly flashy designs. Socks hardly ever survive in museums, and when they do they are very difficult to date or place in a social context. They are therefore, today, one of the most mysterious areas of the Victorian male wardrobe.

40. George Frederic Watts
c. **1890**
George Andrews, Limnerslease (NPG x 27301)

———————— **40, 41** ————————

Watts (1817–1904) was photographed by his personal assistant at Limnerslease near Guildford, where he lived in a small community of artists and craftsmen. Both Academicians were inspired by the Classical age, but Watts painted grand allegorical subjects whereas Alma Tadema (1836–1912) used minute realism to depict scenes of everyday life.

Watts, who has turned up his trouser bottoms, wears a heavy-tweed Inverness cape; Alma Tadema sports a light overcoat. According to an article in *Puck* for 1885, this was a good indicator of social status, better even than a diamond stud, which might, after all, be paste:

the light overcoat is entirely different; because, while it is practically an

41. Lawrence Alma Tadema
1888 (published)
(*for* Our Celebrities: A Portrait Gallery, *pubd annually 1888–96*) (*NPG x 6020*)

unnecessary garment, yet it is more necessary than a diamond stud. A man who is not sound on his financial feet never indulges in a light overcoat. He wears his heavy one right through the snow and sleet of February, the winds of March, the showers of April and the blossoms of May. If questioned during the month of May, he replies that it is altogether too warm for any kind of overcoat, and that he wears a heavy one to keep himself in a perpetual perspiration, with a view to reducing his weight. . . . But when you purchase a light overcoat, and people see you in it, you are sure to go up in their estimation, because they are almost positive that you are rich. . . . If it is too warm to wear your overcoat, carry it on your arm, and you will inspire as much awe and respect as though it were on your back – especially if it has handsome satin lining turning out for the public eye.[10]

—————— 42 ——————

Phipps (1840–1911) began his diplomatic career in 1858. From 1885 to 1892 he was First Secretary of the British Embassy in Vienna. He moved from there to Paris, Brazil, and Brussels.

Astrakhan coats were the most formal type of male outerwear for extremely cold weather. The fur comes from the newborn lambs of a variety of black Iranian sheep, which are killed before the wool has time to grow. The astrakhan coat could convey an impression of understated luxury – the fur was often used as a complete lining to a cloth coat, with just the cuffs and collar revealing the fur outside. Those with more pretensions than money could have simply a fur trim. The quality of the fur could vary enormously, and eventually fairly convincing silk plush imitations were manufactured. *Clothes and the Man* (1900) warned: 'The coats trimmed with astrakhan are alright if the whole thing is of first-rate quality; otherwise the coat will remind you of the usual caricature of a fifth-rate actor'.[11] On discussing fur coats in general, the author warned of hidden expenses. Cabmen expected a fur-coated man to hire them rather than walk, and a man dressed thus had to tip servants twice as much as he did normally.[12]

42. Edmund Constantine Phipps
c. 1890
Adèle, Vienna (NPG x 12739)

—————— **43** ——————

Sala (1828–1896), a well-known jour-nalist, was Editor of the *Illustrated London News* from 1860 to 1886. He is remembered for his light-hearted but perceptive works of social commentary.

A well-brushed, glossy, top hat was a social necessity but once disturbed, the nap had to be professionally rejuvenated. In his youth, H. G. Wells once rum-maged amongst his threadbare posses-sions for suitable attire in which to meet an editor:

> The umbrella, tightly rolled and with a new elastic band, was not so bad, provided it had not to be opened; but the silk hat was extremely discouraging. It was very fluffy and defaced and, as I now perceived for the first time, a little brownish in places. The summons was urgent and there was not time to get it ironed. We brushed it with a hard brush and then a soft one and wiped it round and round again with a silk handkerchief. The nap remained unsubdued. Then, against the remonstrances of my aunt Mary, I wetted it with a sponge and then brushed. That seemed to do the trick. My aunt's attempts to restrain me had ruffled and delayed me a little, but I hurried out, damply glossy, to the great encounter, my début in the world of letters.

The meeting was formidable:

> I got across to the table somehow, sat down and disposed myself for a conversation. I was depleted and breathless. I placed my umbrella and hat on the table before me and realized then for the first time that my aunt Mary had been right about the wetting. It had become a disgraceful hat, an insult. The damp gloss had gone. The nap was drying irregularly and standing up in little tufts all over. It was not simply a shabby top hat; it was an improper top hat. I stared at it. Harris stared at it. Blanchamp and Silk had evidently never seen such a hat. With an effort we came to the business in hand.[13]

43. George Augustus Sala
c. **1890 (published)**
(for Our Celebrities: A Portrait Gallery, *pubd annually 1888–96) (NPG x 9166)*

────── 44 ──────

Chamberlain (1836–1914) was a Birmingham screw manufacturer and eminent local Liberal politician before he entered national politics. He became President of the Board of Trade and the Local Government Board, and Secretary of State for the Colonies.

Chamberlain and Sala (Plate 43) wear a tie-pin and scarf ring respectively, and both wear impressive watch-chains. Showy chains did not find universal approval: in 1876 the author of *How to Dress, or the Etiquette of the Toilette* called for plain jewellery and stated 'a gentleman carries a watch for convenience and secures it safely upon his person, wearing it with no useless ornament paraded to the eye'.[14]

Both men wear handkerchiefs in their breast pockets, a new fashion. Usually these were casually arranged since they were meant to look functional. Starched and folded points were a twentieth-century innovation.

Chamberlain's other decoration is a floral buttonhole. Many varieties of flower were commonly used. The poet Claude Lowther always had a gardenia;[15] Oscar Wilde's character Dorian Gray wore Parma violets, and once cut himself an orchid, 'a marvellous, spotted thing, as effective as the seven deadly sins'.[16] Chamberlain was also an orchid man. A buttonhole of this flower, a monocle and silk hat became well-known as his 'trade marks'.

44. Joseph Chamberlain
1888 (published)
Barraud, London (for Men and Women of the Day*) (NPG x 1110)*

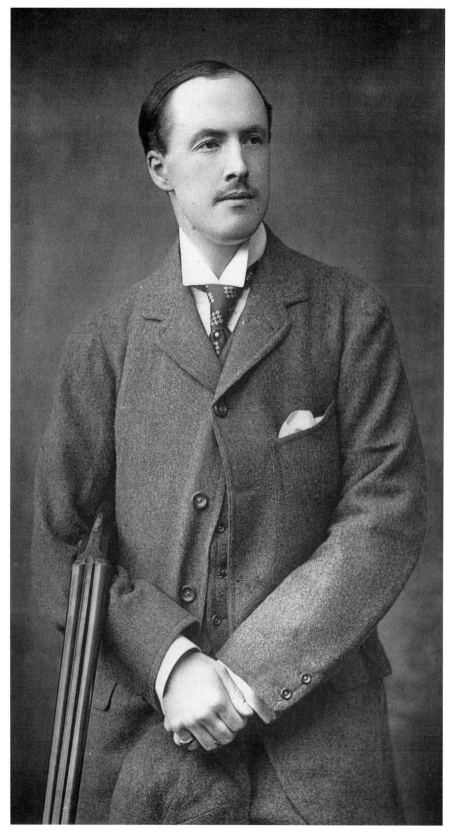

45

A one-time major in the Hampshire Carabineers, Ashburton (1866–1938) succeeded to his title and 36,000 acres in 1889, and devoted his energies to shooting and yachting.

Ashburton's check shirt has a sporty feel, but it is hard to imagine him wearing such a stiff collar for a hard day's shooting. Fancy shirts continued to be popular with all classes, especially for sport and summer wear. Most outfitters sold a very cheap, ready-made, striped cotton shirt called a regatta. In Plates 46 and 47, Edward Birkbeck wears spots for yachting, and Lord Hartington stripes with a formal frock coat.

The matching suit of jacket, waistcoat, soft cap, and possibly knickerbockers rather than trousers in a tweed material was standard wear for country activities. Shooting jackets generally had patch pockets at the breast and large, flapped pockets at the hips. They might also have a big inside 'poacher's pocket' for game. The Norfolk jacket, a more complicated garment with a belt and pleats for ease in front, remained a popular alternative for country pursuits but the plainer shooting jacket was to creep into mainstream dress as a comfortable, hard-wearing garment for everyday wear.

45. Francis Denzil Edward Baring, 5th Baron Ashburton
1890
Franz Baum, London (for Fashion and Sport*) (NPG x 334)*

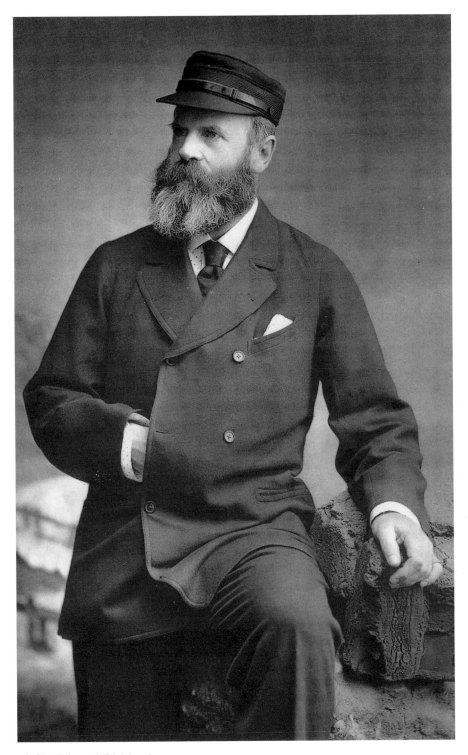

46. Sir Edward Birkbeck
1890 (published)
(for Our Celebrities: A Portrait Gallery, *pubd annually 1888–96) (NPG x 8686)*

Birkbeck (1838–1907) was a Norfolk MP with nautical interests. He was the originator and Chairman of the first International Fisheries Exhibition, held in London in 1883. He became Chairman of the R.N.L.I., and *Who's Who* listed the exclusive Royal Yacht Squadron at Cowes as one of his clubs. Yachting was growing in popularity among the very rich; in 1888 3,000 English people owned private luxury vessels of which 2,000 were yachts.[17]

This interest was reflected in general fashion. Women and children in even the most inland towns and cities wore sailor suits in summer and Birmingham jewellery workshops turned out brooches and buckles with flags, ropes, and anchors by the thousand.

Whilst Birkbeck had a genuine reason to wear his nautical-looking cap and reefer jacket, reefers were also popular as informal garments. Either single- or double-breasted, cut straight in the body with straight hems, they were always worn buttoned-up. *Clothes and the Man* stressed that the double-breasted reefer should be made of

> navy blue serge and of no other material, except real flannel, and the waistcoat and the trousers you wear with it must be of the same material; in fact, you mustn't wear a navy blue serge coat with any other trousers but navy blue serge.

The author was more flexible regarding single-breasted reefers, which were permissible in black serge with grey striped trousers, or worn as part of a tweed suit. It was important to have the reefer made the right length:

> You are going to wear it buttoned up, remember, and if it is too long it will crease at the back every time you sit down, while if it is too short you will have the satisfaction of knowing that people will think one of two things about you – either that you are wearing the coat of your young brother or a ready-made coat.[18]

—————— 47 ——————

Lord Hartington (1833–1908), who became the 8th Duke of Devonshire in 1891, was a distinguished member of Gladstone's cabinet, serving as Secretary of State for Ireland and for India. Together with Joseph Chamberlain he opposed Gladstone's Irish Home Rule Bill of 1886, and formed the breakaway Liberal Unionist party which drove Gladstone from power. Hartington twice refused to become Prime Minister himself. Lady Randolph Churchill remembered him affectionately:

> In private life no one was pleasanter or easier to get on with than the late Duke of Devonshire. His rather stern countenance belied a mirth-loving soul, and he thoroughly appreciated a joke. He was rather careless about his clothes, and once on his birthday his friends, as a joke, sent him every conceivable sort of head-gear, from the ceremonious silk hat to the flannel cricketing-cap. My contribution, I remember, was a pot hat. For hours they poured in; I believe he received over fifty.[19]

The stern countenances of many Victorian men were emphasized by full beards. W. G. Grace, shown in the next picture, was almost as famous for his beard as for his cricketing prowess. Grace's rather wild growth began life in the 1860s when beards were longer. By the 80s it was more usual to have them neatly clipped.

47. Spencer Compton Cavendish, Marquis of Hartington
1890
Russell & Sons, London (NPG x 8035)

48

Grace (1848–1915) and his brother, the greatest cricketers of their time, were both trained in medicine. W. G. practised as a surgeon in Bristol from 1879 to 1899. As an amateur, he played in 'gentlemen versus players' matches, but helped to start the Gloucester County Eleven in 1870. Grace's heyday as a batsman was in the 60s and 70s – in 1876 he scored 400 not out. Altogether he scored 126 centuries and 54,896 runs, and took 2,876 wickets. In the 1880s, Grace was a member of the English team in numerous matches against Australia.

The famous cricketer's whites appear to have been just unpacked from a kit-bag. Creases were inevitable in linen rather than cotton garments. While the day of cricketing in chimney-pot hats had long since gone, cricketing costume was still at an embryonic stage in its development. White clothing was by no means universal; a few years before this photograph, huge spots or checks were common on cricketers' shirts and fancy motifs were still popular. Along with the striped flannel blazer, the best clubs, such as *I Zingari*, wore striped skull caps and matching striped-silk cummerbunds. Grace wears the practical, unstarched sports shirt, probably with a soft turn-down collar, which was becoming usual for many activities such as boating or tennis as well as cricket. Cricket pads and spiked shoes were beginning to be acceptable and by the 1890s white cable-stitch cricket jumpers were sold by outfitters.

48. William Gilbert Grace
1888 (published)
Barraud, London (for Men and Women of the Day*) (NPG x 16478)*

**49. John Burns and colleague
1888–9**
Dusa, (NPG x 4920)

49

John Burns (1858–1943) was the first tradesman to serve in the cabinet, as President of the Local Government Board from 1905 to 1914. He began his political career as a member of the Social Democratic Federation and founder of Battersea Labour League. From 1889 to 1907 he was a London County Councillor and he was elected to Parliament in 1892.

Burns had been apprenticed as an engineer, and this photograph shows that he continued his interest after entering politics. Unlike the photograph of Gladstone felling a tree in his everyday clothes and bowler (Plate 54), Burns's shirt and apron suggest that he had indeed spent a morning at the bench. Work-clothes, like his apron, were worn until worn out, and so they rarely survive. When they do, it is difficult to date them because the styles hardly changed over many years. Photographs like this therefore give invaluable information about the way in which such articles were worn.

It is also unusual to find a photograph of a waistcoat being worn without a jacket. The young man's waistcoat shows how tightly they were cut around the armholes, and the way in which they buttoned very high on the chest in the 1880s. They usually had cotton or silk backs and, by now, had backstraps with adjustable buckles, replacing the traditional tape ties. The waistcoat was almost universally worn, even in hot weather.

By modern standards Victorian shirts were extremely voluminous, being designed to tuck right round between the legs. Although coat-style front openings were known, the tunic-style, which opened only as far as the waist, was general until the 1960s. Collars were usually attached until the 1840s, but by the date of this photograph it was customary for them to be separate. The main seams were likely to be machine-stitched although the rest would be hand-finished. Good quality ready-made shirts had been available for many years and inferior ones for centuries. By the end of the century there was little to choose between off-the-peg and made-to-measure shirts. Although some gentlemen still ordered shirts from shirt-makers, or had them made by relatives or servants, the ready-made shirt trade was a huge industry by this period.

50

Shaw (1856–1950): Socialist, free-thinker, vegetarian, playwright, critic, and public speaker, is glimpsed here at the outset of his career. He once estimated that he earned less than £10 in his first nine years as a writer. At this time he was establishing his name as a drama and music critic.

As with most things, Shaw held very strong views about clothing. He followed Dr Jaeger's dress-reform system of wearing wool next to the skin, and condemned the use of silk, querying the need to wear the excrement of worms!

Always an unconventional dresser, he was once spotted passing the *Tailor and Cutter's* offices attired in

> a loose-fitting Lounge suit, of a kind of terra-cotta shade, made from material that suggested Dr. Jaeger's speciality in woollen wear. Terra-cotta boots, terra-cotta hat, a necktie, and, if we remember aright, a flannel shirt of similar shade, completed the dress. But the harmony was not allowed to end here, for the book he carried under his arm was a copy of the *Idler*, and the terra-cotta colour of its cover matched to a nicety the tints of the whole outfit.[20]

50. George Bernard Shaw
1888
Emery Walker, (NPG x 19647)

Shaw even wore a suit of this colour to the theatre. H. G. Wells remembered him as

a slender young man of thirty-five or so, very hard up, and he broke the ranks of the boiled shirts and black and white ties in the stalls, with a modest brown jacket suit, a very white face and very red whiskers. (Now he has a very red face and very white whiskers, but it is still the same Shaw.)[21]

GROUP

51. Fanny and Harry Stone
1888–90
Ganey & Middlebrook, Kimberley, South Africa (NPG x 32718)

51

Harry Stone, a South African entrepreneur, was a promoter of the Cape to Cairo railway and a friend of Cecil Rhodes.

There is nothing provincial about Mrs Stone's dark satin dress with its rich beading. It may have been bought on a trip to England, but it could equally well have been made in South Africa. Photographs and fashion plates, and the growing ease of communications made it comparatively easy to buy a fashionable dress in quite distant corners of the globe. Puffed sleeves appeared in the late 80s, heralding the look of the 90s. Mrs Stone still has a bustle; although the demise of this feature was decreed by *couturiers* in 1888 it survived for a short time afterwards.

The most remarkable feature of Mr Stone's appearance is the cigar. In a man's world, cigars had been seen in public for many years. The famous photograph of Isambard Kingdom Brunel beside the *Great Eastern* steamship in the 1850s showed him smoking a cigar. Mr Stone, however, is nonchalantly enjoying his in the company of a lady and this illustrates a distinct change of attitude. Gone were the days when a gentleman would creep about the house in a special smoking jacket and hat late at night to take part in a 'secret and masculine orgy' in 'some remote pantry or gun-room'.[22]

While most ladies still abhorred the smell of tobacco, a good many were beginning to smoke cigarettes themselves, especially in fashionable circles.

52, 53

Francis Penrose (1817–1903), a distinguished architect, was Antiquary to the Royal Academy and President of the RIBA. His daughter, later Dame Emily Penrose (1858–1942), became

Principal of Bedford College, Royal Holloway College, and Somerville Hall.

Mr Woods was associated with the firm Christie, Manson and Woods.

Spinsters were more numerous in the nineteenth century than they are today. Fewer boys survived to adulthood and many youths left Britain to serve the Empire. Marriage was often delayed until a man could keep a wife 'in the manner in which she was accustomed'. Many wed late and some, after long engagements, never wed at all.

Some women, like Emily, escaped into successful careers. Most were busy with parties and outings until their late 20s, when the invitations started to grow thinner on the ground. Then, without a wife's responsibilities, time hung heavily.

In her book *The Precariously Privileged* Zuzanna Shonfield examines the diaries of Jeanette Marshall, daughter of an eminent London physician. They reveal how she spent her time before she married in the 1890s aged 36.

> Jeanette now worked an average of three to three-and-a-half hours a day, year in, year out, holiday periods included, making and remaking dresses and bonnets, trimming hats, sewing and embellishing underclothes, altering and contriving mantles and wraps. Much time was also spent on any number of ancillary activities indispensable to the conduct of this domestic industry, such as letters to dyers and cleaners and shopping for fabrics, trimmings and paper patterns . . . Jeanette would have been astonished to find that by her dressmaking she saved her father something in the order of £35 a year, the equivalent of half the annual cost, in wages and maintenance, of employing a first-rate lady's maid.[23]

52. Francis Penrose, his wife Harriette, and daughters Emily (seated), Alice, and Mary
c. 1886–7
Photographer unknown, Athens (NPG x 27601)

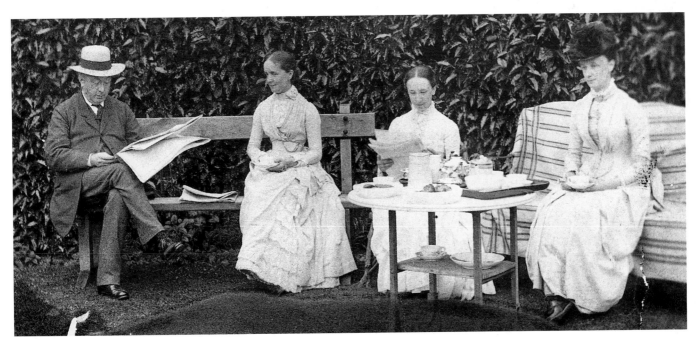

53. Mr Woods and his nieces the Misses Cameron
1886–90
Photographer unknown (NPG x 27534)

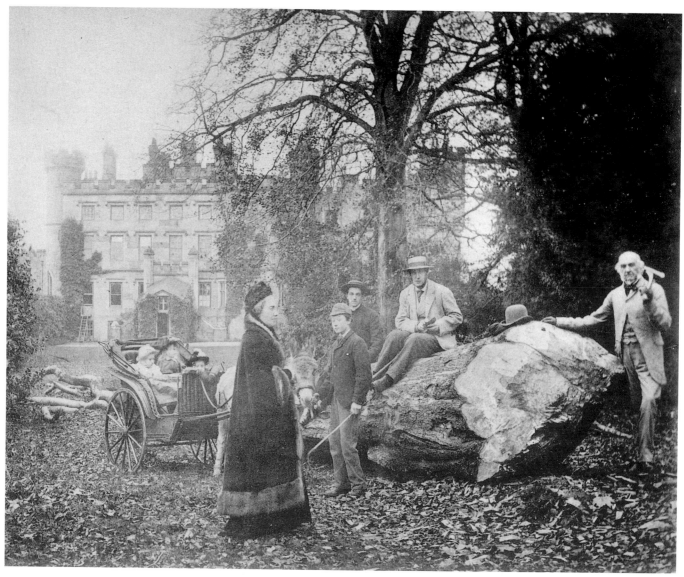

54. William and Catherine Gladstone, and family
1886–90
Poulton, Hawarden (NPG x 5983)

────────── 54 ──────────

The Gladstones are seen outside Hawarden Castle, their Cheshire home. As well as felling trees, Gladstone (1809–1898) enjoyed driving round the estate. E. F. Benson was once invited to accompany him:

A pony-carriage came round, and I was aware that he was going to drive himself. Before getting in he went round to the pony's head and peered at him. 'He's a beast,' he said, 'I must get a heavier whip'. Out he came again with this more

formidable weapon, and off we went, he the intrepid charioteer of something over eighty years.[24]

Mrs Gladstone's (1812–1900) bonnet and fur-trimmed mantle suggest it was cold, although the two younger men wear straw hats. Like caps for married women, bonnets, as worn by Mrs Penrose, had been universal until the 1850s. By now this recognized symbol of feminine modesty was worn mainly by the middle-aged and elderly. Its original sight-restricting brim had disappeared and all that distinguished it from a hat

were broad ribbons tied in a bow, sometimes attached to nothing but a few artificial flowers. Nevertheless, bonnets still conferred on their wearers an air of good character and they had their place in the wardrobe. Servants often had to wear them, as did female members of the newly formed Salvation Army. When Newnham student Molly Thomas went to be interviewed for her first teaching job in 1886 her tutor lent her a bonnet to give her moral support. Molly had never worn one before and she recalled that 'the strings of it were enough to check any tendency to laugh'.[25]

—————— 55 ——————

The sisters' short skirts indicate that these were walking dresses. On returning home they would change into longer daydresses. Full, horizontally draped overskirts were characteristic of the late 80s and balanced the enormous bustle.

Their brother's (1845–1913) hat has the characteristic tall crown of the decade, complementing the higher collars. Much fashionable variation was evident in the curl of brims. In 'The Blue Carbuncle' Sherlock Holmes deduced that a bowler was three years old from the shape of its brim, but any fashion-conscious person could probably have concluded as much.

Both umbrellas and parasols were substantial, with long sticks and heavy handles. Parasols had long been an important accessory, but serviceable-looking umbrellas were now preferred. A 'walk' was coming to mean serious exercise rather than a gentle stroll and an umbrella might well be needed.

The fashionable silhouette is often echoed in the clothes of each sex. Day-dresses had very high neckbands, reflecting male collars, and female hairstyles and hats were worn higher. The Czarina's (1847–1928) hat shows the extreme height which earned some styles the nickname 'three storeys and a basement'.[26] Its bird's wing decoration reflects the contemporary predilection for using dead animals on clothing. Alexandra (1844–1925) wears the newly popular boater. These were considered unbecoming to anyone over 40[27] but she was a beautiful woman who could wear anything.

E. F. Benson described how the Royal family on holiday in Athens

romped and unbent; one day a young Englishman who had the priviledge to sit and laze in the Royal garden heard the sound of tripping feet and male laughter and female cries of dismay, and round the corner of the rose-pergola where he sat came King George, kicking in front of him what had once been a hat. Behind him tripped the Princess of Wales, shrilly protesting, 'I beg you not to, George' she cried; 'It is my hat: so rude of you!' The young Englishman was in a *cul-de-sac*, he could not flee, and presently he was apotheosized into an umpire. 'But she had an ugly hat', pleaded the King, 'and I did not like it, so I took it off and I kicked it.' Then the plaintiff stated her case. 'It was my hat and it was so rude of him, and now I can never wear it any more.'[28]

55. Princess Alexandra, King George I of the Hellenes, and Czarina Maria Feodorovna of Russia
c. **1887**
Photographer unknown (NPG x 32759)

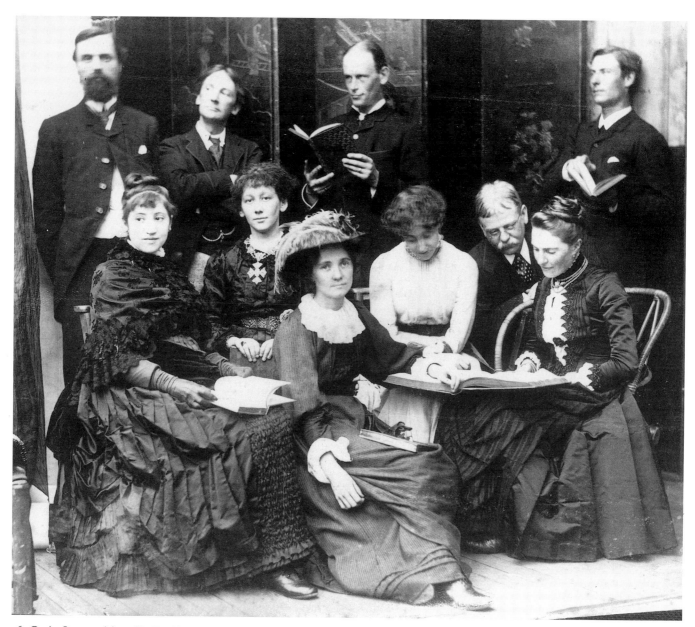

56. G. A. Storey, his wife Emily, family and friends
1886–8

Photographer unknown, Hampstead (NPG x 22271)

——————— 56 ———————

The woman in the foreground wears the type of 'artistic clothing' adopted by followers of the aesthetic movement, who sought to banish all ugliness from their lives. Probably made of green or brown wool, with its high waist, full sleeves, and white muslin frills it closely resembles the sort of costumes worn in Gilbert and Sullivan's *Patience*. Aesthetic dress was meant to have a timeless beauty, free from the whims of fashion. Since the same dress could be worn for several years, and wool or cotton was cheaper than silk, the style was a favourite with the impecunious. Jeanette Marshall wore sage green, peacock, old gold, and reddish-brown aesthetic dresses from 1879 onwards, together with that popular aesthetic accessory, an amber necklace.[29] Artistic ladies delighted in curious jewellery, like the heavy cross around one sitter's neck in this photograph.

This picture is hard to date, not only because of the aesthetic costume, but also because Mrs Storey's dark satin dress (left-hand side) looks some years earlier than the other dresses shown. The tight ruching down the front is typical of the early 80s, but the ladies perusing a book with Mr Storey (1834–1919) belong firmly in the latter part of the decade. Then as now, dresses would be worn by most people for several years, but it was usual to unpick, sometimes dye, turn the fabric inside out and remake a good silk dress that might have years of wear left in it, but which had become conspicuously out of date.

FEMALE

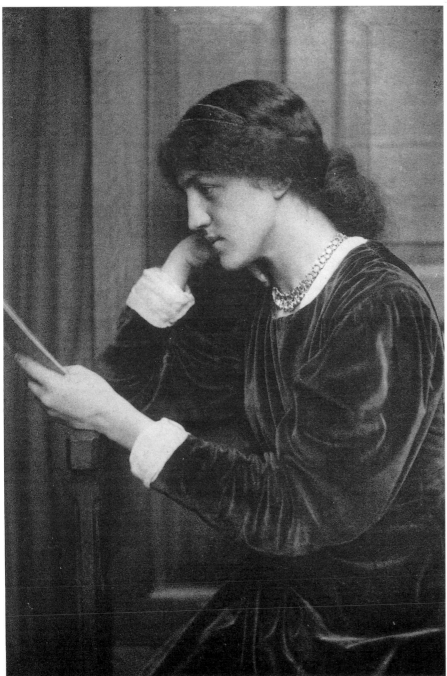

57. May Morris
1886
Frederick Hollyer (NPG x 19854)

May Morris (1862–1938), one of William Morris's two daughters, was a talented embroiderer and designer, well-known in the Arts and Crafts Movement. Like her mother Jane she often sat as an artist's model, but while she shared her mother's thick hair and classical profile, she also inherited her father's square-set features. Both women regularly dressed in the alternative styles which Jane had favoured since the 1860s. May's vaguely medieval dress is worn without corsets. Wearing her hair simply bound up in a 'classical' fillet she looks as if she has just stepped out of one of her father's stained-glass windows. The extreme looseness and plainness of the Morris's clothes was sometimes too much even for those who considered themselves 'artistic'. Jeanette Marshall saw them at a dance in 1883:

> Mrs Morris and her 2nd daughter May were there, and the former looked very well, I thought, though very sloppy, in a cream crêpe, sparingly trimmed with old gold satin, & made high to the throat. Her hair was fuzzy, and she had a white Indian shawl over her shoulders. . . . The daughter, in a brown-red bedgown with no tucker, was a guy everyone voted. She is excessively ugly.[30]

——— **58** ———

Gladys (1901–1978) was G. A. Storey's only child. Many adults who hesitated to don artistic dress themselves, put their offspring in it. The simple styles, carefully designed for children's needs, could be much more comfortable than conventional juvenile clothing. Kate Greenaway's popular illustrated books, published from 1878, were a rich source for quaint artistic costumes based on early nineteenth-century styles. Lots of little girls like Gladys had 'Kate Greenaway' outfits, which were featured for more than a generation in Liberty's dress-department catalogues. While her bonnet is based on the styles of the 1820s, the inspiration for her frock came from the traditional countryman's smock. Although much appreciated in Arts and Crafts circles, these were becoming a rare sight worn unselfconsciously in rural England.

The smock's disappearance was in some measure due to the availability of cheap ready-made woollen suits from clothing centres such as Leeds, Manchester, and Bristol. Mass-produced, machine-embroidered cotton caps and aprons for servants were a product of the Nottingham clothing industry. Although female servants had not as a rule worn a distinctive uniform previously, the humblest family's maid-of-all-work could now be decked out for a modest price; the parlourmaid in her cap and streamers became a familiar figure in the late-Victorian scene.

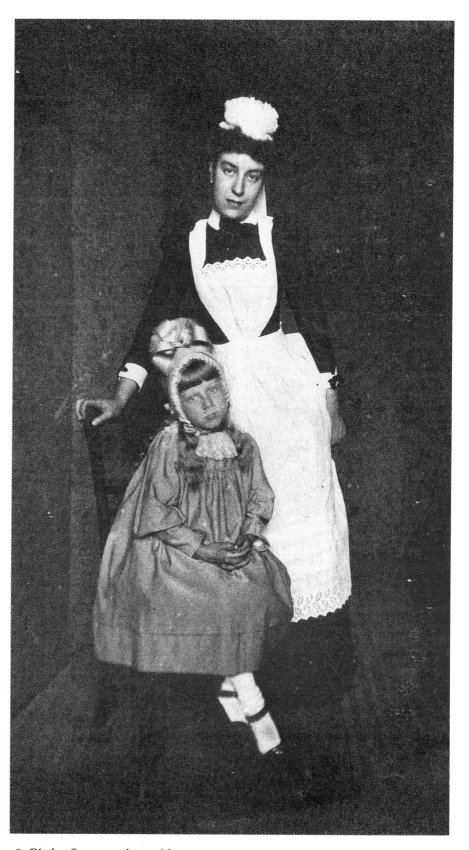

58. Gladys Storey and a maid
1886–90
Photographer unknown, Hampstead (NPG x 32716)

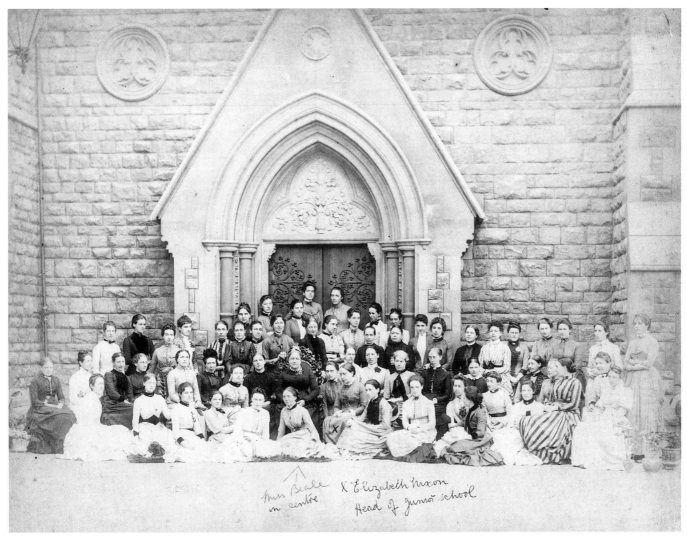

Miss Beale
in centre

X E. Elizabeth Nixon
Head of Junior school

59. Dorothea Beale, Principal of Cheltenham Ladies' College, with her staff
c. 1888
Photographer unknown (NPG x 1679)

—————— **59** ——————

When Dorothea Beale (1831–1906), a pioneer of female education, came to Cheltenham Ladies' College in 1858 it was a small school facing bankruptcy. On her retirement, nearly 50 years later, it was one of the largest and most successful enterprises in Cheltenham. These teachers all wear restrained summer dresses, many with the high velvet neckbands and little brooches so typical of the late 80s. Two intrepid souls have puffed sleeves – in a year or two these would be universal – but the absence of fringes shows a general lack of fashion-consciousness, either through choice or school rules.

Cheltenham girls were carefully looked after. Although Miss Beale did not believe in uniforms, she once noted

We should insist much on a good breakfast, and a glass of milk in the course of the morning; and as regards dress, the abolition of any form of stays that can be easily tightened (I should be glad to show various harmless substitutes for stays, for *some* substitute perhaps is required), or shoes and boots with high heels and pointed toes; we should urge the wearing of woollen material, summer and winter, next to the skin and covering the lungs, and of stockings and shoes warmer than are needed in carpeted rooms.[31]

Cotton dresses were worn from spring to autumn and girls were inspected before leaving their houses to make sure they were suitably dressed, and if necessary carrying a waterproof and umbrella. Moreover, the Principal stated, 'if I may express an opinion, it will be very unfavourable to the fashionable boa, which tends to produce a sore throat by unduly heating it'.[32]

60. Emily Penrose
c. 1886
Russell & Sons, Wimbledon (NPG x 27602)

60

Emily Penrose's (1858–1942) distinguished career lay ahead when this picture was taken. Whereas men could finish university by their early 20s, the hard-won education of many academic women took much longer. After studying languages and archaeology abroad and lecturing for the London University Extension College, Emily Penrose obtained a First from Somerville College in 1892, becoming Principal of Bedford College the following year.

Career women had to strike a balance between following the time-consuming conventions expected of females, and working efficiently. This had been harder in earlier generations: in her book *Cassandra*, Florence Nightingale complained bitterly of the demands made on her which discouraged serious occupations.[33] For instance, maintaining a complicated wardrobe required energy and, for those on small allowances, precious money that could have been spent on books. Many, like Miss Beale, reacted with a total lack of interest in clothes. As an eminent headmistress, she had to be cajoled into wearing something suitable for public functions.

In contrast, several photographs of Emily Penrose show her wearing pretty outfits. This summer dress, probably cotton, has the popular full 'plastron' panel down the bodice front, and elbow-length sleeves. Dark shoes, stockings, hats, and gloves were often worn with pale clothes. Black stockings were new, although other colours had been acceptable for some time. Throughout the early to mid-century white had been the norm, together with dainty slippers of fabric or light leather. The popularity of the more practical black stockings and sturdy leather heeled shoes or boots, which lasted until the Great War (1914–18), reflected changing female lifestyles. The dark woollen braid just visible stitched inside her hem was another practical detail; this helped protect the fabric from contact with the ground.

61. Adelina Patti
1889 (published)
Barraud, London (for Men and Women of the Day*) (NPG x 5451)*

Adelina Patti (1843–1919), 'The possessor of one of the most captivating voices this generation has heard',[34] made her début at the age of seven in the USA. A triumphant appearance in *La Sonnambula* at Covent Garden in 1861 was followed by performances in all the world's great opera houses. During one tour in 1888 she received £1,600 a night. She lived in a castle in Breconshire and was much loved by the Welsh; male-voice choirs used to journey there to serenade her.

Patti could afford to shop at Maison Worth where, even in the 1860s, many customers spent up to £4,000 a year.[35] By the end of the century this type of woman might have an annual dress allowance of £10,000, when a walking dress could be had from a good London dressmaker for 22 guineas.[36] Adelina Patti was one of Worth's principal operatic customers. She paid vast sums for her private wardrobe and stage costumes. Worth guided her choice of clothes, encouraging her to combine glamour with historical accuracy.[37]

Worth's dictatorship over prima donnas of both the stage and of fashionable society the world over was legendary. Until his day even great dressmakers visited great ladies at home, but Worth left his salon for no-one but the Empress Eugénie. His toilettes were probably all the more ravishing because he rarely asked the wearer for her opinion. Since his finishing touches were left until the last minute, countesses and duchesses used to queue up for his approval before setting out for the ball.

Like Adelina Patti (Plate 61), this actress wears one of the extremely high hats typical of the late 80s (and a fox fur tippet). Both hats are decorated with complete stuffed birds. These were featured on all sorts of costume; fans and muffs often had humming-birds impaled on them. Sometimes 30,000 humming-birds were sold to dealers at an afternoon's auction.[38] The number of dead birds used on costume posed a serious threat to many species; the Royal Society for the Protection of Birds was formed in 1889 following a campaign by a Mrs Williamson of Didsbury against the wholesale slaughter of osprey and heron to provide feather decorations called egrets. The Duchess of Portland became the society's first president in 1891 and held the office for the next 65 years.

Even more delicate rare creatures were sometimes used. Lillie Langtry once wore a yellow tulle dress to a ball at Marlborough House,

> draped with a wide-meshed gold fish-net, in which preserved butterflies of every hue and size were held in glittering captivity . . . the Prince of Wales told me that, the morning after, he picked up many of the insects, which were lying about the ball-room floor.[39]

The craze for extreme forms of zoological decoration was short-lived, but some of the fancies introduced at the time enjoyed a lasting popularity. A fox skin with a clip on its nose to make it look as if it was biting its behind around the wearer's neck was to be one of the most potent fashion devices of the twentieth century.

62. Amy Roselle
1887 (published)
Barraud, London (for The Theatre*) (NPG x 12881)*

—————— **63** ——————

Astrakhan has been another enduring fashion. The newly married 19-year-old marchioness's coat copied popular male outergarments which used the fur as a luxurious lining. She may have had it made at one of the top London ladies' tailoring establishments which specialized in riding habits and outerwear. The best known were Redmayne, Busvine and Redfern, Princess Alexandra's favourite tailors.[40]

As the Duchess of Sutherland, this lady (1867–1955) was renowned as a remarkable philanthropist, but the splendour of her lifestyle impressed even Consuelo Vanderbilt, who remembered meeting her during her first season in England:

> One ball stands out clearly because of the beauty of the hostess and of her surroundings. It was given by the Duke and Duchess of Sutherland at Stafford house. The young Duchess was a glittering apparition in her silver dress and diamonds as she stood at the top of the great staircase receiving her guests.[41]

Both sexes wore coats entirely lined or made with all kinds of furs. On her marriage to the Duke of Marlborough, Consuelo was taken to see a relative, the Duke of Hamilton.

> He insisted upon removing my coat, which was of green velvet entirely lined with Russian sables. 'What a wonderful coat, what priceless furs!' he exclaimed. 'I must send for my sables to compare them.' Whereupon he rang the bell and had his valet bring his coat. To his deep concern, it did not equal mine![42]

63. Lady Millicent Hawes, Marchioness of Stafford
1889 (published)
(for Our Celebrities: A Portrait Gallery, *pubd annually 1888–96) (NPG x 9135)*

64. Lady Daisy Brooke, Countess of Warwick
1889 (published)
Barraud, London (for Men and Women of the Day*) (NPG Ax 5464)*

64

Daisy Maynard (1861–1938) was worth £40,000 per year when, at 20, she married the Earl of Warwick's son.

> Her advent in Society was hailed as a triumph. Not merely did interest attach itself to her on account of her inheritance, but her face and form commanded admiration. Had she been only able to say . . . 'My face is my fortune', they must have been blind who denied her pre-eminence on that account alone.[43]

Neither Lord Beresford nor the Prince of Wales was blind: she had affairs with both of them.

Lady Brooke wears a mantle in this photograph. An alternative to the cloak, mantles could be little more than sleeved capes or coat-shaped garments. Often, mantles were made in more sumptuous materials than coats. They were loosely styled to accommodate the enormous bustles of the 1880s, and so enjoyed a new lease of life in that decade. This mantle has sleeves, but similar garments were often made in the 'Dolman' style. In those days this meant a sleeve cut with the bodice, pinning down the elbows but leaving the forearms free. They wonderfully enhanced the line of the upper body, but caused many a broken wrist when their wearers fell over and could not release their arms.

The bustle was created from draperies alone, or with frills of horsehair or corded cotton, a wire cage or some sort of pad. Molly Hughes's mother once asked a visitor

> how she managed to have such an effective bustle. The astounding answer was '*The Times*. I find its paper so good, far more satisfactory than the *Daily News*', and putting her hand under her skirt she tore off a piece to show us.[44]

65. Rhoda Broughton
1889 (published)
Barraud, London (for Men and Women of the Day*) (NPG x 4724)*

66. Marie Perugia, Mrs Leopold de Rothschild
c. **1889–90**
Lord Battersea, Aston Clinton Album

——————— 65, 66 ———————

The Prince of Wales delighted the Jewish community when he attended the Rothschilds' wedding in 1881.

The titles of Rhoda Broughton's (1840–1920) novels, for instance *Doctor Cupid* of 1886, belie their quality. She had 'a rare fund of humour, of a racy and piquant kind'.[45] At one time her books used to be forbidden to young ladies, but by the 80s they were often recommended reading.[46]

These two dresses were made in the transitional period between the bustle's demise in 1888 and the arrival of full sleeves in 1891. Their effectiveness relies on subtle cutting and interesting, asymmetrical bodices. Rhoda Broughton wears a bias-cut fall, a completely new idea. Her dress is cut in one piece; Worth

experimented with this effect and in 1891 launched a 'seamless princess gown'.[47]

Such garments were carefully constructed. The general standard of professional dressmaking had risen under the influence of Worth, who insisted on meticulous craftsmanship. This was the great age of dressmaking: the exquisite exteriors of many surviving dresses are almost outshone by the finish that can be seen when the garment is turned inside out.

The simplicity of Mrs de Rothschild's (*c.* 1860–1937) outfit was undoubtedly achieved at great expense. A young Rothschild once admired her music teacher's home-made bonnet and asked her to make another like it. This was duly delivered. On being told it cost five shillings, she exclaimed 'Good gracious, only five guineas! . . . It's the cheapest bonnet I've ever had, and the prettiest'.[48]

67

This American contralto (*c.* 1860–?) first came to Europe in 1882. In the late 80s she appeared in London with the Carl Rosa company.

Her ensemble, which is rather more old-fashioned than those seen in the preceding two photographs, illustrates the extraordinary upholstered effect of female costume in the late 1880s. H. G. Wells described the contemporary 'look', which was far removed from his adolescent fantasies:

> So far as I was concerned the 'good figure' of that period, with its tight long stays, its padded bustle behind, its single consolidated bosom thrust forward and its 'Grecian bend' thrust back, had scarcely anything to recall the deep breasted Venuses and Britannias who had first awakened my sexual consciousness. The stark and easy generation of to-day can scarcely realize how completely, from the whalebone-assisted collar round its neck to the flounces round its feet, the body of woman was withheld from masculine observation, and how greatly this contributed to the practical effective resistance to 'the nude' in art. Men went to the music halls simply for the rare joy of seeing feminine arms, legs and contours, but I had no money to go to a music hall.[49]

67. Agnes Huntington
1890 (published)
Barraud, London (for Men and Women of the Day*) (NPG Ax 5480)*

———— **68** ————

Belle Bilton (1867–1906) went on stage at the age of 13 together with her sister. When their song-and-dance act reached the West End, Belle became an overnight celebrity; it is said that her photographs sold better than those of Lillie Langtry. Belle's admirers included an army officer by whom she had a son, and another man who installed her in a house in Saint John's Wood. In 1889 she secretly married Viscount Dunlo. His father, the Earl of Clancarty, forced him to sue for divorce, but after a highly publicized but unsuccessful court case the old earl died, and the couple began a happy marriage.[50]

The apocryphal story of an old gentleman at a party who, when asked 'Have you ever seen anything like it?' replied 'No, at least, not since I was weaned!' seems particularly apposite for the 1880s. Evening necklines could be extremely low and sleeves were often done away with. When John Singer Sargent exhibited his painting *Madame X* at the 1884 Paris Salon there was an outcry, because the sitter's black evening dress left her shoulders and arms completely naked, apart from thin chains supporting an extremely low décolletage.[51]

Admiration for tiny waists went hand in hand with the appreciation of fine bosoms. The corset, which created the former, also provided uplift and cleavage and a delicious awareness of a woman's breathing. Plump ladies were now recommended to bare their arms as well as their breasts: 'The arms and shoulders . . . are often the chief beauty of a fleshy woman, and it is to her advantage to give them as effective a setting as possible'.[52]

68. Belle Bilton, Lady Dunlo
1889–91
Bassano, London (NGP x 958)

The grand duchess's (1822–1916) impressive jewels include a cluster of brooches with royal insignia. Not only royalty, but most ancient families still owned priceless jewellery and found plenty of opportunity to wear it. Lady Londonderry used to call her diamond tiara 'the family fender'.[53] The Marchioness of Stafford had the magnificent Marie Antoinette necklace, so called because the diamonds came from a *parure* made by a French court jeweller, who offered it first to Madame du Barry, and then to Louis XVI for Marie Antoinette, who refused it.[54] Consuelo Vanderbilt's marriage to the Duke of Marlborough in 1895 brought new money to an old name:

> Marlborough's ideas about jewels were . . . princely, and since there appeared to be no family heirlooms, jewels became a necessary addition to my trousseau. It was then the fashion to wear dog-collars; mine was of pearls and had nine-teen rows, with high diamond clasps which rasped my neck. My mother had given me all the pearls she received from my father. There were two fine rows which once belonged to Catherine of Russia and to the Empress Eugénie, and also a *sautoir* which I could clasp round my waist. A diamond tiara capped with pearl-shaped stones was my father's gift to me, and from Marlborough came a diamond belt. They were beautiful indeed, but jewels never gave me pleasure and my heavy tiara invariably produced a violent headache, my dog-collar a chafed neck.[55]

69. Augusta Caroline, Grand Duchess of Mecklenburg-Strelitz
1889 (published)
(for Our Celebrities: A Portrait Gallery, *pubd annually 1888–96) (NPG x 9155)*

70. Jennie, Lady Randolph Churchill
c. **1888**
Van der Weyde, London (NPG x 26371)

Lady Randolph Churchill (1854–1921) wears a court dress in this photograph. Once presented, ladies could attend one Drawing Room a year, but Lady Randolph Churchill would have attended frequently as the wife of a statesman. Each débutante was accompanied by someone who had herself been presented. Female relatives of members of the aristocracy, gentry, or professions could be presented, as could those of 'persons engaged in commerce on a large scale', provided there was no direct involvement. However, 'The wives and daughters of the wealthy manufacturers are not *themselves* debarred from attending drawing-rooms and levees if their wealth, education and associations warrant them in so doing'.[56]

Court dress was compulsory at a presentation. Married ladies wore three white ostrich plumes and spinsters two, with white veils and long, white, kid gloves. Unless permission to wear a high neck was granted for health reasons, dresses had short sleeves, low bodices and trains at least three-and-a-half yards (three metres) long, attached at the shoulders or waist. The train was carried over the arm then spread out by officials as each lady approached the Presence Chamber. The lady then had to remain facing the Queen or Princess after curtseying and kissing her hand, and so walked backwards in her train, curtseying to every member of the royal party, until she reached the door.

Court dress was similar throughout Europe, but Lady Randolph Churchill was amused when she visited Russia to see ladies holding up each other's trains. 'Not having any such sumptuous dress as I found was worn, I was reduced on this occasion to a blue-and-gold tea-gown, which did quite well, although it seemed a strange garment in which to go to court'.[57]

71. Mary Moore
1889 (published)
Barraud, London (for Men and Women of the Day*) (NPG x 21404)*

72. Frances Hodgson Burnett
1888 (published)
Barraud, London (for Men and Women of the Day*) (NPG x 5179)*

——————— **71, 72** ———————

Mary Moore (1861–1931) overcame family opposition to her becoming an actress, and joined Sir Charles Wyndham's company in 1885. She became his leading lady and won much acclaim, particularly for her portrayals of helpless but attractive females.

Frances Hodgson Burnett (1849–1924) came from Salford but moved with her family to Tennessee, USA, when they fell on hard times. She wrote for magazines while in her teens and was an established author well before *Little Lord Fauntleroy* made her fortune in 1886.

Returning to England as a celebrity, her American veneer enabled her to move in circles that would never have dreamed of admitting a backstreet Salford girl.

She loved dressing up although, as Marghanita Laski commented, 'photographs of Mrs Burnett taken at this time show her to have been distinctly matronly in appearance, with one of those tight, forbidding Manchester faces'.[58] Friends called her 'Fluffy' because she wore her auburn hair in a frizzed fringe to hide her high forehead. Eventually the colour came out of a bottle – it was even rumoured that she wore a wig.

Mrs Burnett was a great fan of Liberty's. She furnished her London apartment in the aesthetic taste and wore Kate Greenaway-style dresses.[59] The evening gown shown here, based on classical draperies, was clearly inspired by high artistic principles. A timeless design, it closely resembles two aesthetic dresses, based on Ancient Greek costume, illustrated in *Harper's Bazaar* in 1881.[60] One was worn with an 'Etruscan gold necklace and bracelets, being a reproduction of the gold ornaments excavated by Professor Schliemann'.

—— 73 ——

Queen Victoria's eldest daughter Vicky (1840–1901) was married to Crown Prince Frederick of Germany. He was Emperor for only 90 days before his death in March 1888. He was succeeded by his son Wilhelm, better known as Kaiser Bill.

The Manners and Rules of Good Society of 1893 stated:

> The regulation period for a widow's mourning is two years; of this period crape should be worn for one year and nine months, for the first twelve months the dress should be entirely covered with crape, for the remaining nine months it should be trimmed with crape, heavily so the first six months, and considerably less the remaining three; during the last three months black without crape should be worn. After the two years two months half-mourning is prescribed, but many people prefer to continue wearing black without crape in lieu of half-mourning.
>
> The widow's cap should be worn for a year and a day. Lawn cuffs and collars should be worn during the crape period.
>
> After a year and nine months jet trimming may be worn.[63]

73. Victoria, Empress of Germany
1889
Elliott & Fry, London (NPG x 3812)

PART THREE:
1891-95

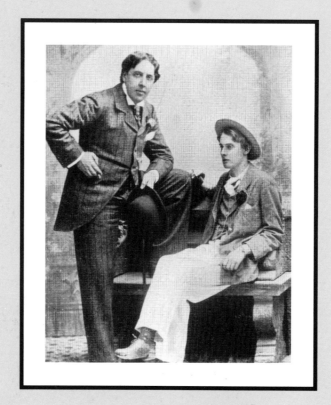

MALE

74

Sir Edward (1851–1925), a lawyer with banking interests, became Sheriff of Cornwall in 1896.

Presentation at Court was important for men as well as women, although most men were presented on the strength of public or professional service rather than for social reasons. Sir Robert's presentation would have been in recognition of his new appointment. Gentlemen attended levees held by the Prince of Wales at St James's Palace. Male court dress was worn not only for levees but also for state balls.

Nineteenth-century court dress evolved from the highly elaborate, embroidered suits worn at the end of the previous century for official occasions. Sir Robert wears the black-velvet suit generally adopted in the late-Victorian period. The last vestiges of Georgian splendour are apparent in his sword, knee breeches and the brilliant *diamanté* effect of the cut-steel buttons. Claret, dark-blue, or brown cloth suits, sometimes still seen on elderly gentlemen, had been usual earlier in the century. These were worn with embroidered silk waistcoats, lace ruffles, and a wig-bag stitched to the neck.

Dr Marshall, a well-known London physician, ordered from Poole's, one of the best West End tailors, a "Court suit of great gorgeousness"

On the appointed day Jeanette described her father's ceremonial preparations just as if it had been herself or Ada primping for a ball. He lunched and dressed in front of the specially lit bedroom fire, and then came downstairs, seeming 'rather nervous and amused at his appearance & yet rather gratified too'. She herself thought he looked 'remarkably well' in the sombre get-up, black silk stockings, shining shoes, with a sword at his side and a cocked hat under his arm.[1]

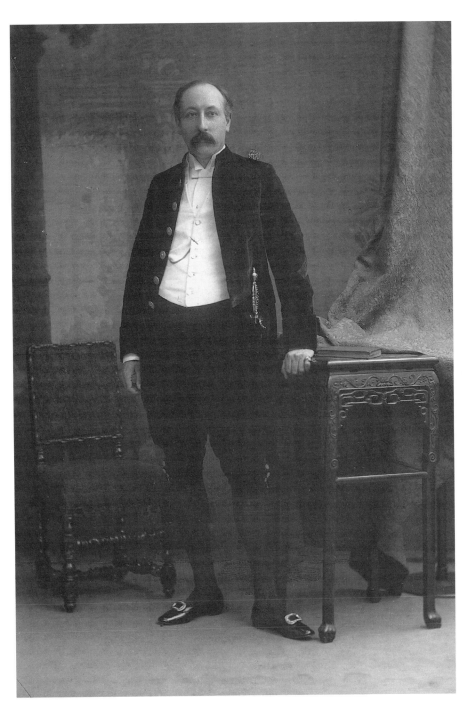

74. Sir Edward Robert Pearce Edgcumbe
1895
Bassano, London (NPG x 28237)

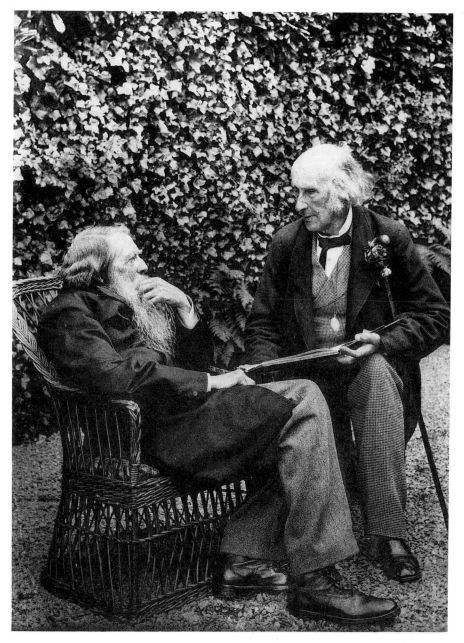

75. Professor John Ruskin and Sir Henry Wentworth Dyke Acland, 1st Baronet 1893

Sarah Acland, Lake Coniston (NPG x 13297)

Ruskin (1819–1900) was one of the most influential art critics of the last century and a prolific writer on many subjects, from architecture to minerals, and social reform. In the 1870s he had been Slade Professor of Art at Oxford University. This photograph was taken at Ruskin's House, 'Brantwood,' in the Lake District by Sir Henry's daughter Sarah Acland (1849–1930), a Fellow of the Royal Photographic Society and of the Royal Society of Arts.

Sir Henry (1815–1900) was about to retire as Regius Professor of Medicine at Oxford University, a post he had held since 1857. He had also been President of the Medical Council and Radcliffe Librarian.

The two sit in Ruskin's garden in clothes that could have been worn at any time over the previous 30 years. Both wear their hair in the long styles of their youth. Only Acland's unbuttoned frock coat might suggest the date, although it may be that it is worn open as a concession to its being August, rather than to current convention. The shiny material of Ruskin's coat was by now distinctly old-fashioned. To someone like Ruskin, an immaculate frock coat was essential. John Galsworthy gave a glimpse of a frock coat in his description of another elderly gentleman, James Forsyte, visiting Soames's new house in 1888.

He started slowly up the hill, his angular knees and high shoulders bent complainingly . . . yet neat for all that, in his high hat and his frock-coat, on which was the speckless gloss imparted by perfect superintendence. Emily saw to that; that is, she did not, of course, see to it – people of good position not seeing to each other's buttons, and Emily was of good position – but she saw that the butler saw to it.[2]

76. The Honourable Alfred Percy Allsop
1895
Bassano, London (NPG x 1662)

Frock coats enjoyed a revival in the 1890s, cut fuller and slightly longer than previously. Allsop's (1861–1929) reaches to just below his knee, whereas that of the Earl of Albemarle in Plate 5 ends above the knee and is closer fitting. Coats tended to be worn open in the 1890s; Allsop's reveals a double-breasted waistcoat, which was correct for frock coats. Its pale colour and the light, probably grey, coat suggest the photograph was taken in the summer.

The 'stand-up-turn-down' collar was worn a great deal in this decade. In *Clothes and the Man* (1900) it was described as the 'Mary Anne' or 'Housemaid's' collar:

> The points to observe when buying one of these collars are, the way in which the ends of the collar are cut, the 'spring' of the collar (that is the shape), and the way in which the top part of the collar is arranged, so that when the collar is buttoned, the tie is not gripped so firmly that it cannot be slipped into its proper place. If you buy a cheap double collar several things will happen. When you put it on for the first time your tie will be gripped so tightly at the back that you won't be able to tie it properly. You will then give the tie an impatient tug, and if the tie is of a delicate nature, it resents this treatment by coming in two pieces, the back button-hole of the collar tears, possibly the stud breaks, and you are in a state of mind bordering on insanity.[3]

Slade, President of the Playgoers' Club, would have known and admired Pinero, one of the most popular playwrights of his day. His successes included *The Second Mrs Tanqueray* of 1893 and *The Notorious Mrs Ebbsmith* of 1895. Max Beerbohm was fascinated by Pinero's eyebrows, which he likened to 'the skins of some small mammal, don't you know – just not large enough to be used as mats'.[4]

Loose cravat-type scarves like Pinero's continued to be worn although the 'four-in-hand' tie, like Allsop's (Plate 76), was becoming more prevalent. The wider shape came in around the middle of the decade, as did larger bow ties like Slade's. According to the *Tailor and Cutter* (1895) 'bow ties should always be worn with a soft-fronted shirt and an ordinary stand-up collar with the points just slightly turned down'.[5]

The stand-up collar was rigidly starched and ironed to a high polish, and the main problem, apart from discomfort, was preventing the tie from slipping about. Special clips were sold to secure it but the simplest method was to have a tape loop on the back yoke of the shirt. The author of *Clothes and the Man* was pleased that the plain stick-up collar had gone out of fashion, since it was 'about the most uncomfortable collar that any man could devise. When you leaned down the collar gaped open, and when you rose again the collar closed and nipped a small piece out of your neck'.[6]

77. Arthur Wing Pinero
1895
Frederick Hollyer, London (NPG x 12547)

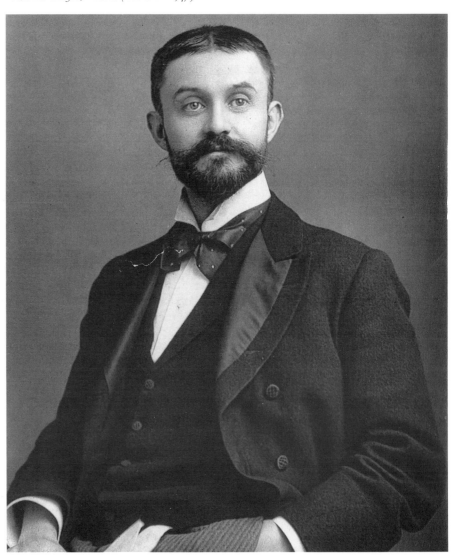

78. R. Jope Slade
1893 (published)
Alfred Ellis, London (for The Theatre*) (NPG x 22604)*

--------- **79** ---------

This photograph was taken in the year Pembroke (1853–1913) succeeded to Wilton House, 60,000 acres, and a title dating back to 1551. He was an MP from 1877 to 1895, serving under Salisbury as Lord of the Treasury. In 1895 he became Lord Steward. Over six feet tall and exceptionally handsome, he was a magnificent figure at royal functions.[7]

Here Pembroke wears a morning coat, an acceptable alternative to the frock coat on all but the most formal occasions. The moustache was perhaps the most characteristic facial hair of the period. A music-hall song asked 'what's a kiss without a moustache?' and ceramic manufacturers found that special moustache cups were a lucrative novelty. Whereas the moustache of the 80s tended to be simple, if sometimes rather long, in this decade they were often waxed and curled. Together with the shorter hairstyles then prevalent, they imparted a snappy, rather military look to the wearer. Wax for moustaches could be bought in little pots from barbers, or waxing and curling could be done on the shop premises.

Barbers offered many services in addition to haircutting. Arnold Bennett's character Darius Clayhanger paid a subscription for his daily shave, for which a cut-throat razor would have been used.[8] Vigorous scalp massage might also be offered by barbers. Patent hair-brushing machines with geared high-speed rotary brushes were a feature of many shops until well into the present century. If these failed to produce a luxuriant growth, wigs could be bought from some barbers, such as Truefitts in the West End.[9]

79. Sidney Herbert, 14th Earl of Pembroke
1895
Bassano, London (NPG x 1667)

Rothes (1877–1927) was a soldier and landowner. Since he was only 17 when this picture was taken, he was probably clean-shaven through necessity rather than choice. There were no such things as teenagers in the sense of an age group with a separate identity expressed through freely chosen fashions. Juvenile clothing was distinctive, with fancy suits, short jackets and Eton collars. It placed the wearer quite beyond the pale in the eyes of slightly older youths entitled to adult dress. H. G. Wells's hero Kipps, a draper's apprentice in the 1890s, suffered from his juvenile clothing when it came to outings:

> Sometimes the apprentice next above him would condescend to go with him; but when the apprentice next but one above him condescended to go with the apprentice next above him, then Kipps, being habited as yet in ready-made clothes without tails, and unsuitable, therefore, to appear in such company, went alone.[10]

This photograph was probably taken when Rothes left public school and could easily show his first adult suit. Based on a Norfolk-type jacket, it gives an air of maturity while being more appropriate to his age than morning dress and top hat. The author of *Manners for Men* (1897) wrote that

> a boy's first 'country suit' after he leaves school is a great event to him. At Eton and Harrow the style of dress might almost be called a uniform, and the first suit of tweeds marks the emancipation from school life.[11]

80. Norman Evelyn Leslie, 19th Earl of Rothes
1894
Bassano, London (NPG x 7129)

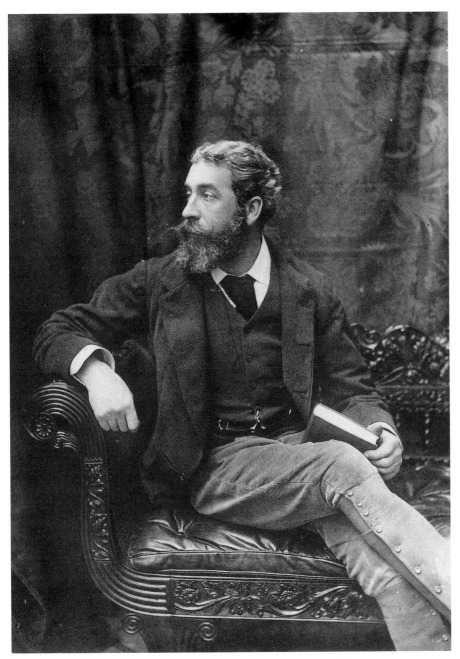

81. Cyril Flower, 1st Baron Battersea
c. **1891–5**
Self-portrait, Hertfordshire (NPG x 15702)

Battersea (1843–1907) won the House of Commons steeplechase in 1889 and became Lord of the Treasury under Gladstone in 1892. He married Constance de Rothschild, and with her money lived splendidly. His pleasures included making fanciful additions to his Norfolk home, amassing a fine modern art collection, sport, and photography. This picture is from an album of photographs taken at one of the Batterseas' homes, Aston Clinton in Hertfordshire, which record not only his photographic skill but also his many distinguished friends.

Battersea was an eccentric dresser and this is shown in his careful choice of corduroy breeches and gaiters for this self-portrait with a book in his hand. His watch chain, made of leather with tiny metal stirrups, suggests he was dressed for riding. However, equestrian paraphernalia was often used as a source of decorative motifs for general wear. E. F. Benson considered him very handsome:

> he had fine features and silky grey hair brushed back from his forehead and a Jovian beard. His wife was plain and stout and infinitely amiable. She had a boundless fund of vague goodwill for the world in general, and for her husband an unbridled admiration. . . . He was coming across the garden one morning from his early bathe, dressed in the bright colours he affected, a green tam-o'-shanter, a blazer and a pink shirt, and as he approached the loggia where we were breakfasting, she could not curb her fervour. 'Does not dearest Cyril look too beautiful this morning?' she cried. 'Dearest Cyril, I was saying how beautiful you looked!' It was too much. . . . 'Oh, Connie,' he called, 'how *can* you be so silly?' . . .[12]

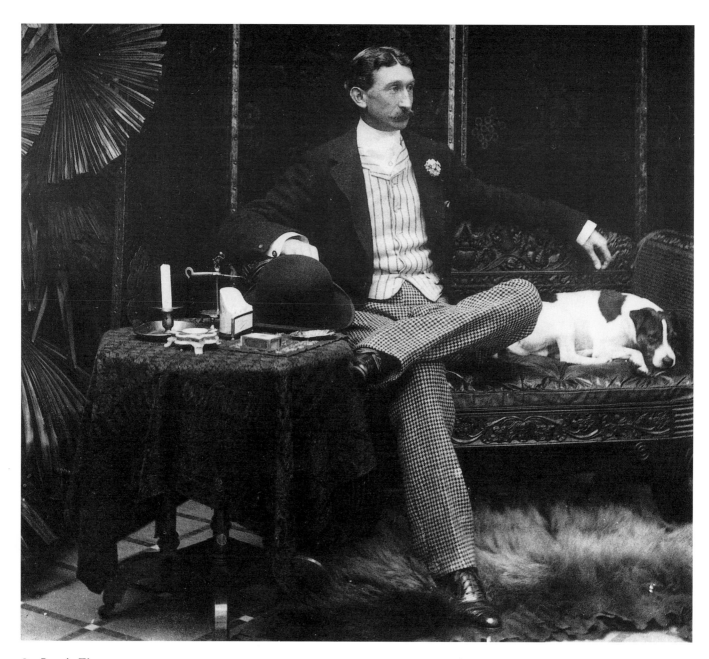

82. Lewis Flower
c. 1891–5
Lord Battersea, (NPG x Ax 15716)

──────── 82 ────────

Lewis Flower was Lord Battersea's younger brother and evidently shared his love of showy clothes. The *Tailor and Cutter* asked, 'What sportsman does not possess a pair of Shepherd's plaid trousers?'[13] Lewis Flower wears his, seen here dressed as a sporting gentleman down to the last detail, a Jack Russell terrier.

Dandies were very much a feature of the late-Victorian era, when they were known as 'Mashers' or 'Piccadilly Johnnies'.[14] A gentleman with an interest in clothes could amass a vast wardrobe. Lemuel Bangs, the London agent for the American publishers Scribners, was found on his death in 1889 to own 188 ties, 26 lined fancy waistcoats and 14 overcoats.[15]

Black-and-white photography has inevitably left the impression that clothes were more restrained than they actually were. The colours used for an ensemble such as Lewis Flower's would have been very carefully selected to create a striking effect. In the Sherlock Holmes story 'The Noble Bachelor' Lord Robert St Simon dressed carefully 'to the verge of foppishness, with high collar, black frock-coat, white waistcoat, yellow gloves, patent-leather shoes, and light-coloured gaiters.'[16]

─── **83** ───

Robert Louis Stevenson (1850–94) rose to fame when his first full-length novel, *Treasure Island*, appeared in 1883. This and later works, including *Kidnapped* and *The Strange Case of Doctor Jekyll and Mr Hyde*, seem as popular today as they were when first published. Stevenson suffered from a respiratory complaint and spent much of his life travelling in search of a healthy climate. In 1888 he took his family to the South Seas. They settled in Samoa, where he was known as *Tusitala* – 'the story teller'. He died there of a brain haemorrhage in 1894.

Spurs show that Stevenson is in riding dress, as is the man in heavy leather gaiters behind him. The one on the left is wearing a very early example of what came to be known as co-respondent shoes – these rather racy brown-and-white lace-ups being associated with the type of person who might be an accessory to a divorce case. The cummerbunds are interesting; these enjoyed a brief fashion in Europe, both for day and evening wear in the early 1890s.

The left-hand man also seems to be wearing a knitted cardigan, which could have been imported from Europe. Machine-knitted cardigans were produced by the thousand in hosiery towns like Leicester. British clothing exports were worth several million pounds a year.

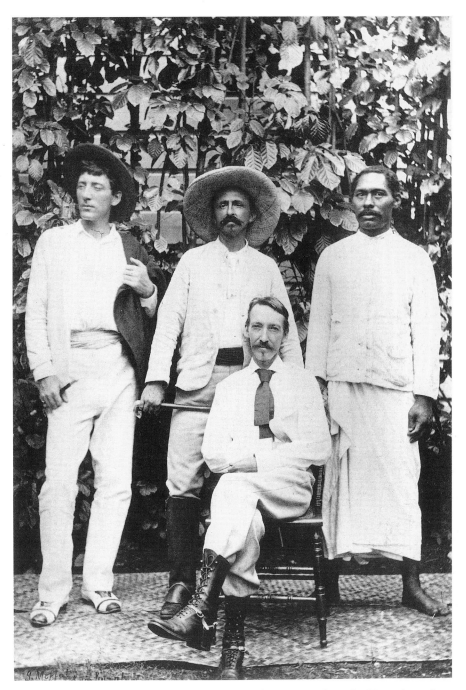

83. Robert Louis Stevenson (seated), Lloyd Osbourne, Captain Wurmbrand and Henry Simele
1891–4
Probably copied by J. Moffat of Edinburgh from an original by J. Davis of Samoa (NPG x 4628)

84

Blunt (1840–1922) was a colourful character. An early career in the diplomatic service having given him a taste for travel, he visited India, Arabia, Persia, Syria, and Mesopotamia. He supported both the Egyptian and Irish nationalist movements and was elected to parliament as a home-ruler. His activities led to his imprisonment. At his home, Crabbet Park in Sussex, he formed the Crabbet Club, with members from literary and political circles. He also devoted a great deal of time to breeding Arab horses on his 2000-acre estate. Every summer he would take off, nomad-style, with his retinue and horses and camp out at his friends' country houses.

Blunt is seen here on one of his Arab steeds. His costume seems to be ordinary summer dress, with the newly fashionable straw boater and co-respondent-type shoes like those worn by Robert Louis Stevenson's colleague (Plate 83). While male hunting costume had been established long ago, and the female riding habit had by this time evolved into its modern form with a safety skirt over breeches, for general riding men could still wear a variety of different types of dress. Describing Rotten Row in her youth, Lady Randolph Churchill remembered

> The men, irreproachably attired in frock coats, pearl-grey trousers, and varnished boots, wore the inevitable tall hat, a great contrast to the *négligé* rough rider appearance of the present day, when all elegance is proscribed in favour of comfort.[17]

Jodhpurs, introduced from India, were becoming popular when she wrote her reminiscences in 1908.

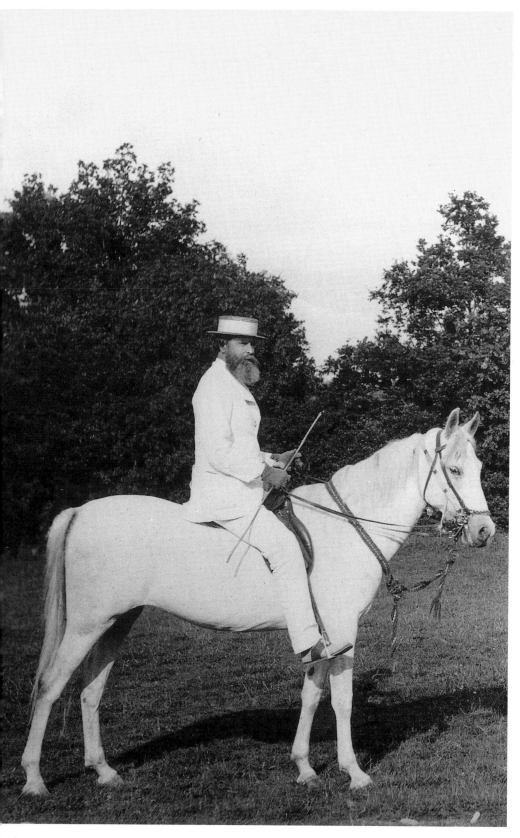

84. Wilfrid Scawen Blunt
c. **1895**
Photographer unknown, Sussex (NPG x 1115)

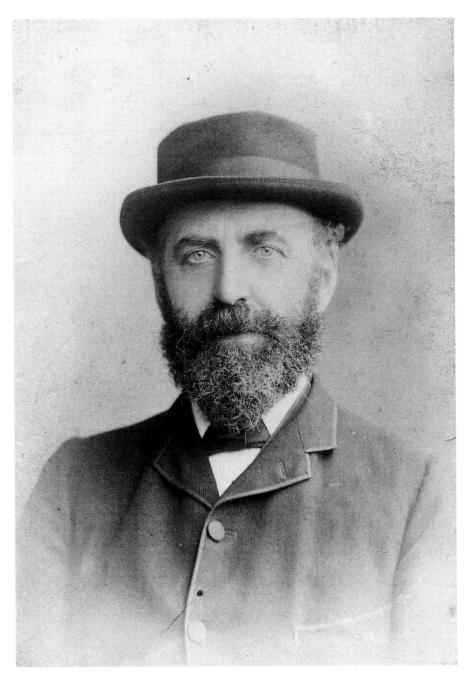

85. William Thomas Stead
1892
Medrington's Grand Studio, Liverpool (NPG x 12923)

When the soft felt hat came into fashion in the 1890s it heralded a new, informal approach to male dress. Top hats, boaters, and bowlers were all relatively heavy with hard, unyielding brims that must have dug into the brow mercilessly after an hour or two. For the first time a man could be respectably covered and comfortable at the same time. The style worn by William Stead (1849–1912) was called an 'alpine'. It differed from the 'trilby', called after Du Maurier's novel of 1894 (in which the heroine of that name wore a soft felt hat) in that the crown had a shallow, circular indentation making it flat on top whereas the trilby had two peaks.

These hats were acceptable for everyday wear, but not for occasions of importance and gravity. June Forsyte's fiancé Phillip Bosinney blotted his copybook when he first called on her elderly aunts in a 'soft gray hat'. The story was rapidly relayed around the family. Each Forsyte male had asked himself:

> 'Come, now, should *I* have paid that visit in that hat?' and each had answered 'NO!' and some, with more imagination than others, had added: 'It would never have come into my head!' . . .
>
> [Bosinney] was an architect, not in itself a sufficient reason for wearing such a hat. None of the Forsytes happened to be architects, but one of them knew two architects who would never have worn such a hat upon a call of ceremony in the London season. Dangerous – ah dangerous![18]

——————— 86 ———————

Wilde (1854–1900) was at the height of his fame when this photograph was taken. *Lady Windermere's Fan* had been performed to great acclaim in 1892 and his masterpiece, *The Importance of Being Earnest*, would appear in 1895. Wilde's friendship with Lord Alfred Douglas (1870–1945) was also at its height and within months of this picture being taken, Wilde was imprisoned for homosexuality.

The best-known portraits of Wilde show him as the grand aesthete in his famous knee breeches. Wilde was always fascinated by his self-image and frequently changed his appearance; the dress-reform knee breeches belonged to a short phase in his development. He usually dressed with the immaculate taste of a rather dandified man-about-town. Beerbohm, whose cartoon of Wilde was used against him in court, gave a word picture in his private 'character book':

> Luxury – gold-tipped matches – hair curled – Assyrian – wax statue – huge rings – fat white hands – not soigné – feather bed – pointed fingers – ample scarf – Louis Quinze cane – vast malmaison – catlike tread – heavy shoulders – enormous dowager – or schoolboy – way of laughing with hands over mouth – stroking chin – looking up sideways – jollity overdone – but real vitality – . . . Effeminate, but vitality of twenty men.[19]

Lord Alfred Douglas in later life objected strongly to accusations that *he* was effeminate. He pointed out in his autobiography that it was hardly his fault that he had been extraordinarily good-looking, and always appeared much younger than his age.[20]

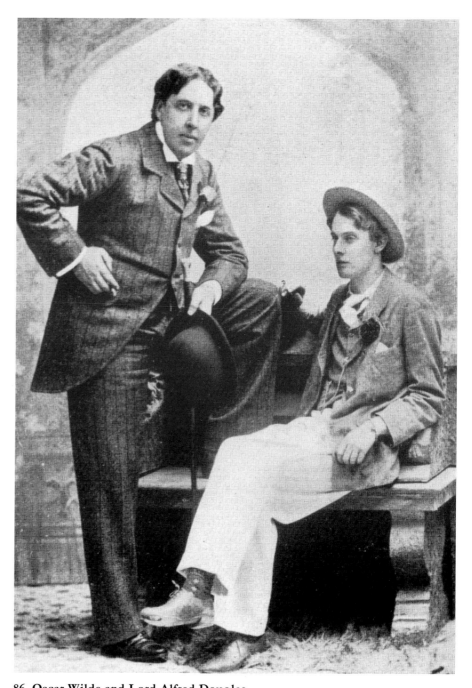

86. Oscar Wilde and Lord Alfred Douglas
1894
Published in Lord Alfred Douglas's Autobiography, *1929*

87

This was taken at the printers' annual 'wayzgoose' at Taplow, Buckinghamshire. The curious white patches on the men's foreheads show the result of wearing a hat all summer. Morris (1834–1896), one of the key figures of his age, was an artist, craftsman, poet, and Socialist. Although Wilde had abandoned his more outlandish attempts at male dress reform by the 1890s he still maintained, in the words of Lord Henry Wotton in *The Picture of Dorian Gray*, that 'the costume of the nineteenth century is detestable. It is so sombre, so depressing'.[21] This view had long been held by Morris and his circle. While his wife Jane's clothing inspired female aesthetic dress, Morris never wore his ideal male attire. Garments described in his vision of socialist Utopia, *News from Nowhere*, combined beauty, utility, and craftsmanship. For instance the Thames boatman's dress

> was not like any modern work-a-day clothes I had seen, but it would have served very well as a costume for a picture of fourteenth-century life: it was of dark blue cloth, simple enough, but of fine web, and without a stain on it. He had a brown leather belt around his waist, and I noticed that its clasp was of damascened steel beautifully wrought.[22]

Morris usually wore stout working clothes, a soft-collared shirt coloured with indigo blue (one of the natural vegetable dyes so important to him) and no necktie. He believed that mainstream dress reinforced the class system, forcing men into clothes that were inappropriate for their occupation and income and difficult to maintain. As on the occasion of this picture, in which he is surrounded by stiff collars and ties, Morris made no concessions to sartorial convention. His dress was an outward symbol of his belief in the dignity of labour.

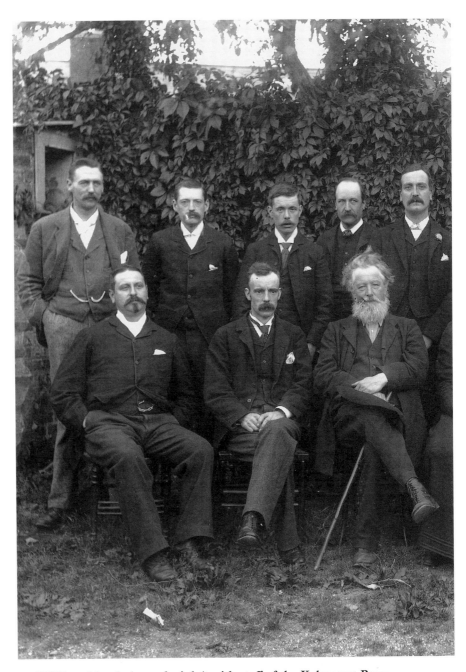

87. William Morris (seated, right) with staff of the Kelmscott Press 1895
Emery Walker, Taplow (NPG x 32758)

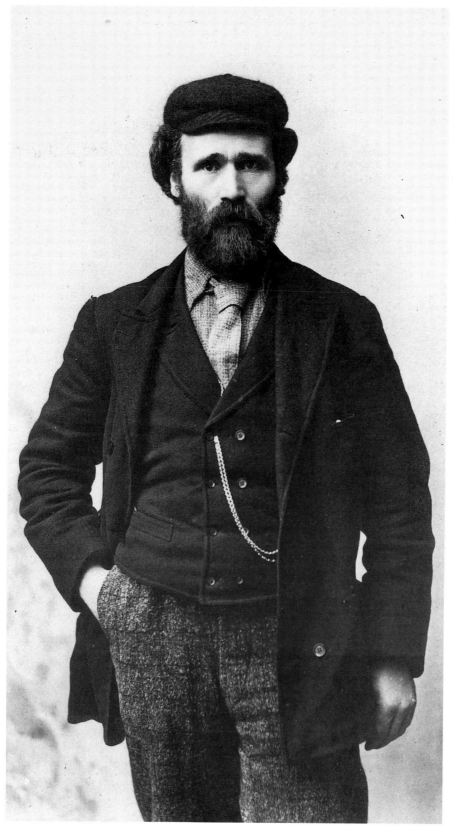

88. James Keir Hardie
c. **1892**
Arthur Weston, London (NPG x 13173)

Keir Hardie (1856–1915) worked in a coal-mine from the age of ten. In 1892 he became one of the first working-class MPs, representing the Scottish Labour Party. He made his entrance into the House heralded by a brass band, wearing a cap and a rough tweed suit.

This picture shows the sort of clothing which so excited his fellow members who, almost to a man, would have worn a silk hat, and frock or morning coat in Parliament. Hardie rejected these garments which, to working people, so strongly evoked the authority of the Establishment. Ever since 1842 when the Chartist leader Feargus O'Connor appeared before a mass demonstration in the artisan's traditional fustian clothing, and was received for this gesture with rapturous applause,[23] working-class activists had realized the importance of clothing as a political statement.

However, Keir Hardie's outfit, while being quite distinct from conventional middle- and upper-class clothing, is by no means typically working-class. His rough shirt and tie owe more than a little to contemporary dress-reform ideas. Many early Socialists were also active in the dress-reform movement, seeking alternatives to mainstream fashion which they rejected as reflecting the society they wished to change. The home-spun look of reform-dress was very useful to men like Keir Hardie: his outfit conveyed the message 'I am your equal, a thinking man' to middle-class audiences, while still incorporating elements of working-class clothing. Hardie would have drawn the line at appearing in corduroy trousers and a muffler, whilst the working man's Sunday best was considered just an inferior imitation of upper-class fashion.

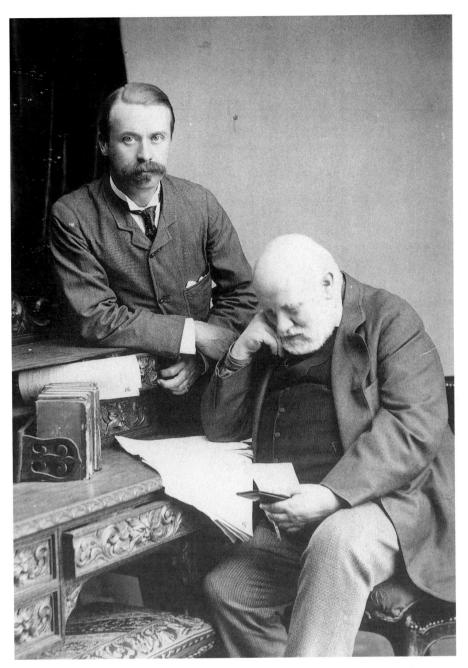

89. Sir George Scharf and Frank Donnely
c. 1894
J. C. Stodart, Margate (NPG x 22543)

Scharf (1820–1895) was the first Director of the National Portrait Gallery and Donnely was his private secretary.

The frock coat and top hat were seen by many Victorians as the ultimate democratic attire, a triumph of capitalism and industry, of civilization over primitivism, and of the intellect over the emotions. As symbols of the establishment they were undoubtedly effective, but as more and more gentlemen came to be occupied in the sort of professions that involved actually sitting down at a desk to work, or even some physical activity – as in the case of Scharf and Donnely, who might well have picked up the occasional picture – more practical clothing began to be widely adopted for everyday working hours. While Scharf wears ordinary informal clothing, Donnely's jacket, as can be seen from its detachable buttons, is of some washable cotton material and it is clearly a type of overall. Such protective garments rarely survive and very little is known about their use or manufacture at this time.

Offices could be grubby places to work in, despite the invention of the fountain pen in 1884. It was common to see clerks with sleeve protectors, black-cotton tubes elasticated at each end and reaching from elbow to wrist. These minimized wear on expensive jackets, and kept cuffs clean and unfrayed. Starched cuffs were quickly worn out. To combat this, separate reversible ones were popular, but not among gentlemen. Starched cuffs did have some benefits however; memoranda could be jotted on them and the illustrator Linley Sambourne used his as a sketch pad.[24]

GROUP

90. King Alfonso XIII of Spain with his mother Queen Maria Christina
c. **1892**

Fernando Debas, Madrid (NPG x 3823)

After Alfonso XII's death, his widow Maria Christina (1858–1929) ruled as 'child-bearing regent' (the first European to do so since the late Middle Ages) until the birth of their son. The little boy (1886–1941) has been 'breeched' – the fact that he wears trousers rather than a dress suggests he was aged about five or six when the picture was taken. Buttoned boots, which had to be fastened with a button-hook, were a torment to generations of children.

The sailor-suited monarch sits uncomfortably alongside his mother, who wears full evening dress. The print was touched up to make her waist look even smaller. This was a common device; in the Edwardian period women were sometimes photographed against shaped boards to exaggerate their figures.

The Queen's fussy neckline might be due to modesty, but judging by the rest of her figure it probably conceals a small bust. Francie Forsyte, who was similarly endowed, wore 'much tulle about the shoulders' of her maize-coloured evening dress at a family ball while her maiden friends each appeared 'by magic arrangement in a differently coloured frock, but all with the same liberal allowance of tulle on the shoulders, and at the bosom – for they were, by some fatality, lean to a girl'. Other Forsyte ladies wore 'shoulder-straps and no tulle – thus showing at once, by a bolder exposure of flesh, that they came from the more fashionable side of the park'.[25]

91. May Morris with her husband Henry Halliday Sparling (left-hand side) and Gustave Steffen with his wife Anna
c. 1892–4
Photographer unknown (NPG x 32598)

——————— **91** ———————

May Morris (1862–1938) met Sparling (1860–1924) when he was Organizing Secretary of the Socialist League. They married in 1890 and separated in 1894. Steffen (1864–1929) was a Swedish economist.

Like so many tourists in great European cities these couples are hampered by coats, umbrellas, and guide books. The two-piece tailor-made costume was one of the great inventions of the last century. Smart and practical, it reflected the 'New Woman's' increasingly busy life. May Morris wears hers with a severe hairstyle, pince-nez, and trilby, demonstrating the sort of 'mannish' air which so terrified

Punch cartoonists and like-minded males. The masculine wardrobe had always been plundered for feminine novelties, but, starting with Mrs Bloomer's unsuccessful calls for dress reform, the growing number of fashions which copied menswear closely coincided with ever more insistent demands for female emancipation.

Closer inspection of May Morris's buckle shows that it was hand-made in the exquisite silverwork so typical of the English Arts and Crafts Movement. Such buckles were also mass-produced in Birmingham, and many ordinary women appreciated their flattery of a trim waist.

They must have been particularly attractive on nurses' uniforms, since they continued to wear them long after they had passed out of general fashion.

The other three people look distinctly 'artistic' – Sparling's hair is rather long for a young man, whilst his hat and Steffen's floppy tie complete the picture. However, Mrs Steffen's smock, a style beloved of artistic ladies, would have really singled them out in a crowd – and reinforced the prejudices of the general population who tended to regard reform-dress as almost as ugly as the people who wore it.

Fancy bazaars were a far more lucrative way of raising money in the nineteenth century than they are today and sometimes huge sums were involved. G. A. Storey (Plate 19) remembered one held at the Free Trade Hall in Manchester which lasted a week and raised £22,000 for the Pendlebury's Children's Hospital.[26] Bazaars were quite a feature of the London Season. Society ladies used to run their own stalls, luring gentlemen to pay exorbitant prices for trifles.

The bazaar and its lengthy preparations played an important part in church and chapel life. In *Anna of the Five Towns* Arnold Bennett described how the heroine was invited to a Sunday school sewing meeting to make things for the Autumn Bazaar.[27] The present author's family still possess several embroidered tablecloths bought at 'sales-of-work' as well as her great-grandmother's 'bazaar apron', kept specially for such functions.

Bazaar aprons can be seen on the two conservatively dressed ladies whose puffed sleeves seem to be their only concession to the 1890s. Their flamboyant companion could easily have been the 'large woman' referred to in Dorothy Quigley's book *What Dress makes of Us* (1898) who, because she 'had a fancy for wearing rich brocades figured with immense floral designs, was familiarly called by her kind friends "the escaped sofa"'.[28] Dorothy Quigley also had a few words to say about the effect of funny little hats and madonna-like bands of hair on the round faces of dumpy women which Mrs Steffen (Plate 91) would have found helpful.

92. (From left to right, standing:) Alice Mary Roe, her husband Charles Edward Roe, Robert William Dolling, with four unknown people
***c.* 1891**
W. A. Attree (NPG x 22088)

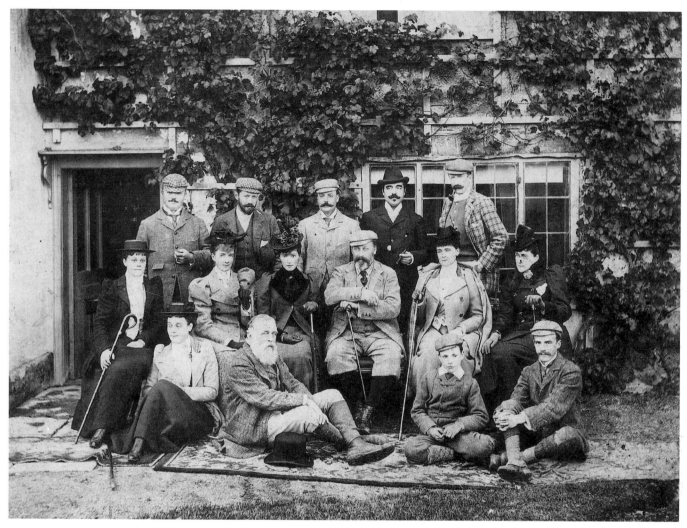

93. Edward, Prince of Wales, and a shooting party
c. 1893–5
Photographer unknown (NPG x 32731)

————— **93** —————

(Standing, second from the left:) the Honourable Seymour Fortescue and (second from the right:) the Marquis de Soveral. (Seated to Edward's left:) Daisy Brooke, Countess of Warwick

This picture was taken shortly after the notorious Tranby Croft affair. Edward's (1841–1910) fellow-guest was caught cheating at baccarat, the Prince's favourite game. He denied this but signed a pledge never to play again, witnessed by Edward and other guests. Although the witnesses were sworn to secrecy a scandal broke and the accused sued them for defamation of character. The case was lost but the Prince spent days in the witness box.

Game-rearing was a major occupation on most estates. Sandringham's game book for 1896–7 recorded the demise of 18,376 birds and 7021 hares and rabbits.[29] The domestic arrangements for shooting parties were organized on a similar scale, particularly if Edward was invited. When he came to Blenheim the Duchess of Marlborough remembered

This visit was a tiring and anxious experience for me, since I was responsible for every detail connected with the running of the house and ordering the pleasures of my numerous guests. The number of changes of costume was in itself a waste of precious time. To begin with, even breakfast, which was served at 9.30 in the dining-room, demanded an elegant costume of velvet or silk. Having seen the men off to their sport, the ladies spent the morning round the fire reading the papers and gossiping. We next changed into tweeds to join the guns for luncheon, which was served in the High Lodge or in a tent. Afterwards we usually accompanied the guns and watched a drive or two before returning home. An elaborate tea gown was donned for tea, after which we played cards or listened to a Viennese band or to the organ until time to dress for dinner, when again we adorned ourselves in satin, or brocade, with a great display of jewels. All these changes necessitated a tremendous outlay, since one was not supposed to wear the same gown twice. That meant sixteen dresses for four days.[30]

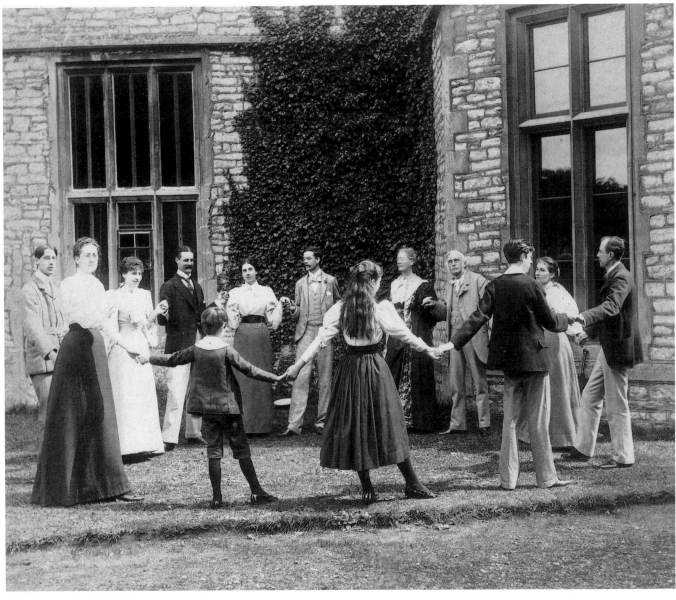

94. The Strachey family
1893
Graystone Bird, Somerset (NPG x 13120)

─────── 94 ───────

(Clockwise from the far left:) *Oliver,*
Dorothy, Richard, Pippa, Ralph, Lady Strachey
(1840–1928), Sir Richard Strachey (1817–
1908), Elinor, unknown man, Lytton (1880–
1932), Marjorie, James, and Pernel.

This picture gives unusual back- and
side-views of costumes, showing
the gathering that was customary even on
the backs of gored skirts, and the way the
boys' jackets were made without vents.
The clothes of the small boy, the older
one to his right and the one on the far left
demonstrate the progression from juve-
nile dress to the Norfolk jacket, which
would have been considered suitable as a
first adult attire. These were much worn
by young men; the *Tailor and Cutter's*
reporter in Nottingham noted:

> I came across here, as everywhere else,
> many young fellows who favour the
> tweed and Cheviot Norfolk jacket and
> knickers, and some of the wearers find
> these garments so comfortable that I am
> sorry to add, they do not know when to
> leave them off: they do not seem to know
> when they are worn out or look shabby.

They appear ignorant of the fact that
rough brown materials will look shabby
with a large amount of wear. They will
not look nice and new always, and they
are naturally of un-trim and un-dressy
appearance, which is much intensified by
long service, more especially when
perhaps pressed in for bicycle use and
golf wear in all sorts of weathers.[31]

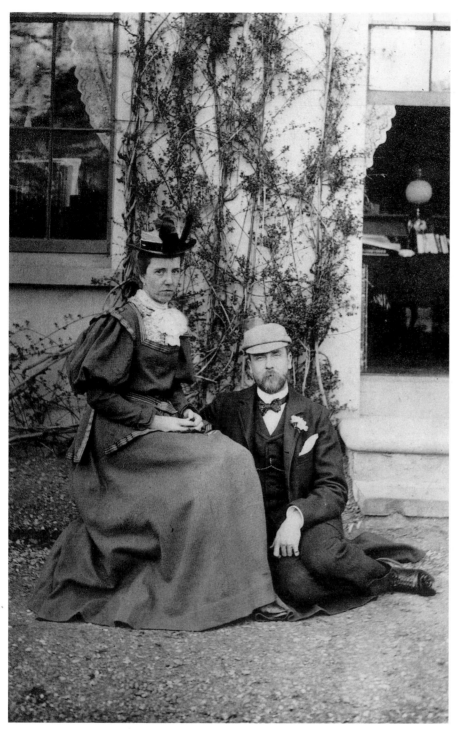

95. Montague Sharpe and his wife Mary Annie
c. **1895**
Photographer unknown, Ealing (NPG x 28794)

Sharpe (1856–1942) became Chairman of Middlesex Quarter Sessions, Middlesex County Council, the RSPB, and Hanwell Conservative Association. On retirement from the last-mentioned position in 1922 he received a knighthood. His other interests included archaeology, shooting, boating and photography.

The fashionable line of the mid-1890s owed more than a little to aesthetic dress, the most striking similarity being the full sleeves which reached their maximum size in 1895 and 1896. The wide aesthetic sleeve had been inspired by costumes in early-sixteenth-century Italian paintings. Mrs Sharpe's contrasting *chemisette* panel in the neck, edged with striped ribbon, may also have been taken from this source. Contemporary commentators were more likely, however, to point to the leg-of-mutton sleeves of the 1830s, which were themselves derived from historical dress, as the principal influence on modern fashion.

Peaked caps first appeared as a naval style and were briefly fashionable in the early years of the century, but by 1830 it was observed that caps were worn mainly 'by boys and the lower orders generally'. The sight of 'low apprentice lads' in them made it 'almost degrading to wear a cap in public, however comfortable and convenient at times'.[32] Boys and railway men remained their chief patrons until the 80s, when tweed caps began to be worn with Norfolk jackets, knickerbockers, and similar garments. Initially close-fitting, these caps became fuller from the 1890s. Whilst for activities like golf, caps were incorporated into the fashionable wardrobe, they were much too popular with the 'lower orders' to ever become part of mainstream fashion. By the Edwardian period the cap's essential place in working-class dress was well established.

96. George, 2nd Duke of Cambridge, fellow officers and ladies
c. 1895
Photographer unknown (NPG collection)

——————— 96 ———————

The Duke of Cambridge (1819–1904), Queen Victoria's cousin, was Commander-in-Chief of the British Army from 1856 to 1895 when the post was abolished. This picture dates from shortly before his retirement, to judge by the size of the ladies' sleeves. Sadly, although surrounded by other people's wives, his own never appeared with him in public. In 1842 he secretly married Louisa Fairbrother, a pantomime actress. Whilst maintaining Gloucester House as his official residence he would slip away to his family nearby. Louisa's death in 1890 ended this extremely happy, if unconventional, marriage.

The ladies already wear the contrasting dark and pastel shades which were such a feature of *fin-de-siècle* and Edwardian fashion. Stronger colours had been permissible in the summer for some time, but were not recommended for those past the first flush of youth. These handsome women were probably about 50. Nevertheless, many middle-aged women would have hesitated to appear in such finery, for fear of being described as 'mutton dressed as lamb'. There was strong pressure on women to dress according to their age and position, be it widow, wife or spinster; old women were meant to *look* old. Dorothy Quigley devoted a chapter of *What Dress Makes of Us* to 'Hints on dress for elderly women'. In this she quoted the saying 'As a woman grows old the dress material should increase in richness and decrease in brightness'.[33] Headgear for the older woman was also subject to criticism: 'Elderly women should not wear bright flowers on their bonnets or hats. Fresh-looking roses above a face that has lost its first youthfulness only make the fact more obvious'.[34]

Like Mrs Louisa FitzGeorge, the Duke of Cambridge's wife (*see* Plate 96), Isabel (*c.* 1867–1906) had trodden the boards, as 'Belle Bilton'. However, her marriage to the then Lord Dunlo (1868–1929) had been subject not to secrecy, but to a blaze of publicity as the old Earl forced his son into an unsuccessful divorce suit. By the time this photograph was taken the couple had settled at Garbally Park, County Galway, on £12,000 a year. Belle was busy producing five children, whilst Fred bred horses, hunted, and went steeplechasing.[35]

The couple are immaculately turned out in morning dress. A gentleman's accessories were crucial; it was said that 'a well-appointed hat, faultlessly-fitting gloves, and well-made boots are three essentials to a well-dressed man, without which the otherwise best-constituted dress will appear unfinished.'[36]

The soft prettiness of Belle's coat probably suited her sweet-tempered nature. The fashion for extremely feminine frills and bows could have started in reaction to the severe lines of tailor made suits and masculine looking ties, shirts, and hats, as well as to the rich, heavy clothing of the last decade. It was a 'look' that would be further developed in the Edwardian era. Hat nets, also worn by the ladies with the Prince of Wales and the Duke of Cambridge in the previous pictures, not only protected the complexion but charmingly softened the features. They were in keeping with the new feminine look and their popularity grew, despite warnings that spotted nets could dazzle the eyes and that if they were too tight they could break the eyelashes.[37]

97. William Frederick Le Poer Trench, 5th Earl of Clancarty and his wife Isabel
1893–4
Bassano, London (NPG x 6269)

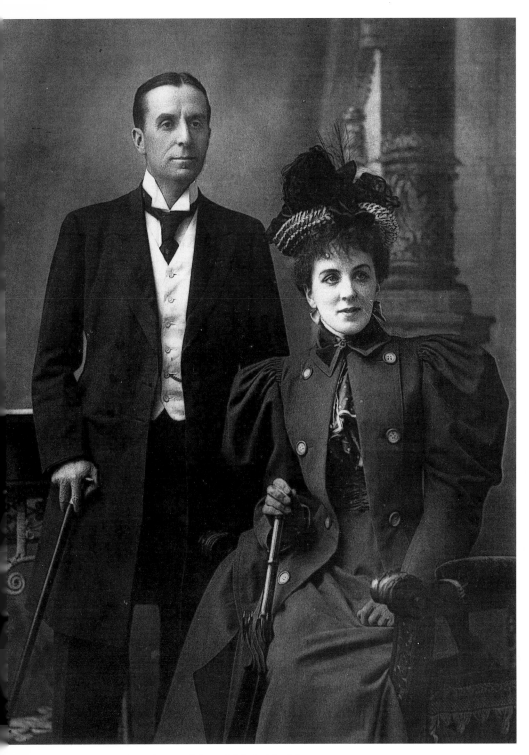

**98. Weedon Grossmith and his bride May
1895**
Alfred Ellis, London (for The Theatre*) (NPG x 16925)*

— 98 —

Weedon Grossmith (1852–1919), actor-manager of the Vaudeville theatre, went on stage after training as an artist. A talented author, together with his brother George he chronicled the suburban life of Charles Pooter in *Diary of a Nobody*. This modern classic was published in 1892.

Pooter's adventures often concerned his appearance. He never seemed able to find the right clothes (unlike Mr and Mrs Grossmith, who were evidently people of fashion). A pair of trousers cut loose over the boot and tight at the knee 'looked like a sailor's, and I heard Pitt, that objectionable youth at the office, call out "Hornpipe" as I passed his desk.'[38] On another occasion, he came to grief with a cloth pattern:

> I ordered a new suit of dittos for the garden at Edwards' and chose the pattern by gaslight, and they seemed to be a quiet pepper-and-salt mixture with white stripes down. They came home this morning, and, to my horror, I found it was quite a flash-looking suit. There was a lot of green with bright yellow-coloured stripes.[39]

Pooter's son Willie, who called himself Lupin, would have been equally horrified, as he was when Pooter wore a straw helmet with a frock coat at the seaside. Pooter in turn was mystified not only by Lupin's 'fast-coloured clothes and ties' but also by all the minor details such as manicuring, smock frocks, hats 'as big as a kitchen coal-scuttle, and the same shape', and parasols 'about five feet long' that his wife Carrie assured him were all the rage.[40]

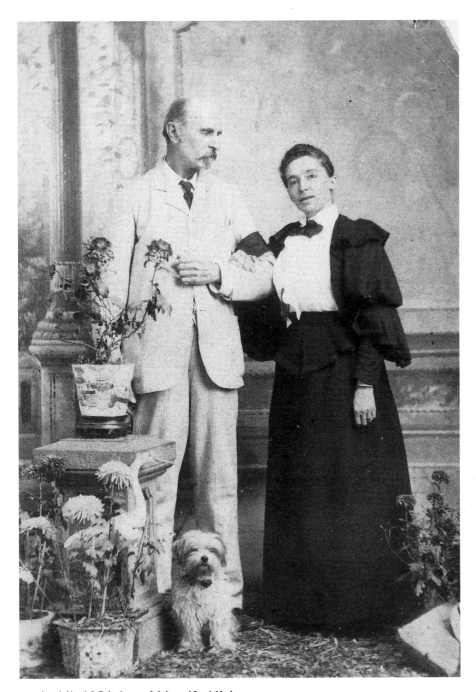

99. Archibald Little and his wife Alicia
1894
Tze-Yung-Ming & Co., Shanghai (NPG x 20060)

99

Little (1838–1908) went to China in 1859, where he set up a trading company, a mining company, and a railway. His interest in the country was not solely economic; in 1898 he made the first ascent of the Yang Tse rapids by steamer, and he wrote many books and articles about China.

The opening of China and Japan to Western trade not only created new markets for British goods, but also produced a stream of oriental imports to delight the British public. Liberty's and similar shops found a ready market for silks, embroideries, porcelain, and lacquerwork. Such novelties helped to stimulate an awareness of oriental art, a crucial influence on the aesthetic movement, which had filtered into mainstream fashion and decorative art by the late 80s. Oriental products also challenged British industry on its own ground. European-style clothes such as embroidered and padded-silk dressing gowns were made for the West, and the British silk and straw hat industries were both affected by competition from cheap imports.

Mr Little wears a light suit typical of European dress in China, with a black mourning tie and armband. Men generally wore black for funerals but afterwards, unlike women who donned special clothes for months or years, they only needed to wear a black arm- and hatband for a comparatively short time. Mrs Little's white blouse suggests that the couple were in half-mourning, which was worn either at the end of the mourning period, or for a friend or distant relative.

FEMALE

———— 100 ————

Lady Clare (1893–?) was the daughter of the 5th Earl of Annesley. Many girls in service sent home photographs like this, as well as money and cast-off clothing.[41]

This nurse wears the respectable servant's bonnet. Lady Diana Cooper, the Marchioness of Granby's daughter, remembered her nanny 'always wore black, winter and summer – a bodice and skirt made of "stuff". . . she wore for the Park a minute black bonnet that just covered the top of her dear head, moored down with strong black velvet ribbons tied beneath her chin.[42] Black dresses were given to parlourmaids by the 80s, but many servants wore ordinary clothing. *The Nursery Maid*, published around 1880, made no mention of uniforms but recommended colourfast, washable dresses:

> If you are expected to clean your own nursery and sleeping rooms, you must have a blue apron, besides three of print, and two or three white aprons to put on when you take the children into the dining or drawing room. Most mothers provide a flannel apron for the nurse to put on when she washes the infant. I have not mentioned stockings; black worsted are the most economical, buy two pair of these and two of white for Sundays, or when you may be sent with the children to visit their friends. Have a pair of strong walking shoes or boots, as you will go out daily with the children, and a pair for the house, in which you may move without noise. I also advise you to have a pair of warm carpet or list slippers as you will rise in the night to attend to the children.[43]

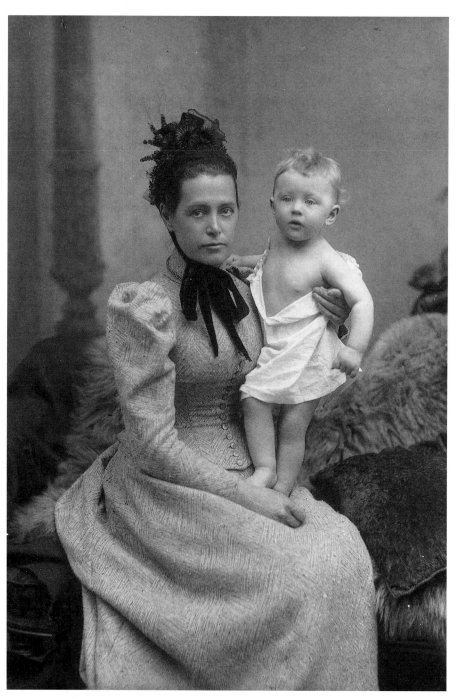

100. Lady Clare Annesley with her nurse
1894
Bassano, London (NPG x 8328)

————— 101 —————

Lady Edgcumbe was the second wife of Sir Edward Edgcumbe. Here, she wears a broad-brimmed hat in the popular 'Gainsborough' style, tilted on one side, which shows off her fine head of hair. A woman's hair was her crowning glory. Length and thickness were much admired. Advertisements for lotions and preparations often showed ladies brushing rippling locks which reached to their knees or ankles. Many women, like Paul Morel's little hunchbacked workmate in D. H. Lawrence's *Sons and Lovers*,[44] could be cajoled into letting down their glorious tresses.

Some people preferred short hair, for instance the young Ellen Terry and E. Nesbit. Others were compelled to have it cut. The governess who was employed on condition that she cut her hair in 'The Copper Beeches', one of the *Adventures of Sherlock Holmes*, found a plait similar to her own in a drawer. This led to the discovery that she was unintentionally impersonating an imprisoned girl whose hair had been cut during an illness. Long hair was generally cut at such times, not because it was thought to effect a cure, but because it often became irretrievably matted. In 1884 Ethel Smyth became seriously ill with rheumatic fever. Her beautiful long hair was only saved afterwards because a friend's mother spent three days untangling it. A few months later she was seeking lodgings in Rome. Success eluded her until, at a house owned by a hairdresser, she let down her hair and was given a room.[45]

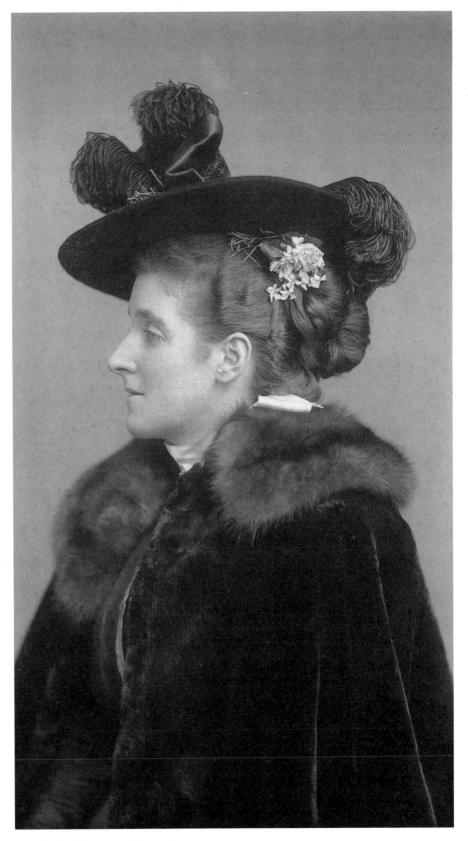

101. Lady Frances Edgcumbe
1895
Bassano, London (NPG x 28228)

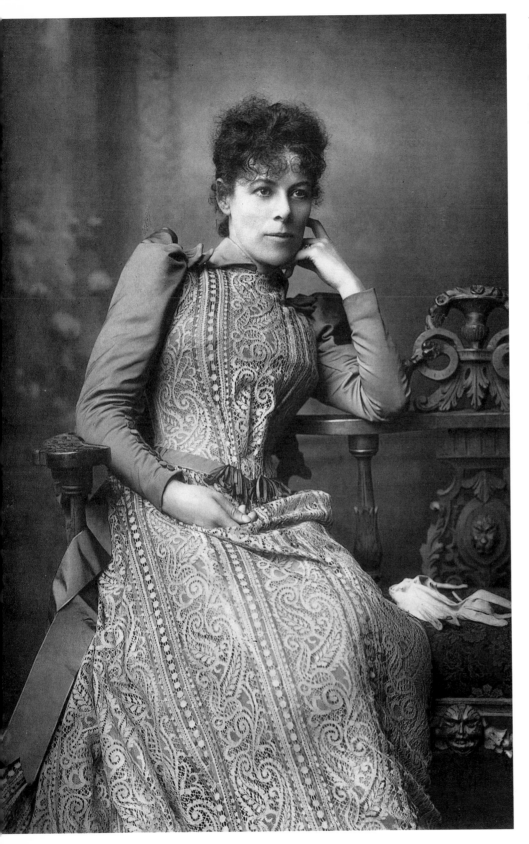

This Shakespearian actress (1854–1914) was also renowned for parts such as Mrs Egerton Bompas in Pinero's *The Times* and Fuschia Leach in the stage adaptation of Ouida's society novel *Moths*. In 1892 she was President of the Theatrical Ladies' Guild.

Her hair looks naturally curly, an attribute much admired in the days before permanent waving was available, when any haircurling efforts with hot tongs, rags, or glues like gum arabic were liable to be instantly spoilt by a shower of rain.

The lily has been gilded, however, since she is clearly wearing cosmetics. Actresses and ladies of dubious reputation were not the only ones to paint their faces; Princess Alexandra herself was well known for her make-up. Although this practice would have been unthinkable among the respectable middle classes, many of the sitters in these photographs, like Lady Dolly in *Moths*, endured the daily 'bore of being "done up", and the bore of being "undone"':

It is a martyrdom, but they bear it heroically, knowing that without it they would be nowhere; would be yellow, pallid, wrinkled, even perhaps would be flirtationless, unenvied, unregarded, worse than dead![46]

The top of Fanny Brough's corset is just discernible through her machine-lace dress, forming a hard ridge across the bustline. Although large sleeves flattered the waist by making it appear smaller, tight lacing remained as widespread as ever.

102. Fanny Brough
1893 (published)
Barraud, London (for Men and Women of the Day*) (NPG x 27637)*

103. Augusta, Empress of Germany
1895
J. C. Schaarwächter, Berlin (NPG x 3811)

104. Rachel, Countess of Dudley
1894
Bassano, London (NPG x 7121)

105. Baroness Rodney
1894
Bassano, London (NPG x 8331)

───────── **103, 104, 105** ─────────

Augusta (1858–1921), William II's wife, could be as prickly as her husband. After a family wedding in Athens the Prince of Wales reported that she had been 'most amiable and not at all on her high horse'.[47]

The 1st Earl of Dudley, who had so disliked dark clothing (*see* Plate 31), died in 1885 and the 2nd Earl inherited 30,000 acres, including estates in Jamaica and the patronage of 13 livings. The year after his wife (?–1920) sat for Bassano he became Parliamentary Secretary to the Board of Trade.

All these women here wear afternoon dresses. The Empress's was probably worn for an official function in the daytime, while the Countess's outfit would be suitable for shopping, paying formal calls or attending luncheon parties. Hats were not removed when visiting.

The Empress's striped velvet shows clearly the gored cut which gave skirts of this period their smooth-fitting line. The gores curved in over the hips and flat or cartridge pleats gave fullness at the back. The skirt usually had a deep interlining round the hem, a stiff muslin lining and often a woollen braid to protect the edge from wear. The sleeves, which were sometimes bias-cut to achieve the required fullness, were also lined and stiffened. Occasionally paper was used for this. Even an apparently loose bodice would be set on a foundation with as many as 20 whalebones, and the high neckbands were often boned as well. Whereas dresses in the previous decade were generally front-fastening with buttons, it was now more usual for them to fasten at the back with a row of little hooks with the result that someone else's help was indispensable whilst dressing. The separate bodice and skirt were also held together at the back by hooks.

107, 108

Both Lytton Strachey's sister Pippa (1872–1968), and Ethel Smyth (1858–1944) campaigned for women's rights. Ethel Smyth was a talented composer with sufficient strength of character to insist on studying at the Leipzig Conservatorium while still in her teens. She produced grand oratorios, concertos and masses. Her English début came in 1893 when the Royal Choral Society sang her *Mass in D* at the Royal Albert Hall. Artistic genius did not prevent her from being a hearty outdoor type, playing in a ladies' cricket team, riding to hounds, and setting off on unaccompanied adventures in the Italian Alps. She described how, walking to her lodgings from the station in Florence after one escapade,

> to my horror I met Lady Ribblesdale . . . who looked rather startled, as well she might. My straw hat might have been borrowed of a scarecrow, my boots had not been blacked for a fortnight, and my blouse had only once been washed – and that by me in a mountain stream. I hastily shifted the cape on to my left arm and never knew if she caught sight of the revolver with its knotted strap (the buckle had been torn off long since), but I do know that she remarked to the Duchess of Sermonetta that Mrs. Smyth would be much distressed if she were to learn that her daughter was rambling about alone in such an extraordinary get up; wherein she did my mother injustice.[49]

Marco, a Saint Bernard-cross rescued from a life pulling carts in Vienna, was a faithful companion. He 'protected' her during rehearsals, terrified Tchaikowsky, and once chased the Duke of Connaught out of her garden.[50]

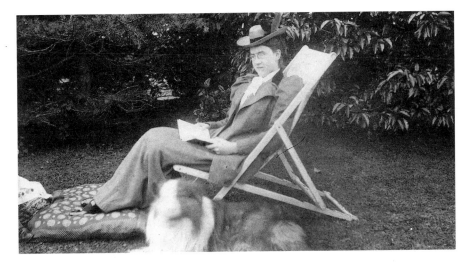

107. Pippa Strachey
1891
Photographer unknown (NPG x 13127)

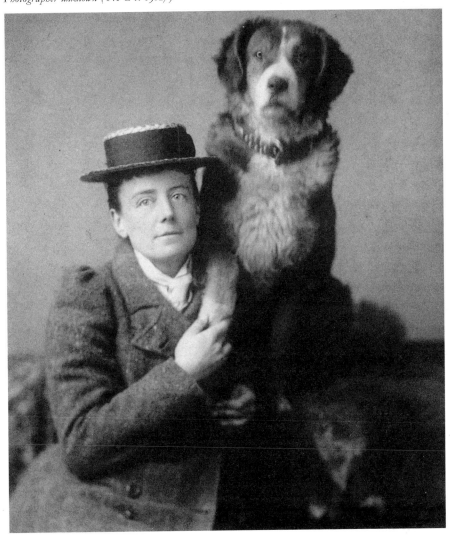

108. Ethel Smyth and Marco
1894
Photographer unknown (NPG x 13395)

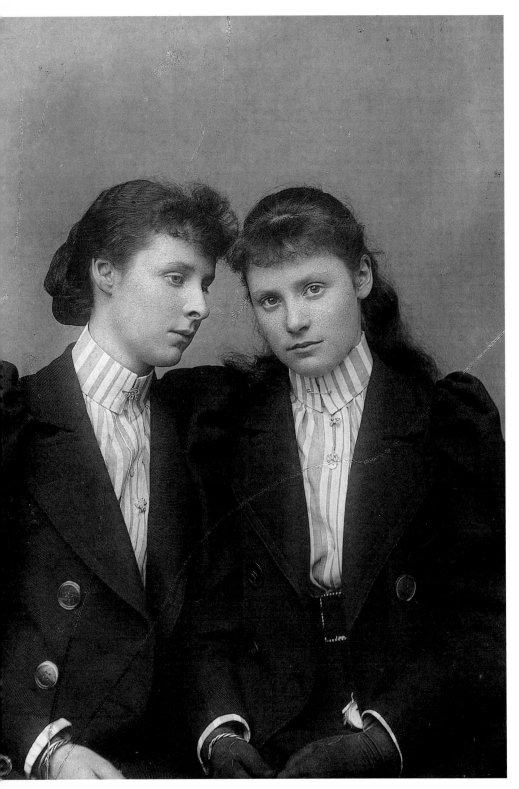

109. Lady Susan Beresford and her sister Lady Clodagh Anson
1893–4
Bassano, London (NPG x 7107)

S usan (*right*, 1877–1947) and Clodagh were daughters of the Marquess of Waterford. At 16, Lady Susan still wears her hair loose. It would be 'put up' when she 'came out' in Society at 17 or 18.

As children, sisters were frequently dressed identically. The photograph of Edward and Alexandra with their children (Plate 21) shows all three princesses in matching outfits. Some continued the practice in adulthood. Matching twosomes were sufficiently common for their presence in James Tissot's paintings to be unremarkable and so the artist could economize on models. At the top end of the social scale, Princess Alexandra and her sister the Czarina used to meet identically dressed after travelling halfway across the globe. This was thanks to Worth, who kept records of their measurements and despatched twin outfits to London and St Petersburg beforehand.[51]

Jeanette Marshall and her younger sister Ada always dressed alike. In 1881 the *Pictorial World* published a drawing of them entitled 'Fair Aesthetes', in matching outfits made from cotton crêpe bought at the 1880 John Lewis sale.[52] They kept up the habit until well into their 30s, when Ada rebelled and sometimes chose different hats.

In the Marshalls' case the choice of dress was largely the elder sister's. Whether this was true of all women who dressed alike would be impossible to say. Given the importance of clothing as a vehicle for self-expression in Western cultures, it is remarkable that so many women suppressed their individuality by dressing identically, particularly since a proportion denied themselves, or were denied, any choice at all.

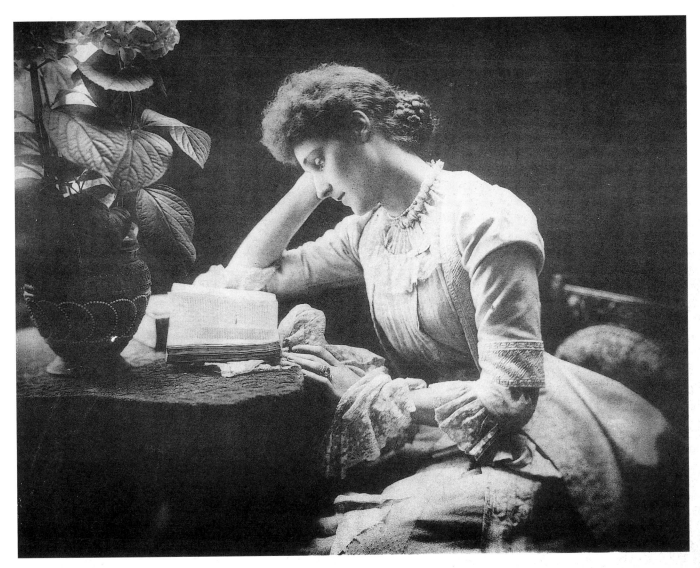

**110. Violet Manners, Marchioness of Granby
1892**

H. S. Mendelssohn, London (NPG x 22147)

——————— **110** ———————

Violet Manners (1856–1937), later Duchess of Rutland, was an artist. She worked daily in her studio and exhibited at the Grosvenor Gallery and the Royal Academy. She produced exquisite portrait drawings, notably of her fellow 'Souls', a close circle of friends that included Lord Curzon, Arthur Balfour, Harry Cust, and Margot Asquith among others. She was also a sculptress; Rodin thought highly of her work.

She was considered one of the most beautiful women of her time, with thick auburn hair, a creamy complexion and a 'clear-cut, cameo-like face'.[53] Her beauty was enhanced by a willow-like slenderness and strict, aesthetic tastes, described by Jane Abdy and Charlotte Gere in their book on the 'Souls':

In colour she liked only the faded and subdued. Even too-vivid curtains were placed on the lawn in summer to fade. For her clothes she chose non-colours: creams, fawns, soft blue-greys and blue-greens, the hues of Chinese ceramics. She adapted the contents of the family jewel-chest in a charming and haphazard manner: the great badge of the Order of the Garter (not at the time borne by a member of the family) became a necklace; she wore her tiara back to front, enclosing her Grecian chignon. Diamond insects and stars seemed to hover around her diaphanous dresses. Everything floated and trailed: veils, streamers of lace around the head, scarves round the neck, ribbons, long trains unsupported by illogical bustles which concealed the natural grace of the figure.[54]

The 61-year-old 5th Earl of Annesley married his second wife (1870–1941) in 1892. Lady Clare was the eldest of their four children.

From around 1877 a new type of garment, called a teagown, began to be mentioned in fashion magazines, in which one could relax or entertain friends informally at home. These were elegant, loose robes, enabling the wearer to look smart without having to wear a tight cocoon of clothing. At first, their use was restricted to married ladies but single girls later took to them. Some were made by top *couturiers* from luxurious materials and could cost just as much as ordinary dresses. Teagowns became extremely popular. Beatrice Sutton was a 'gay and flitting butterfly in a pale green teagown' when she played hostess to the Sunday school sewing meeting in *Anna of the Five Towns*.[55] Ladies often wore them for quiet dinners at home when they did not wish to dress elaborately.[56] Countess Annesley even chose to be photographed in hers; it was the type of garment in which a mother might visit her nursery.

The loose evening dress worn by Lady Ridgeway (?–1907) echoes the feel of the teagown. 'The Healthy and Artistic Dress Union', founded in 1890 for the 'propagation of sound ideas on the subject of dress'[57] published in its journal *Aglaia* details of health-promoting adaptations of conventional fashions. In 1893 an 'empire' evening dress was illustrated[58] which bore a striking similarity to Lady Ridgeway's toilette. However, the wrinkles around her waist, visible beneath the net overdress, show that she was corseted and therefore clearly not an adherent of the dress-reform movement.

111. Priscilla Cecilia, Countess Annesley, with her daughter Lady Clare Annesley
1894
Bassano, London (NPG x 3823)

112. Lady Caroline Ridgeway
1893–4
Bassano, London (NPG x 8305)

—————— 113 ——————

Baroness Mowbray (1870–1961) was presented at court to mark her marriage into one of the oldest families in England. Being photographed in one's court dress was considered an essential finale to a memorable day.

Preparations started early. Laura Troubridge once had to rush out with her sister because the wrong shoes had been delivered:

> We got some shoes at last in the Burlington Arcade, dashed home and set to work directly at the dressing process. A. became hopeless over her hair, which she longed to do in little curls at the top, but everything would go wrong and it was getting late. Coiley (the grand dressmaker) was there and tried on her gown, which was much too big at the waist, so it had to be torn to pieces and made up again in a wild hurry. Those precious curls came right at last, Stanbrook attacked one side, Maria the other, while Amy gnawed sandwiches in the middle. Coiley and a 'young person' were clawing her gown, which was lying in a distended heap on the bed, and I surveyed the prospect from a neighbouring armchair.[59]

Lillie Langtry's mother refused to let her eat beforehand in case she got a red nose. Her ivory brocade gown was garlanded with Maréchal Niel roses:

> Enormous posies of flowers were then in fashion, so, steadying myself with an immense bouquet of real Maréchal Niel roses, thoughtfully sent to me by the Prince of Wales, I curtseyed and kissed the hand of Her Majesty without committing any of the indiscretions against which my mother had warned me.[60]

113. Mary, Baroness Mowbray, Segrave and Stourton
1894
Bassano, London (NPG x 8342)

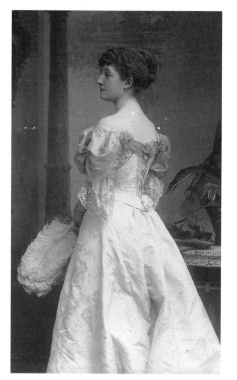

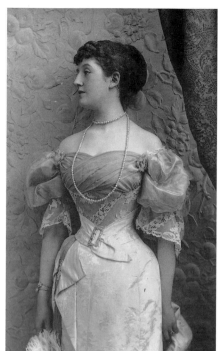

114. Mrs R. F. Brain, Lady Mayoress of Chatham
1895
Bassano, London (NPG x 28225)

115 & 116. Priscilla, Countess Annesley
1894
Bassano, London (NPG x 28225)

114, 115, 116

Mrs Brain's costume looks as if it might almost be fancy dress. This was so popular, at all levels of society, that numerous books of designs were published. The ball that outshone all others in a long succession of aristocratic extravaganzas was held by the Duke and Duchess of Devonshire in 1897. Several of the participants had their costumes immortalized in the studios of Bassano and other leading photographers, such as Alice Hughes, Lafayette, and Downey & Thomson.

Historical costume also provided inspiration for ordinary day and evening wear. The Lady Mayoress's outfit owes more than a little to costume in portraits painted by early-sixteenth-century Italian artists like Bronzino and Lorenzo Lotto. This might seem rather obscure for the average woman in the street, but a deep interest in history permeated Victorian society. Popular magazines issued reproductions of famous paintings and books on art were bestsellers. Municipal art galleries were established in every large

town, opening late into the evening to accommodate the queues of eager visitors that formed around them.

Countess Annesley (1870–1914) could admire ancestral portraits in the homes of her family and friends. Her dress is based on the type worn in the paintings by Van Dyck and Lely that hung in many great houses. The large sleeves and bodice drapery of mid-seventeenth-century costume coincided beautifully with contemporary fashion. The two periods also shared a penchant for lace. Real old lace and copies of it were often used. The Countess wears a Georgian-type lace to go with the eighteenth-century-looking dress fabric rather than a heavier seventeenth-century style that would have been more appropriate for the cut of the gown itself.

PART FOUR:
1896-1900

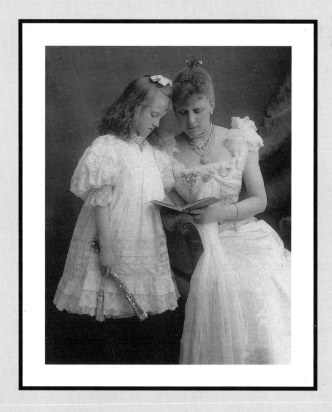

MALE

Walker (1837–?) was a surgeon and naturalist who took part in expeditions in British Columbia, Russia and America.

> It may be that women have no positive appreciation of what is beautiful in form and colour – or it may be that they have no opinions of their own when the laws of fashion have spoken. This at least is certain, that not one of them in a thousand sees anything objectionable in the gloomy and hideous evening costume of a gentleman in the nineteenth century. A handsome man is, to their eyes, more seductive than ever in the contemptible black coat and stiff white cravat which he wears in common with the servant who waits on him at table.[1]

The ugliness of male evening dress and its similarity to waiters' uniforms were constant laments throughout this period, but as 'the Major of *To-Day*' pointed out in *Clothes and the Man*, 'If a gentleman is a gentleman, no one is likely to mistake him for a waiter, and if he is not a gentleman, what does it matter if the mistake is made?' As for the first complaint, 'why should not men be satisfied to form a black·background for ladies' pretty dresses?'[2] Anyone looking at one of Tissot's ballroom paintings must agree that the contrast between male and female evening dress was indeed very striking. This was perhaps why the simple dress suit was so popular with the ladies.

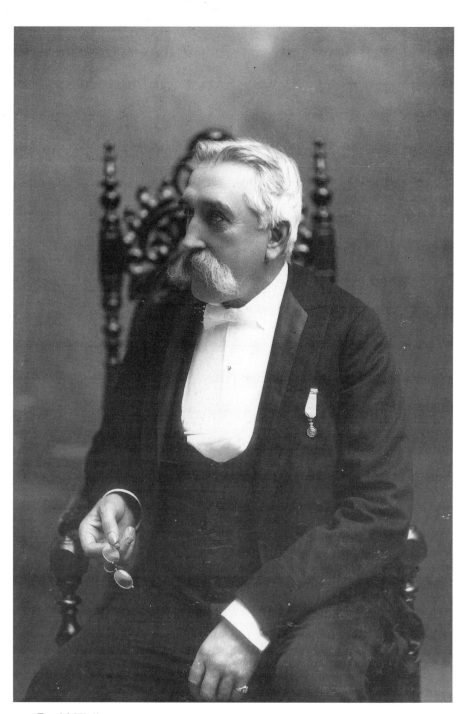

117. David Walker
1899
Thwaites, Oregon, USA (NPG x 27212)

These men, who were both musicians and composers, became friends in 1888 when Paderewski (1860–1941) asked Saint-Saëns's (1835–1921) opinion of his piano concerto. They remained in contact for many years.

Paderewski's mane of golden hair once caused the artist Burne-Jones to stop his cab and exclaim 'I have seen an archangel'.[3] A few days later the two were introduced and Burne-Jones was able to complete, from life, a portrait started from memory. Paderewski's appearance fulfilled everyone's idea of the sensitive, eccentric genius. In this picture his dress clothes consist of a turn-down collar, loose scarf and a frock coat. This was decidedly improper for anyone else but a genius, as Mr Pooter's unworldly friend Cummings in *Diary of a Nobody* found out when he turned up at a party in a black frock coat and white tie.[4]

Attempts were made, from time to time, to introduce variety into men's evening dress but these met with little success among the general public. Even the *Tailor and Cutter's* reporter at the 1897 Master Tailors' banquet found little evidence that recent novelties were actually being worn. For instance, the only embroidered coat collar in sight proved to be around the neck of 'Mr . . ., the inventor of the embroidered collar boom'.[5] Nor could the correspondent find examples of the reported fashion for claret- and blue-velvet coats. Perhaps he was not looking far enough up the social ladder; E. F. Benson remembered that Lord Battersea used to dine in a ruby-coloured velvet suit.[6]

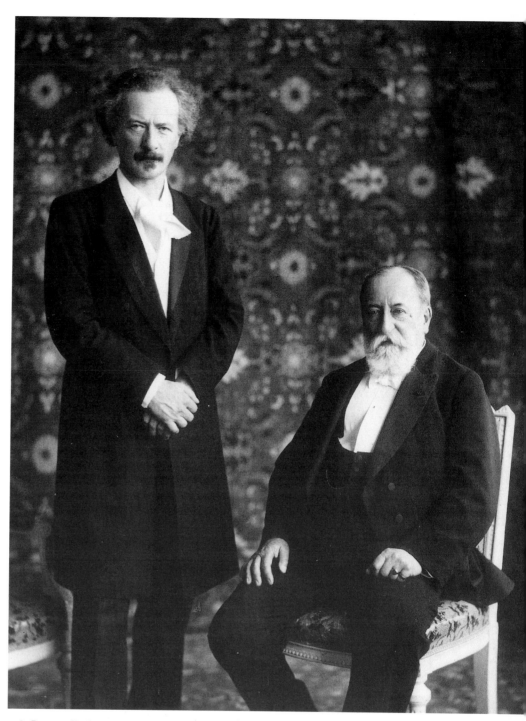

118. Ignatz Paderewski and Camille Saint-Saëns (seated)
c. 1900
De Jongh, Lausanne (NPG x 22279)

Q: 'why was Hayden Coffin?'
A: 'Because he gave his Vesta Tilley.'
(Old joke.)

119. Charles Hayden Coffin
c. 1900
Alfred Ellis, London (NPG x 12562)

Velvet was considered an acceptable material for dinner jackets – one innovation in evening wear which did become generally accepted in the 1890s and eventually ousted the tail coat. It was said to have been introduced as early as 1875, when the Prince of Wales's retinue wore short, navy jackets on a trip to India.[7] The jacket of this well-known actor and singer (1860–1935) has unusual froggings, and a roll collar, which characterized this garment from its introduction. His white tie and waistcoat, and Saint-Saëns's white tie and black waistcoat worn with tails show that there was no hard and fast rule in this area. Coffin could have worn a cummerbund, introduced in the early 1890s, as an alternative to his waistcoat.

The dinner jacket was an important step forward in male comfort in an age when most middle- and upper-class men dressed for dinner, even when alone. However, it further complicated the already complex etiquette of dress. Many a parvenu agonized over the choice of garment and wrote to 'the Major' for advice:

> One of the questions which I am asked most frequently by the readers of *To-Day* is: When may I wear a dinner jacket, and when must I wear a dress coat? Perhaps the best answer is: If you are in any doubt, wear a dress coat; you will never be absolutely wrong then. A dinner jacket may be worn on all informal occasions, as, for instance, at a music hall, at a quiet informal dinner at home, or at some intimate friends, or at a theatre with some intimate friends. But you must not wear a dinner jacket if you go to a ball, or a public dinner, or any large function of the kind.[8]

120. Lloyd Tyrell-Kenyon, 4th Baron Kenyon
1896
Walery, London (NPG x 4619)

Kenyon (1864–1927) was a 32-year-old bachelor with 10,000 acres divided between Shropshire, Lancashire, and Essex. In 1916 he became aide-de-camp to George V, and got married in the same year. He was Chancellor of North Wales University College, Pro-Chancellor of the University of Wales and President of the National Museum of Wales.

Kenyon is shown here with his hat, stick, and gloves; essential outdoor accessories which required correct handling on entering someone's house. However, as *Etiquette for Gentlemen* (1880) pointed out, 'There is a graceful way of holding the hat which every well-bred man understands, but which is incapable of explanation'.[9] There was also a fine distinction between a formal call, when a man was expected to hold his hat, gloves, and stick until he had shaken hands with the hostess, then place them on a chair or table; and an invitation to tea, when he was expected to leave them in the hall.[10] To avoid confusion, the wearer's initials were often marked on the leather hat-band. Balls were even more dangerous places for hats than tea parties. The folding gibus (opera-hat), as held by Hayden Coffin (Plate 119), was invented in 1835 so that the hat could be carried in the ballroom.

Kenyon's dashing 'top frock coat', which nearly reached the ankles, had a nipped-in waist and velvet trimmings. These were extremely popular, reflecting the increasingly dandified look of men's fashion in the 90s.

———— **121** ————

The face of Kitchener (1850–1916), every schoolboy's hero, was immortalized on a powerful World War One recruitment poster. The Great War was to be his last campaign; he went down with HMS *Hampshire* in 1916. Kitchener first distinguished himself going to the aid of General Gordon at Khartoum in 1884. He then became Governor-General of East Sudan, and received his baronetcy in 1898 following another Khartoum expedition.

Khaki uniforms were first used by the British army in India in the 1860s. With modern warfare techniques, soldiers across the Empire found that their white and scarlet uniforms made easy targets, and they used to tone down their clothing with mud before the new colour, its name derived from a Persian word for dust or ashes, was issued. The Boer War was the first major confrontation in which khaki was generally adopted. Although more practical, the new uniform was still considered extremely smart and manly; officers enjoyed wearing their Sam Browne belts, another innovation from India, and carrying swagger sticks. The high collar gave a satisfying rigidity while conforming to mainstream fashion. Indeed, in these Imperial times, when the British army's exploits across the globe were avidly reported in the press, civilian fashion paid homage to the military. This is perhaps most noticeable in the extremely short hairstyles and tight waxed or clipped moustaches that were popular.

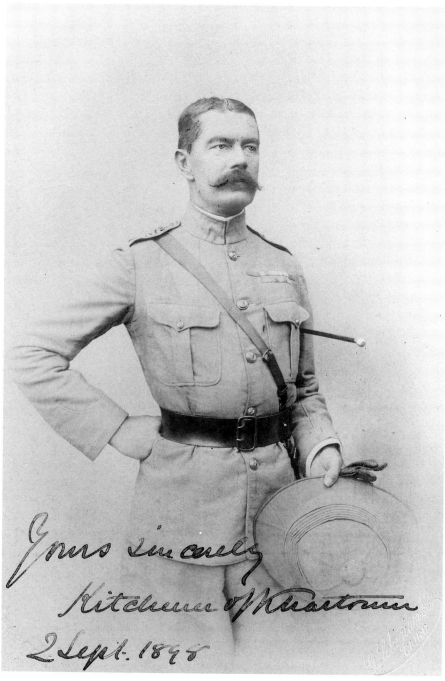

**121. Horatio Herbert, 1st Baron Kitchener of Khartoum
1898**
G. Lekegian, Cairo (NPG x 14994)

This sitter was on the staff of the British Embassy in Vienna.

Necktie silk was a mainstay of the English silk-manufacturing areas. In 1897 the *Tailor and Cutter* stated: 'For really high-class neckwear there is, of course, nothing to equal the Spitalfields looms. The price of these very beautiful fabrics, however, places them beyond the reach of any but the very well-to-do'.[11] Tie silks were also woven in Macclesfield and Coventry. Because of their narrow widths and the frequency with which new patterns were introduced, the use of hand looms was still economical, and they remained in use until the 1930s.

In June 1897 the *Tailor and Cutter* noted an unsuccessful promotion of royal-purple ties for the Jubilee. It was dismissed as 'a very trying colour for men to wear unless they are of very dark complexion'. Red was also considered difficult for the fair-skinned to wear, making an otherwise well-dressed individual look 'quite commonplace and vulgar, not to say repulsive'.[12] A gentleman had to choose his tie with care. The sharp-tongued Margot Asquith once questioned the Marchioness of Stafford's father's taste in the middle of Bond Street:

> 'What a vulgar tie you are wearing, Lord Rosslyn', she said. 'Yes', he replied, 'you're right. I remember when putting it on this morning thinking the same thing, but I comforted myself with the thought that I should never meet anyone vulgar enough to say so.'[13]

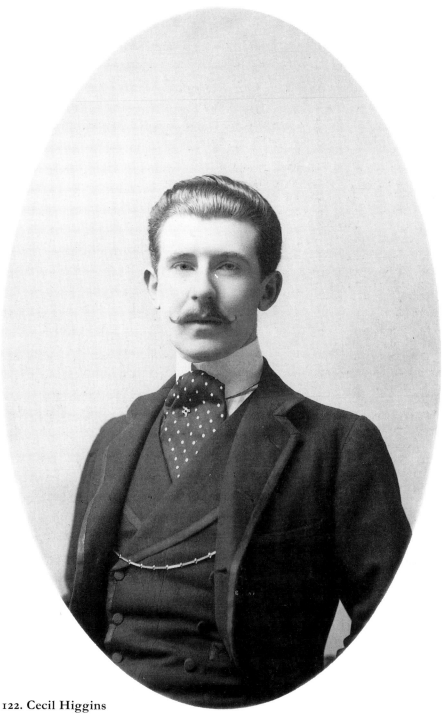

122. Cecil Higgins
c. 1900
Photographer unknown (NPG x 18465)

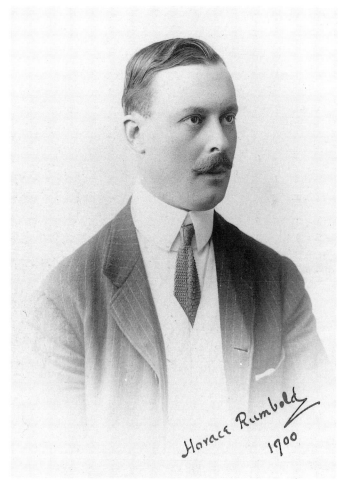

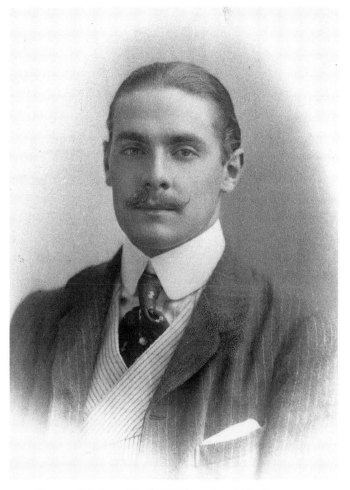

123. Horace Rumbold
1900
Photographer unknown (NPG x 22137)

124. George Herbert Hyde Villiers, Lord Hyde
1899
Photographer unknown (NPG x 6079)

——————— **123, 124** ———————

Hyde (1877–1955) served under Rumbold (1869–1941), who was Second Secretary at the British Embassy in Vienna. Rumbold later succeeded to his family baronetcy and Hyde, later the 6th Earl Clarendon, eventually became Chairman of the BBC and Lord Chamberlain. Both are captured in these images as fashionable young men.

By the late 90s collars had reached their greatest height. In 1899 Kipps equipped himself with three stand-up collars: 'They were nearly three inches high, higher than those Pearce wore, and they made his neck quite sore, and left a red mark under his ears . . .'[14] The collar was an extremely sensitive garment in other ways. Fashions changed rapidly and the choice was huge. For instance, the 1903

catalogue of wholesale warehousemen Welch Margetson listed 97 basic shapes with variants on each.

The fancy, double-breasted waistcoat was very much a feature of this period. Jackets were worn open showing an expanse of chest, which could be emphasized by narrowing the distance between buttonholes towards the waist and, as in Cecil Higgins' case (Plate 122), wearing the watch-chain high and horizontal. The nipped-in jacket added to the effect; some men were even reputed to wear corsets like the dandies of the 1830s they consciously imitated.

Although Rumbold's clothing is less extreme, it is more forward-looking than that of Hyde and Higgins. Braided edges belong to the nineteenth century just as much as pin-stripes were to be a feature of the twentieth. This was the last great era

of the dandy; fussing about clothes would soon be condemned as effeminate. Rumbold's comfortable outfit heralds the new ideal of wholesome, clean-shaven masculinity which has pervaded male costume for most of the twentieth century.

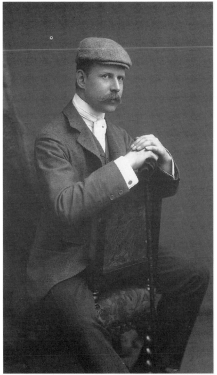

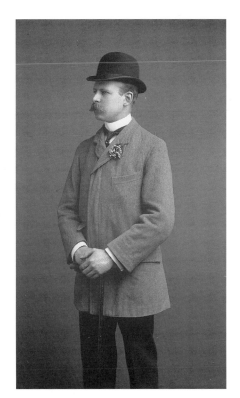

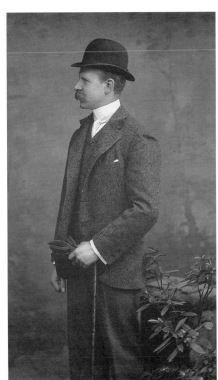

125, 126 & 127. Baron de Heeckeren 1898

Bassano, London (NPG x 4756, 4757, 4761)

——————— **125, 126, 127** ———————

Choosing the right self-image was obviously difficult for this gentleman, who brought several changes of clothing to the photographer's studio. Hats were clearly important to him since, as another picture revealed, he was quite bald. The photographs give the impression of a sporty character. The jacket he wears with a nosegay, called a 'covert coat', was originally designed for riding wear, but became popular as a useful informal overgarment for town wear. It reached to just below the lounge jacket worn underneath and had side slits, a fly front and four pockets.

Each of the three outfits shown would have been appropriate for a distinct occasion. The average working man might have an everyday suit, a Sunday suit and an overcoat. The range of garments in a wealthy gentleman's wardrobe, as well as their quality and age, would therefore single him out in a crowd of ordinary people. Henry James was particularly meticulous. H. G. Wells, who came from a working-class background, wrote of him in 1895:

He thought that for every social occasion a correct costume could be prescribed and a correct behaviour defined. On the table (an excellent piece) in his hall at Rye lay a number of caps and hats, each with its appropriate gloves and sticks, a tweed cap and a stout stick for the Marsh, a soft comfortable deer-stalker if he were to turn aside to the Golf Club, a light-brown felt hat and a cane for a morning walk down to the Harbour, a grey felt with a black band and a gold-headed cane of greater importance, if afternoon calling in the town was afoot.[15]

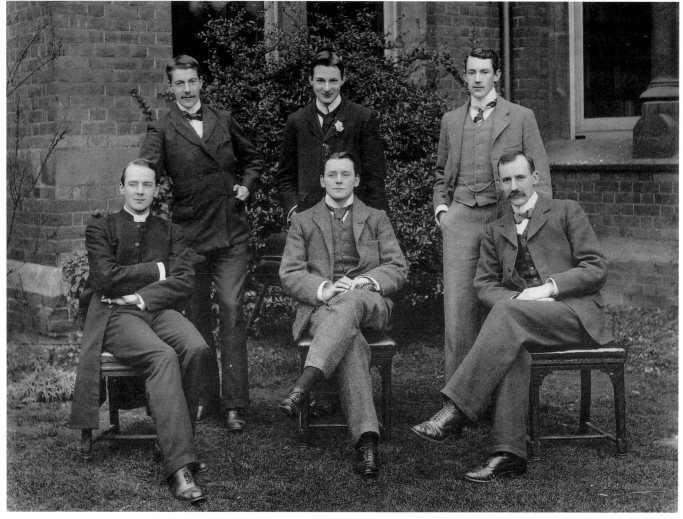

128. The brothers Masterman
1899
Stearn & Sons, Cambridge (NPG x 21234)

——————— **128** ———————

(Standing, left to right:) Harry (who died of fever in the Boer War); Charles (an author and Liberal MP who became first Minister for National Health Insurance); Walter (an author).

(Seated:) John (Vicar of St Aubyn's Church, Devonport, who became Bishop of Plymouth); Ernest (who went to Palestine as a medical missionary); Arthur (a natural history lecturer who became Superintending Inspector to HM Board of Agriculture and Fisheries).

With the exception of John (1867–1933), who wears clerical dress, these ambitious, outstanding men in their 20s and early 30s all wear suits of matching fabric. Lounge jackets, which had been worn informally since the mid-century, were becoming increasingly popular. This type of outfit, already known in the USA as a 'business suit',[16] was beginning to replace the complex array of different garments for different occasions that had typified the male wardrobe. Changing one's clothes several times a day was all very well for the gentleman of leisure, and while he provided the masculine role model, people with less leisure had been prepared to emulate him. However, many young men at the turn of the century aspired to be high-achieving professionals rather than idle gentlemen, and the image created by their simpler, more versatile clothing reflected this new ideal.

The new man had better things to do with his time than cultivate moustaches, which he probably considered unhygienic in any case. Only one of the Masterman brothers has facial hair. Whereas a clean-shaven chin had been the exception until the 1890s, more and more young men now chose other ways of proving their masculinity than sprouting beards and moustaches.

129. Arthur Balfour with the Harvard and Yale Universities rowing crews on the terrace of the House of Commons
1899
Sir Benjamin Stone, London (NPG x 32628)

———————— **129** ————————

The American Henley rowing teams' visit was recorded by Stone, an MP, businessman, and photographer who took around 2,000 pictures of members, visitors, and staff at the House of Commons between 1890 and 1910. In 1897 he founded the National Photographic Record Association to preserve images of English life.

A report kept with this picture noted

an impressive consumption of tea and cakes. In due course Mr. Chamberlain was . . . introduced to the young American lions. The Colonial Secretary was perfect in every detail, down to his eye-glass and the inevitable orchid. He chatted to the young men for a few minutes, and then moved away, his place

being taken shortly afterwards by Mr. Balfour, who came out hatless and smiling.

The nonchalant American with his hands in his pockets to the left is striking, with his modern-looking belt and striped shirt with a plain collar. Patterned shirts were already common but from this date striped shirts with white collars and cuffs began to be acceptable for formal daywear. Eventually they became almost a uniform for city gents.

This youth is also the first person in this collection to be seen wearing a jacket without a waistcoat. The trend towards simpler, more comfortable male dress is said to have originated in America, where a universally recognized caricature called 'the Dude', with monocle, top hat, and cane, lampooned the traditional image of

the perfect gentleman. This character was so well known that men wearing exquisite European-style turn-outs were taunted by street children and laughed at by prospective employers. Illustrators like Charles Dana Gibson provided a new stereotype in their attractive depictions of casual and athletic-looking young men. When these appeared in the mid-90s American menswear publications recommended them to readers, rather than fashion-plates, as a guide to the current 'look'.[17]

These Harvard and Yale alumni were both brainy and athletic. They were good-looking in a Gibsonesque way with their strong, clean-shaven chins, and taller than their frock-coated English hosts.

130. The Imperial Penny Postage Conference
1898
Photographer unknown (NPG x 32130)

─────── **130** ───────

(Standing, left to right:) *Arthur Bingham Walkley (Secretary to the Conference); Harry Buxton Forman (Assistant Secretary GPO); Rt. Hon. Spencer Horatio Walpole (Secretary GPO); Sir Walter Peace (Natal Agent General); Arthur Ashley Pearson (representing Crown Colonies); Sir James Winter Spearman (Premier, Newfoundland).*

(Seated, left to right:) *Donald Alexander Smith, 1st Baron Strathcona (Canadian High Commissioner); The Hon. Sir William Mulock (Canadian Postmaster General); Henry FitzAlan Howard, 15th Duke of Norfolk (Postmaster General); The Hon. Sir David Tennant, (Cape Agent General).*

Just as the American rowing teams demonstrated the 'look' of their generation, so this assembly of middle-aged and elderly men captures the characteristic appearance of their age group. The seven beards, one moustache and two pairs of long side-whiskers sported by the Imperial Penny Postage Conference look back to the 60s and 70s, when extremely long beards and 'Dundreary' whiskers were popular. These last were called after a popular stage character, Lord Dundreary, who typified an English upper-class 'twit'.

Despite the rivalry of the morning coat for more than a generation, and more recently that of the business suit, the frock coat was still an indispensable attribute of most men of a certain age and standing in society. When the *Daily Chronicle* suggested abolishing it, the *Tailor and Cutter* leapt to its defence:

Such a cold blooded suggestion is enough to drive every sartorial artist frantic. Where would the tailors' skill have a chance of being displayed if such a change was brought about? Just fancy our Fleet-street editors going about in jackets and flannel blazers, our Members of Parliament ditto, showing up all their narrow chests, round shoulders and lop sides. No, they have only to try it once to see that their power and greatness is as much due to the nicely made Frock coat as it is to their own ability, and perhaps more so.[18]

131. (*Left to right:*) T. M. F. Minstrell (*Morning Advertiser*); Theo Bello (*Morning Post*); J. F. M. Bussy (*The Standard*); Alfred James (*Daily News*)
1898
Sir Benjamin Stone, London (NPG x 19940)

132. James Oram, Cloakroom attendant, House of Commons
1897
Sir Benjamin Stone, London (NPG x 32625)

———— 131, 132 ————

Without their captions it would be very difficult for us to distinguish between Oram, a working-class man who would have been expected to dress smartly because of his workplace, and these middle-class journalists dressed in everyday clothes for their work. By the late nineteenth century the essentials of mainstream male dress were the same for all classes. As wages rose, the proportion of income spent on clothing increased, while developments in the ready-made clothing industries meant that many garments were cheaper. Thus, the general standard of clothing improved. However, a contemporary standing next to Oram would have had no difficulty placing him in the social order. His watch-chain was unlikely to have been gold and his ascot necktie looks suspiciously like the ready-made sort which was mounted on cardboard. No gentleman would consider wearing such a tie. Most importantly, the poor cut and fabric of his suit would have revealed the limitations of his wallet, even if it had been new rather than creased and shapeless with age. Until the 1960s, when man-made fibres became widespread, it was common to see people in old, black, cloth jackets which had not only become shiny, but had also acquired a sort of rusty tinge.

133. The directors and staff of Henry Graves & Co. Ltd
c. 1900
Photographer unknown (NPG ref. neg. no. 16955)

———————— 133 ————————

This group is almost certainly enjoying a works' outing. These became common as employers grew more enlightened and even provided improved buildings with facilities like canteens and longer holidays.

Many of the men are wearing straw boaters, which had by now reached all sections of the population. Any summer crowd in this era, such as those photographed at Victoria's Diamond Jubilee Celebrations in 1897, represented a sea of straw, and prosperity for the hat-making area round Luton in Bedfordshire. Arnold Bennett commented in his journals on the crowds he saw that hot day,

remembering particularly the 'straw-hatted and waistcoatless men'.[19]

In this photograph several of the Graves employees wear light-coloured Homburgs. This soft felt hat came into fashion in the late 1880s. A particular favourite of the Prince of Wales, it was so named because he frequently visited that city.[20] The two men in bowler hats were probably managers. Even in Laurel and Hardy's time the bowler hat was the mark of the foreman. Robert Roberts, remembering his Edwardian childhood in the Salford slums, noted 'for men with any claim at all to standing the bowler hat, or "Billy Pot", was compulsory wear. Only the lower types wore caps.'[21] Several of the caps worn here are in the new, wider

shape that reflected the larger hats and fuller hairstyles adopted by women towards the turn of the century.

GROUP

Pearson (1857–1936) was called to the bar before becoming Professor of Applied Mathematics and Mechanics at University College, London, in 1884. His interest in biology led to his becoming Professor of Eugenics there from 1911 to 1933. The *Dictionary of National Biography* describes him as 'among the most influential university teachers of his time; admired and feared rather than loved'.

The rabbit, clothing and children's names would have spoken volumes to an observant contemporary, even without the knowledge that the Pearsons lived in Hampstead. The stereotypical academic family in Posy Simmonds' cartoons of the 1970s and 80s was already recognizable 100 years ago.

Mrs Pearson (?–1928), herself in an 'artistic' woollen dress, put her offspring in rough and ready garments instead of the inappropriate finery endured by most children. Educational reformers like Montessori were beginning to find followers in advanced circles, where learning by rote and being seen but not heard were giving way to free expression and discovery through play. At the same time dress-reformers were devising sensible clothes for children that were easy to wash and wear. This new approach to children's clothing was one of the most important contributions of the dress-reform movement to general fashion.

In Flora Thompson's 'Candleford Green' of the 1890s, the new vicar and his wife epitomized the modern·approach to child-rearing. Their charming but bad-mannered daughters Elaine and Olivia

ran about barefoot. . . . Their ordinary every-day dress was a short brown holland smock, elaborately embroidered, which for comfort and beauty would have compared favourably with the more formal attire of other children of their class had it not invariably been grubby.[22]

134. Karl Pearson with his wife Maria, and their children Egon and Sigrid Laetitia
c. 1897
Photographer unknown (NPG x 21747)

135. Algernon Swinburne and his sisters at the funeral of their mother Lady Jane Swinburne at Croydon 1896

Commissioned by J. S. Martin. Copied by Howard M. King, Croydon (NPG x 12832)

─────────── **135** ───────────

Traditionally only men went to funerals, but it became increasingly common for women to attend, especially when the dead person was a relative. Parents would be mourned for 12 months. The deepest mourning, featuring black crape and dull-black fabrics like paramatta, was worn for six months. Black without crape was then worn for four, during which time linen collars and cuffs could replace the crape ones, and some jewellery could be worn. 'Half-mourning', which could include jet jewellery, shiny black silks, mauves, greys, and whites, was adopted for the remaining two months.[23]

As in this picture, mourning dress followed general fashions, albeit with restraint. The foreground woman wears a crape cloak in the high-collared flared style which was warm and practical but did not crush huge sleeves. Another mourner has a hat veil, which must have been very convenient on such a tearful occasion. Only widows sometimes wore special costume, a strange crape cocoon, for the funeral itself. However it was still customary to distribute gifts of black leather gloves for the funeral as the guests assembled in the bereaved household beforehand. (In the same way, wedding guests used to be given white gloves as 'favours'.) Wells Museum, in Somerset, has a very rare pair of unused funeral gloves, complete with a paper label from the shop which sold them.

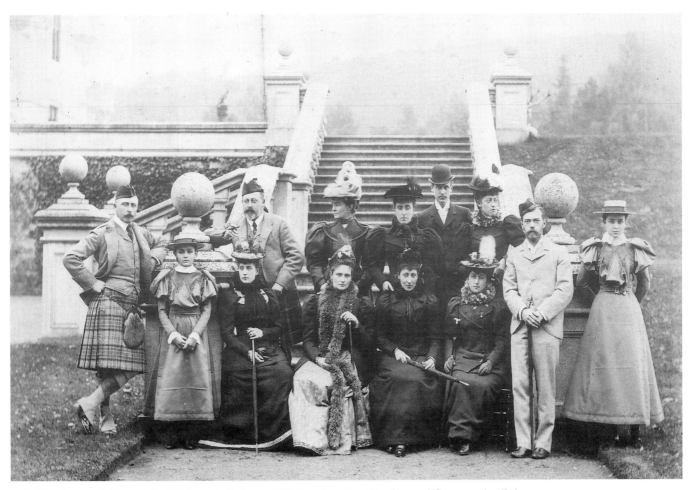

136. (*Back row, left to right:*) Edward, Prince of Wales; Louise, Duchess of Connaught; Princess Helena Victoria of Schleswig Holstein; two unknown people

(*Front row, left to right:*) Arthur, Duke of Connaught; Princess Patricia of Connaught; Princess Alexandra; Alexandra, Tsarina of Russia; Louise Victoria, Duchess of Fife; Queen Maud of Norway; Tsar Nicholas of Russia; Princess Margaret of Connaught
1896
Robert Milne of Aboyne and Ballater, Balmoral (NPG x 8494)

——————— 136 ———————

Edward (1841–1910) tried to entertain his nephew when he visited Balmoral in 1896, but as Nicholas (1868–1918) wrote to his mother, 'After he had left I had an easier time, because I could at least do what *I* wanted, and was not *obliged* to go out shooting every day in the cold and rain . . .'[24]

Edward loved uniforms and was delighted when Nicholas made him Honorary Colonel of a Russian regiment. Lord Carrington encountered him trying on the uniform: 'a fat man in a huge shaggy greatcoat looking like a giant polar bear. It was the Prince of Wales!'[25]

Edward was extremely clothes con-scious. He kept two valets and a brusher and often changed six times a day.[26] In 1898 the *Tailor and Cutter* compared the styles of Edward and his brother the Duke of Connaught (1850–1942) (seen at the far left of this picture). Edward's grey worsted frock coat's shortish sleeves revealed enough cuff to balance his white spats, collar, and white-edging 'slip' to his waistcoat:

> the white being placed at the extremities of his figure has the effect of giving him all the advantage of every inch of height he possesses, and thus helps to counteract the excess of width which is so often found in gentlemen beyond the prime of life.[27]

The Duke of Connaught's black vicuña coat had bolder lapels to give the appearance of extra width. The editors of the *Tailor and Cutter* liked his white-spotted black bow tie but not his white hat. However the tall, slim duke won over all, his military bearing contrasted with Edward's heavy tread made them look like father and son.

This picture shows that the Duke of Connaught's daughters had new frocks for the Tsar's visit – creases in the woollen cloth where it was folded on the bolt are clearly visible on both.

—————— **137, 138** ——————

Francis Burnand (1836–1917) was the editor of *Punch*, and Mrs May (?–1910) and Mrs Lucy were the wives of two of his foremost cartoonists.

Every season brought even wider sleeves until 1897 when, having exhausted all their design possibilities, the fashion industry decreed a sudden shrinkage. The yoke, above a slightly gathered bodice, began to create the full-bodied luxuriance which was to be emphasized by the characteristic 'S'-bend corset of the Edwardian era. The contrasting colour schemes of pastels and touches of very dark shades, seen earlier, were further developed, and served to enhance the feminine frilliness that was becoming a dominant theme in fashion. Surface details such as pin-tucks and insertions, lace and ribbons, long feather boas, and mountains of feathers on the broad hats all softened the decorative effect, while the angular silhouette was replaced by a gentler line with a flowing bell-shaped skirt.

Hats, which had been large to balance the sleeve, became even larger, their magnitude and bewildering complexity of decoration supported by full, fluffy hairstyles. Such imposing headwear could confer presence and sophistication on its owner. At about this time, Ann Pornick, returning from her honeymoon with Kipps, was described by H. G. Wells as

> the same bright and healthy little girl woman you saw in the marsh. . . . Only now she wears a hat.
>
> It is a hat very unlike the hats she used to wear on her Sundays out – a flourishing hat, with feathers and a buckle and bows and things. The price of that hat would take many people's breath away – it cost two guineas! Kipps chose it. Kipps paid for it. They left the shop with flushed cheeks and smarting eyes, glad to be out of range of the condescending saleswoman. . . . And, you know, the hat didn't suit Ann a bit.[28]

137. (*Left:*) Mr and Mrs Brownsfield of Rotherhithe and (*right:*) J. C. Macdona, MP for Rotherhithe, and his wife Esther
1899
Sir Benjamin Stone, London (NPG x 32629)

138. (*Left to right, standing:*) Mrs Phil May; Francis Cowley Burnand, with his wife Rosina; Ethel Burnand; William Jones, MP for Caernarvonshire and (*seated:*) Mrs Nancy Lucy; Miss Cavendish; Miss Burnand
1899
Sir Benjamin Stone, London (NPG x 32627)

FEMALE

139. Mary Anne Keeley
1897
Photographer unknown (NPG x 18974)

─────── 139 ───────

This actress (1805–1899) went on stage in 1825. She retired in 1869, on the death of her husband the actor-manager Robert Keeley, but continued to give recitations for charities.

At 92 she is still tightly corseted. Her bodice goes back a mere decade, but she curls her hair in the style of her youth. Although hair is a highly fashion-sensitive area, it was surprisingly common for women to cling to a favourite style for over half a century. Aunt Ann, at the start of the *Forsyte Saga* in 1886, wore a row of curls across her forehead,

curls that, unchanged for decades, had extinguished in the family all sense of time. . . . The maid Smither performed every morning with extreme punctiliousness the crowning ceremony of that ancient toilet. Taking from the recesses of their pure white band-box those flat, gray curls, the insignia of personal dignity, she placed them securely in her mistress's hands, and turned her back.[29]

The Lady's Maid, written around 1880, discussed the case of an elderly mistress:

Your lady's wardrobe will be entirely under your care; for she will hardly be able to look at it herself. Every speck of dust in the gathers of her gown, every plait that stands awry in her cap, will be a reproach to you. Aged ladies generally have all their gowns and all their caps made exactly alike, so that you will have no trouble in studying fashions, and may give all your care to the neatness of your work.[30]

Numerous photographers in this collection show dogs, from the gigantic Marco (Plate 108) to lap-dogs like this little pug. Different breeds go in and out of fashion just as new styles of clothing come and go. Terriers were particularly popular in the last century, but pugs were common too. The novelist Rhoda Broughton had several, who were said to 'accompany their mistress like a body-guard' through the streets of Oxford.[31]

The juxtaposition of dog hairs and Lady Randolph Churchill's (1854–1921) elegant costume, with inserted satin scallops in the skirt, raises the question 'how were such dresses kept clean?' Many layers of underclothing, including a short-sleeved shift, or alternatively combinations, kept rich outer materials well away from the body. Even well-worn surviving Victorian garments usually have unsoiled linings. The lady's maid, if one was employed, would brush off dust and dog hairs and carry out the never-ending task of removing dried mud from skirt hems. She would spend most of the linen to the laundress, all marked so that it could be listed and checked off on its return, retaining the most delicate lingerie to wash and press herself. However, it was harder to tackle atmospheric dirt which, in an age of coal fires and 'pea-souper' fogs, must have quickly taken its toll of expensive silks. Grease-absorbing materials like stale bread, bran, and borax could be rubbed on spots, or volatile liquids like turpentine or benzine applied.[32] Professional dry-cleaning firms had advertised their services since the 1830s. At first dresses were unpicked before cleaning; the process became more efficient as time went on but it remained very expensive.

140. Jennie, Lady Randolph Churchill
1898
Bassano, London (NPG x 15368)

141. Kate Courtney
1898
Sir Benjamin Stone, London (NPG x 32720)

141, 142

Whilst Kate Courtney's businesslike shoes and sensible hairstyle and bonnet suggest a serious purpose behind her visit to the Houses of Parliament, other females went with more frivolous intentions. *Black and White Magazine* noted (September 1891) 'many a charming form in heliotrope or white':

The ladies are not concerned that the entertainment in the Parliamentary theatre continues to be depressingly dull, for to them tea, with strawberries and cream upon the terrace, to say nothing of a charming little dinner in 'the Alcove' later on, constitute attraction enough for a visit to Westminster. On Tuesday last a lady, who appeared in a somewhat *fin-de-siècle* hat, and who, I understand, is a constant habitué of 'private views' and similar functions, created quite a small sensation . . .[33]

The extremely versatile tailor-made suit is worn here on a visit to the House, made of smartly decorated soft wool, and could be made in a tweedier version for a chilly picnic. Like Mrs Penrose (1858–1942), seated under the umbrella, Miss Courtney wears a bonnet; rather old-fashioned for a woman of her age. The two homburgs worn on the picnic were also 'old hat' in comparison to the impressively large headgear worn by the right-hand woman. Her hat and tight-sleeved coat put the date of this picture nearer to 1900 than the full-sleeves of the tailored suit would suggest. The left-hand woman leans her head against one of the short, semi-circular high-collared capes so fashionable at this time, while the drape of the garment underneath her suggests the rubberized fabric of a mack-intosh, by then in general use.

142. Emily Penrose, her mother Harriette, and sisters Alice and Mary
c. **1898–1900**
Photographer unknown (NPG x 27619)

──────── **143** ────────

Elaine Guest's (1871–1961) velvet bodice and soft, wool skirt are in keeping with the new fashionable emphasis on texture. Galsworthy summed up the changing character of women's clothing over this decade in his descriptions of Irene Forsyte. In the late 1880s her dress had 'fitted her like a skin – tight as a drum', but as she walked in a park in Paris, towards 1900, 'the sunlight gleamed on her hair as she moved away, and seemed to lay a caress all down the clinging cream-coloured frock'.[34]

To modern eyes, Elaine Guest's heavy jewellery, buttons, and sequinned belt make jarring notes in her ensemble. Heavy, rather haphazard jewellery does seem to have been popular; it can be seen in several photographs in this collection from the late 90s. The 'chatelaine', clipped to her belt, was supposed to carry all the domestic bits and pieces a lady might require. This one supports a needle-case, seal, and watch. As early as the 1880s ladies' watches were sometimes mounted on leather straps to wear on the wrist; the left-hand woman in Plate 142 has one. Watches mounted on metal bracelets were also available.[35]

Another accessory which this sitter would certainly have needed, although it is not visible, was a hat-pin, to hold her hat onto her hair. As hats became larger these were more and more necessary. Edwardian hat-pins were decorative and extremely long, often having a special cap covering the dangerous spike.

143. The Honourable Elaine Guest
1898
Bassano, London (NPG x 4222)

──────── **144** ────────

This lady's neck and cuff ruffles contribute to the newly fashionable softer image, together with her boa and beribboned, striped parasol. Several

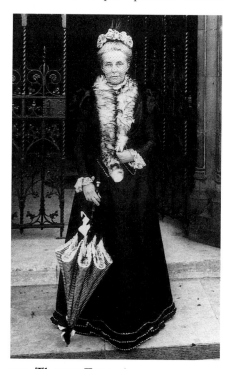

144. Theresa Escombe
1897
Sir Benjamin Stone, London (NPG x 32719)

photographs in the collection show dresses in horizontally striped materials. With the exception of a few brief periods such as the 1890s and the early 1860s, horizontal stripes have hardly ever been popular, perhaps because they give an unflattering illusion of width.

A parasol would have been considered essential on this sunny July day. Complexions were still protected to keep them white and unwrinkled, but many older women would have exclaimed, as did Lady Dorothy Nevill, about the changing habits of youth:

> Look at the girls nowadays . . . playin' golf in their thumpin' boots with never a veil or a pair of gloves till their skin's like a bit of mahogany veneer. I should think the young men would as soon think of kissin' a kipper. And to make it worse they are beginnin' to dab themselves with lip-salve and muck. I never saw such a mess!'[36]

Theresa Escombe's dress, although dark, is made from a summer-weight silk. Many fabrics coming into fashion at this time were soft and clinging, like muslins and crapes. Others, such as fine taffetas, although lighter and more pliable, still had 'body'. Used for dresses and petticoats, they rustled with every movement and this 'frou-frou' contributed to the fashionable effect. While this rustling quality could be achieved through spinning and weaving, metallic salts usually had to be added in the dying process to give the right texture. Many people have seen the effect of time on 'weighted' silk, on discovering a family heirloom like great-grandmother's wedding dress reduced to crumbling tatters.

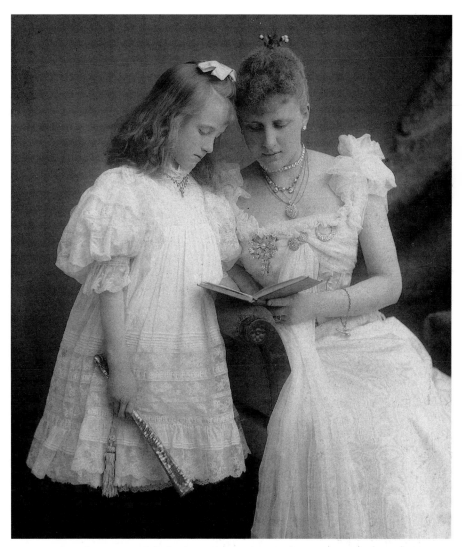

145. Louisa, Countess of Orford, with her daughter Dorothy Rachel Melissa 1897

Bassano, London (NPG x 30680)

——————— **145** ———————

Dorothy's (1889–?) necklace has a coral centrepiece. Coral, traditionally thought to ward off evil spirits, has been given to children for centuries. Coral and pearls were considered especially suitable for girls. Like the abalone shell seen on the fan stick, these materials were now more freely available. Diamonds, not yet 'a girl's best friend', but rather the prerogative of married women, also became less scarce following the opening of Rhodesian mines, although entrepreneurs tried to maintain their exclusivity. Cecil Rhodes made his fortune from the de Beers Diamond Company, founded in 1880.

Normally Dorothy might only see her mother (?–1909) in such finery for a goodnight kiss, or perhaps glimpsed through the bannisters as visitors were greeted and shown to the cloakroom. E. F. Benson vividly recalled spying on dinner-party guests from this viewpoint:

> They had gone in mere chrysalides, swathed in shawls and plaids; they emerged magnificent butterflies, all green and pink and purple. As each came floating forth, her husband offered her his arm and they went thus into the drawing room.[37]

Benson was writing about the 1870s, but the scene would have been the same at the end of the century, which the possible addition of yellow to the galaxy of colours. This colour, which can be hard on pale British complexions, was briefly in vogue. It conveyed a *fin de siècle* decadence, as in *The Yellow Book*, but its popularity was also due to electric lighting, which was finding its way into theatres and many well-to-do homes. Evening clothes, once designed to be seen by gaslight, were now more brightly illuminated and different colours were often preferred. Yellow was thought to look particularly effective in this new kind of light.

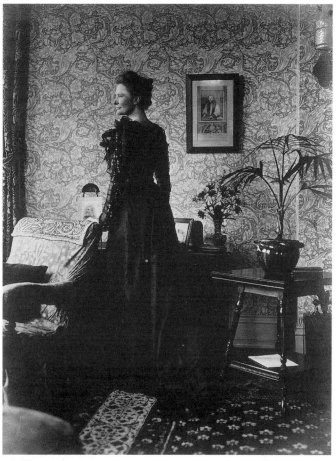

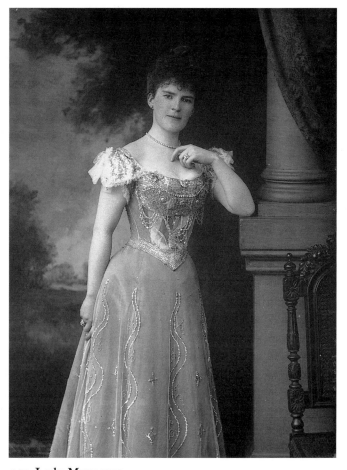

146. Emily Penrose
c. 1900
C. W. Carey (NPG x 27613)

147. Lady Musgrave
1898
Bassano, London (NPG x 4799)

——————— **146, 147** ———————

Another view of Emily Penrose (1858–1942) in this dress was published by the *Girl's Realm*. As Principal of Royal Holloway College she was already one of the great names in female education, held up as an example of female achievement to the magazine's readers. She subsequently moved to Somerville College, Oxford. On her retirement from there in 1926 she was made a DBE.

The great age of beaded dresses, which lasted until the 1930s, was about to begin. Glass beads, diamanté-paste stones on little mounts, and sequins were all used to produce sumptuous effects on evening dresses. Sequins, or spangles, traditionally made of metal, were now manufactured more cheaply out of gelatine. Beads and sequins were threaded on to reels of cotton. Then, with the material to be beaded tightly stretched on a frame, the thread was passed by hand through the fabric using a fine 'tambour' hook. This held each piece down and created a chain-stitch underneath. The process itself was quite fast, but since large areas of fabric were often covered in this way, it was expensive. Such elaborate decoration was only possible given the large scale of the fashion industry. Establishments like Worth employed well over 1,000 dress-makers. Specialist workshops, particularly in Paris, manufactured beadwork which could be purchased by shops and smaller dressmaking concerns.

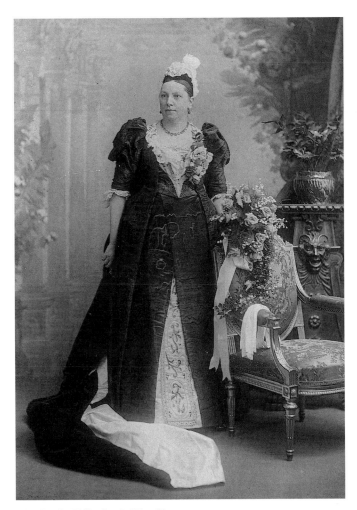

148. Lady Elizabeth Wardle
1897
Bassano, London (NPG x 30634)

149. Elizabeth, Baroness Seaton
1896
Bassano, London (NPG x 30613)

─────── **148, 149** ───────

A court presentation dress was an expensive extravagance unless it could be adapted for ordinary evening wear. Another photograph of Baroness Seaton (?–1937) shows her dress worn with veil and court plumes. In this one they have been replaced by a fashionable, flared evening cape which does not quite cover her full sleeves.

Her dress might have come from a French *couturier*, or the woven silk brocade may have been imported from France by one of the English 'court dressmakers' like Madame Elise or Kate Reilly, who understood the intricacies of costume for such occasions. However, silks of this quality were produced in England, for instance by Warner & Sons, of Braintree, Essex. They supplied many

fabrics for Princess May of Teck, who later became Queen Mary.

Lady Wardle's (?–1902) husband Sir Thomas, President of the Silk Manufacturers' Association, also produced high-quality textiles. The standard of dyeing and printing at his factory in Leek, Staffordshire, was good enough even for William Morris, who conducted his early experiments there. Under Morris's influence, Lady Wardle set up the Leek School of Embroidery, involving both ladies and working women. Its output included not only a life-size replica of the Bayeux tapestry, but many ecclesiastical pieces designed by Edward Burne-Jones.

Lady Wardle's court dress was probably worn in 1897, the year Sir Thomas received his knighthood. As an elderly woman, a dark colour was acceptable and she may have had permission to wear

longer sleeves. The *tablier* decoration on the front of the skirt, which gives a historical feel to the outfit, is embroidered; where better to advertise the Leek School of Embroidery than at court!

This sitter (?–1959) regards the camera knowingly, with a relaxed awareness of her charms. Her pose is strikingly reminiscent of figures depicted by the French graphic artist Alphonse Mucha. His posters epitomized the Art Nouveau style of the turn of the century, which is echoed in Lady Grey-Egerton's softly draped teagown and luxuriant full *coiffure*. She may already be dressing her hair over the wire frames, or pads, known as 'rats', which gave hairstyles in the next decade such volume. Hair was an important Art Nouveau motif; swirling tresses were often blended with sinuous plant-like forms, not only on posters, but also on metalwork, glassware, and ceramics. The change from frizzed fringes and top-knots to fuller styles came as Art Nouveau reached the height of its popularity. H. G. Wells described Ethel Lewisham's hair as 'a new wonderland of curls and strands' in *Love and Mr Lewisham*, set at about this time,[38] and D. H. Lawrence made Clara Dawes's heavy, dun-coloured hair one of her chief attractions in *Sons and Lovers*. Clara also had the sort of full, mature figure that was to become the new fashionable ideal.[39]

The effectiveness of Lady Grey Egerton's dress is largely created by its soft frills. The lace has been cut to fit the sleeve, which suggests that it was machine-made. By now, machine laces were so sophisticated that they are hard to distinguish in a photograph from handmade lace or hand-embroidered net. Most machine lace in the 1890s was made on the Levers machine, which could convincingly imitate many laces. In 1883 a method was invented whereby cotton machine-embroidery on silk was left behind when the silk was burnt away by an acid, resulting in a 'chemical' lace that became hugely popular.

150. Lady Mary Grey-Egerton
1898
Bassano, London (NPG x 31367)

NOTES

INTRODUCTION

1. For further details see H. and A. Gernsheim, *A History of Photography*, Thames & Hudson, 1955. For George Bernard Shaw see p. 422.
2. Langtry, L., *The Days That I Knew*, first published by George H. Doran Co., 1925; Futura Publications Ltd., 1978, p. 40.
3. Marlow, J., *Mr and Mrs Gladstone – an Intimate Biography*, Weidenfeld & Nicolson, 1977, p. 259.
4. Burnand, Sir F. C., *Records and Reminiscences*, vol. II, Methuen & Co., 1904, pp. 284–305.
5. Burnand, op. cit., p. 310.
6. Ibid., p. 207–8.
7. Bingham, M. *Earls and Girls – Dramas in High Society*, Hamish Hamilton, 1980, pp. 10–30.
8. Fisher, G. and H., *Bertie and Alix – An Anatomy of a Royal Marriage*, Robert Hale & Co., London, 1974. p. 132.
9. Langtry, op. cit., pp. 202–8.
10. Quoted in Montgomery, J., *1900 – The End of an Era*, George Allen & Unwin, 1978, p. 92–3.
11. Winston Churchill, quoted in Vansittart, P., *Voices 1870–1914*, Franklin Watts, New York, 1985, p. 122.
12. Evans, H. and M., *The Party That Lasted 100 Days. The Late Victorian Season: a Social Study*, MacDonald & Jane's, London, 1976, p. 11.
13. Montgomery, op. cit., pp. 88–91.
14. Ibid., p. 93.
15. Paderewski I. and Lawton, M., *The Paderewski Memoirs*, Collins, 1939, p. 243.
16. Vanderbilt Balsan, C., *The Glitter and the Gold*, Heinemann, 1953, p. 26.
17. For further details about the mass clothing industries see Levitt, S., *Victorians Unbuttoned – Registered Designs for Clothing, Their Makers and Wearers, 1839–1900*, George Allen & Unwin, 1986.
18. Tarrant, N. A. E., *Great Grandmother's Clothes, Women's Fashion in the 1880s*, The National Museums of Scotland, Edinburgh, 1986, p. 22–3.
19. Blum, S. (ed.), *Victorian Fashions & Costumes From Harper's Bazaar: 1867–1898*, Dover Publications Inc., New York, 1974, pp. 238–9.
20. The *Tailor and Cutter*, 9 September 1897, p. 452; 16 September 1897, p. 467; 23 September 1897, p. 479.

PART 1: 1880–85

Male – Plates 1–18

1. Ballin, A. S., *The Science of Dress in Theory and Practice*, Sampson Low, Marston, Searle & Rivington, 1885, pp. 198–9.
2. The *Tailor and Cutter*, 25 November 1897, editorial.
3. Langtry, op. cit., pp. 36–7.
4. Ibid., p. 52.
5. Ibid., p. 65.
6. Anon, *Etiquette for Gentlemen*, Ward, Lock & Tyler, c. 1880, p. 23.
7. See Hardy, Thomas, *Under the Greenwood Tree*, 1872.
8. The *Tailor and Cutter*, 4 March 1897, p. 118.

Group – Plates 19–23

9. The *Tailor and Cutter*, 18 November 1897, p. 594.
10. Walkley, C., *The Way to Wear'em – 150 Years of PUNCH on Fashion*, Peter Owen, 1985, pp. 78–9.
11. Ibid., p. 22.
12. Tarrant, op. cit., p. 8.
13. 'Sylvia', *How to Dress Well on a Shilling a Day*, Ward, Lock & Co., 3rd ed., c. 1885, pp. 94–6.
14. Webb, C. W., *An Historical Record of Corahs of Leicester*, Corah, N. D., p. 39.
15. Langtry, op. cit., p. 97.
16. Lawrence, D. H., *Sons and Lovers*, 1913, ch. 2.
17. Ballin, A. S., op. cit., p. 111.
18. Ibid., p. 289.

Female – Plates 24–32

19. Langtry, op. cit., p. 38.
20. Troubridge, L., *Life amongst the Troubridges. Journals of a young Victorian 1873–1884* ed. Jacqueline Hope-Nicholson, John Murray, 1966, p. 160.
21. Haweis, B., *The Art of Beauty*, Chatto & Windus, 1878, p. 274.
22. Montgomery, op. cit., p. 166.
23. Newton, S. M., *Health, Art & Reason – Dress Reformers of the 19th Century*, John Murray, 1974, p. 93.
24. Smyth, E., *Impressions that remained: Memoirs*, vol. II, 1880–91, p. 81, Longmans, Gleen and Co., 1920, 3rd Ed.
25. Shonfield, Z., *The Precariously Privileged – A Professional Family in Victorian London*, Oxford University Press, 1987, p. 150.
26. de Marly, D., *Worth – Father of Haute Couture*, Elm Tree Books, 1980, p. 178.
27. Langtry, op. cit., p. 12.
28. Ibid., p. 40.
29. Cornwallis-West, Mrs G., *The Reminiscences of Lady Randolph Churchill*, 1st ed. 1908, Cedric Chivers Ltd., 1973, pp. 49–50.

PART 2: 1886–90

Male – Plates 33–50

1. Marlow, op. cit., p. 256.
2. Quoted in Penelope Byrde, *The Male Image – Men's Fashion in England 1300–1970*, Batsford, 1979, p. 89.
3. Marlow, op. cit., p. 270.
4. Langtry, op. cit., p. 190.
5. The *Tailor and Cutter*, 9 September 1897, p. 452.
6. Fennimore Cooper, J., *England, with Sketches of Society in the Metropolis*, Richard Bentley, 1837, vol. II, p. 220.
7. Bennett, E. A., *An Old Wives' Tale*, 1913, p. 245.
8. Burnand, op. cit., p. 208.
9. Abdy, J. C., and Gere, *The Souls: an Elite in English Society 1885–1930*, Sidgwick and Jackson, 1984, p. 69.
10. Quoted in the *India Rubber and Electrical Trades Journal*, 5 August 1885, p. 5.
11. 'The Major of To-Day', *Clothes and the Man*, Grant Richards, 1900, p. 186–7.
12. 'The Major of To-Day', loc. cit.
13. Wells, H. G., *Experiment in Autobiography*, 1st ed., 1934. J. B. Lippincott, 1967, pp. 294–5.
14. Anon, *How to Dress, or the Etiquette of the Toilette*, Ward, Lock & Tyler, 1876, p. 10.

15. Cooper, Lady D., *The Rainbow Comes and Goes*, Rupert Hart-Davis, 1958. New edition, Century Publishing, 1984, p. 40.
16. Wilde, O., *The Picture of Dorian Gray*, 1st edition Ward, Lock & Co., 1891. Penguin Books, 1949, ch. 17, p. 214.
17. Montgomery, op. cit., p. 125.
18. 'The Major of *To-Day*', op. cit., pp. 53–4.
19. Cornwallis-West, op. cit., p. 155.
20. The *Tailor and Cutter*, 9 Dec 1897, p. 622.
21. Wells, op. cit., pp. 454–5.

Group – Plates 51–56

22. Benson, E. F., *As We Were – A Victorian Peep-Show*, Longman, 1930, p. 18.
23. Shonfield, op. cit., pp. 62–3.
24. Benson, op. cit., p. 108.
25. Hughes, M. V., *A London Girl of the 1880s*, Oxford University Press, 1st edition 1946, 1978, p. 125.
26. Cunnington, C. W. and P., *Handbook of English Costume in the Nineteenth Century*, Faber & Faber, 1959, p. 532.
27. Quigley, D., *What Dress Makes of Us*, Hutchinson & Co., 1898, p. 58.
28. Benson, op. cit., p. 161.
29. Shonfield, op. cit., p. 120.

Female – Plates 57–73

30. Shonfield, op. cit., p. 117.
31. Kamm, J., *How Different From Us – A Biography of Miss Buss and Miss Beale*, The Bodley Head, 1958, p. 172.
32. Kamm, loc, cit.
33. Nightingale, F., 'Cassandra', in *Suggestions for Thought to Searchers After Religious Truth*, Eyre & Spottiswoode, 1860, vol. II, p. 380.
34. From *Men and Women of the Day – A Picture Gallery of Contemporary Portraits*, vol. II, ed. C. Eglington, Simpkin Marshall & Co., 1888.
35. de Marly, op. cit., p. 100.
36. Abdy and Gere, op. cit., p. 11. and Conan Doyle, Sir A., 'Silver Blaze' in *The Memoirs of Sherlock Holmes*, 1894.
37. de Marly, op. cit., p. 180.
38. Cunnington, op. cit., p. 514.
39. Langtry, op. cit., p. 115.
40. de Marly, op. cit., p. 157.
41. Vanderbilt Balsan, op. cit., p. 33.
42. Ibid., p. 57.
43. *Men and Women of the Day*, vol. II, 1889.
44. Hughes, M. V., op. cit., p. 84.
45. *Men and Women of the Day* vol. II, 1889.
46. Benson, *As We Were*, p. 312.
47. de Marly, op. cit., p. 193 and Blum, op. cit., p. 238.
48. Howard Spring, M., *Frontispiece – A Childhood Portrait*, Collins, 1969, p. 22.
49. Wells, *Experiment in Autobiography*, p. 149.
50. Bingham, op. cit., pp. 10–30.
51. Lomax, J. and Ormond, R., *John Singer Sargent and the Edwardian Age*, Leeds Art Galleries, 1979, pp. 32–3.
52. Quigley, op. cit., p. 107.
53. Benson, op. cit., p. 177.
54. Stuart, D., *Dear Duchess – Millicent, Duchess of Sutherland*, Victor Gollancz, 1982, p. 58.
55. Vanderbilt Balsan, op. cit., p. 54.
56. 'A Member of the Aristocracy', *Manners and Rules of Good Society*, Frederick Warne & Co., 19th ed., 1893, p. 69.
57. Cornwallis-West, op. cit., p. 173.
58. Laski, M., *Mrs Ewing, Mrs Molesworth, Mrs Hodgson Burnett*, Arthur Baker, 1950. Quoted in Thwaite, A., *Waiting for the Party – The Life of Frances Hodgson Burnett, 1849–1924*, Secker & Warburg, 1974, p. 85.
59. Ibid., p. 119.
60. Blum, op. cit., p. 129.
61. 'A Member of the Aristocracy', op. cit., p. 223.

PART 3: 1891–95

Male – Plates 74–89

1. Shonfield, op. cit., p. 141.
2. Galsworthy, op. cit., part II, ch. 3, p. 152.
3. 'The Major of *To-Day*', op. cit., p. 137.
4. Quoted in Rewald, J. G., *Beerbohm's Literary Characters*, Allen Lane, 1977, p. 74.
5. Cunnington, op. cit., p. 326.
6. 'The Major of *To-Day*', op. cit., p. 141.
7. Vanderbilt Balsan, op. cit., p. 75.
8. Bennett, E. A., *Clayhanger*, 1st ed., 1910. Penguin Books; 1975, Book III, ch. 7, p. 355.
9. Shonfield, op. cit., p. 9.
10. H. G. Wells, *Kipps – the Story of a Simple Soul*, Macmillan & Co., 1905, ch. II, part 3.
11. Mrs Humphry, *Manners for Men*, 1st ed. 1897, Webb & Bower; 1979, p. 119.
12. Benson, E. F., *Final Edition*, Longmans, Green & Co., 1940, pp. 50–1.
13. The *Tailor and Cutter*, 2 June 1898, p. 282.
14. Cunnington, C. W. and P. E., and Beard, C., *A Dictionary of English Costume*, Adam & Charles Black, 1960, p. 134.
15. Thwaite, op. cit., p. 127.
16. Conan Doyle, A., *The Adventures of Sherlock Holmes*, 1892.
17. Cornwallis-West, op. cit., p. 41.
18. Galsworthy, op. cit., pp. 7–8.
19. Rewald, op. cit., p. 158.
20. Douglas, Lord A., *Autobiography*, Martin Secker, 1929, p. 23.
21. Wilde, op. cit., ch. II, p. 37.
22. Morris, W., *News From Nowhere*, 1890, in Briggs, A., *William Morris, Selected Writings and Designs*, Penguin Books, 1962, p. 187.
23. Engels, F., *The Condition of the Working Class in England in 1845*, new ed., Granada Publishing Ltd., 1982, p. 99.
24. Burnand, op. cit., p. 305.

Group – Plates 90–99

25. Galsworthy, op. cit., book I, part I, ch. VIII, pp. 196–9.
26. Storey, G. A., *Sketches From Memory*, Chatto & Windus, 1899, p. 359.
27. Bennett, E. A., *Anna of the Five Towns*, Methuen, 1902, ch. VII.
28. Quigley, op. cit., p. 93.
29. Montgomery, op. cit., p. 96.
30. Vanderbilt Balsan, op. cit., p. 93.
31. The *Tailor and Cutter*, 3 June 1897, 'Dress in Public Places'.
32. 'A Cavalry Officer', *The Whole Art of Dress*, Effingham Wilson, 1830, p. 51.
33. Quigley, op. cit., p. 113.
34. Ibid., p. 115.
35. Bingham, loc. cit.
36. Anon, *Etiquette for Gentlemen*, Ward, Lock, & Tyler, *c.* 1880, p. 24.
37. Ballin, op. cit., pp. 200–1.
38. Grossmith, G. and W., *Diary of a Nobody*, 1st ed. 1892. Penguin Books, 1979, ch. V. p. 68.
39. Ibid., ch. XVIII, p. 183.
40. Ibid., ch. VI, p. 77; ch. XVII, p. 170; ch. VII, p. 86; ch. V, p. 69.

Female – Plates 100–116

41. Thompson, F., *Lark Rise to Candleford*, Oxford University Press, 1939; Penguin Books, 1973, ch. VI, p. 102.
42. Cooper, op. cit., ch. I, p. 14.
43. Anon, *The Nursery Maid*, Houlston's Industrial Library, *c.* 1880, p. 12.
44. Lawrence, D. H., op. cit., ch. V.
45. Smyth, op. cit., pp. 87–8.
46. Ouida, *Moths*, Bernard Tauchnitz, Leipzig, 1880, vol. I, p. 144.
47. P. Magnus, *King Edward the Seventh*, John Murray, 1964; Penguin Books, 1967, p. 271.
48. Quigley, op. cit., p. 83.
49. Smyth, op. cit., p. 100.
50. Ibid., p. 168, p. 151.
51. de Marly, op. cit., pp. 156–7.
52. Shonfield, op. cit., p. 120, p. 162.
53. Langtry, op. cit., p. 45.
54. Abdy and Gere, op. cit., p. 48.
55. Bennett, E. A., *Anna of the Five Towns*,

56. Galsworthy, op. cit., book I, ch. V, p. 69.
57. *Aglaia*, editorial, vol. I, 1893.
58. Ibid., vol. I, p. 34.
59. Troubridge, op. cit., p. 144.
60. Langtry, op. cit., p. 89.

PART 4: 1896–1900

Male – Plates 117–133

1. Collins, W., *The Black Robe*, 1881, ch. VIII.
2. 'The Major of *To-Day*', op. cit., p. 68.
3. Paderewski, I. J. and Lawton, M., *op. cit.* p. 185.
4. Grossmith, G. and W., op. cit., ch. IX, p. 104.
5. The *Tailor and Cutter*, 4 March 1897, p. 118.
6. Benson, *Final Edition*, p. 51.
7. Magnus, op. cit., p. 175.
8. 'The Major of *To-Day*', op. cit., pp. 71–2.
9. Anon, op. cit., p. 13.
10. Evans, H. and M., op. cit., p. 46.
11. The *Tailor and Cutter*, 23 September 1897, p. 490.
12. Ibid., 17 June 1897, p. 305.
13. Stuart, op. cit., p. 20.
14. Wells, H. G., *Kipps*, ch. II, part 5.
15. Wells, H. G., *Experiment in Autobiography*, p. 453.
16. Barraclough Paoletti, J., 'Ridicule and Role Models as Factors in American Men's Fashion Change, 1880–1910.' *Costume* 19, 1985, pp. 121–34.
17. Ibid, loc. cit.
18. The *Tailor and Cutter*, 29 April 1897, p. 216.
19. Bennett, E. A., *The Journals*, ed. Frank Swinnerton, Penguin Modern Classics, 1953, p. 31.
20. Cunnington, C. W. and P. E., and Beard, C., *op. cit.*
21. Roberts, R., *The Classic Slum*, Pelican, 1971, p. 39.

Group – Plates 134–138

22. Thompson, op. cit., ch. XXXIX, p. 526.
23. 'A Member of the Aristocracy', op. cit., p. 224.
24. Magnus, op. cit., p. 319.
25. Ibid., p. 308.
26. Fisher, G. and H., op. cit., p. 78.
27. The *Tailor and Cutter*, 7 July 1898, p. 353.
28. Wells, H. G., *Kipps*, book III, ch. I, part I.

Female – Plates 139–150

29. Galsworthy, op. cit., book I, ch. I, p. 10.
30. Anon, *The Lady's Maid*, Houlston's Industrial Library, *c.* 1880, p. 90.
31. *Men and Women of the Day*, 1889.
32. For further details see Walkley, C. and Foster, V., *Crinolines and Crimping Irons – Victorian Clothes: How they were cleaned and cared for*, Peter Owen, 1978.
33. Furniss, H., 'The Week in Parliament', *Black and White Magazine*, September 1891.
34. Galsworthy, op. cit., part II, ch. III, p. 137; part III, ch. I, p. 641.
35. *See* photograph of Lady Mary Hobhouse, National Portrait Gallery, ref. x 15581, *c.* 1890.
36. Benson, *As We Were*, p. 287.
37. Ibid., p. 17.
38. Wells, H. G., *Love and Mr Lewisham*, Harper & Row, 1900, ch. XXI.
39. Lawrence, D. H., op. cit., ch. X.

FURTHER READING

ADBURGHAM, Alison, *Shops and Shopping, 1800–1914*, London, Allen and Unwin, 1981.

BLUM, Stella, *Victorian Fashions and Costumes from Harper's Bazar*, (sic) *1867–1898*, New York, Dover Publications Inc, 1974.

BYRDE, Penelope, *The Male Image: Men's Fashion in England 1300–1970*, London, Batsford, 1979.

CUNNINGTON, C. Willett & Phillis, *Handbook of English Costume in the Nineteenth Century*, London, Faber and Faber, 1959, 1970.

GERNSHEIM, Helmut & Alison, *The History of Photography*, 1969.

GERNSHEIM, Alison, *Victorian and Edwardian Fashion, A Photographic Survey*, New York, Dover Publications Inc., 1963, 1981.

GIBBINGS, Sarah, *The Tie*, Studio Editions, 1990

GINSBURG, Madeleine, *Victorian Dress in Photographs*, London, Batsford, 1982.

GINSBURG, Madeleine, *The Hat*, Studio Editions, 1990

KIDWELL, Claudia Bush & STEELE, Valerie, *Men and Women: Dressing the Part?*, USA Booth Clibborn, 1989.

KIDWELL, Claudia Brush & STEELE, Valerie, *Men and Women: Dressing the Part*, Smithsonian Institute Press, 1989

LEVITT, Sarah, *Victorians Unbuttoned: Registered Designs for Clothing, their Makers and Wearers, 1839–1900*, London, Allen and Unwin, 1986.

NEWTON, Stella Mary, *Health, Art and Reason: Dress Reformers of the Nineteenth Century*, London, John Murray, 1974.

WALKLEY, Christina, *The Ghost in the Looking Glass*, London, Peter Owen, 1981.

WALKLEY, Christina, & FOSTER, Vanda, *Crinolines and Crimping Irons. Victorian Clothes: How They Were Cleaned and Cared For*, London, Peter Owen, 1978.

WALKLEY, Christine, *Dressed to Impress*, Batsford, 1989

WATT, Judith, *The Story of the Tie*, London, Pelham, 1989.

WAUGH, Norah *The Cut of Women's Clothes*, London, Faber and Faber, 1973.

The Cut of Men's Clothes, London, Faber and Faber, 1973.

WILSON, Elizabeth, & TAYLOR, Lou, *Through the Looking Glass, a History of Dress from 1860 to the Present Day*, London, BBC Books, 1989.